SHOPS & SHOWROOMS

HIP INTERIORS

KELLEY CHENG NARELLE YABUKA

HIP INTERIORS

SHOPS & SHOWROOMS

KELLEY CHENG NARELLE YABUKA

ROCKPORT

HIP INTERIORS:
SHOPS & SHOWROOMS

First published in the United States of America by:
Rockport Publishers, a member of
Quayside Publishing Group
33 Commercial Street
Gloucester, Massachusetts 01930-5089
Telephone: (978) 282-9590
Fax: (978) 283-2742
www.rockpub.com

Library of Congress Cataloging-in-Publication data available

ISBN:
1-59253-209-8

10 9 8 7 6 5 4 3 2 1

First published in 2005 by:
Page One Publishing Private Limited
20 Kaki Bukit View
Kaki Bukit Techpark II
Singapore 415956
Tel: (65) 6742-2088
Fax: (65) 6744-2088
enquiries@pageonegroup.com
www.pageonegroup.com

Conceived, designed and produced by:
Page One Publishing Private Limited

Editorial/Creative Director: Kelley Cheng
Editor: Narelle Yabuka
Assistant Editor/Editorial Co-ordinator: Ethel Ong
Senior Designer/Design & Layout: Huang Yulin

Printed in China

CONTENTS

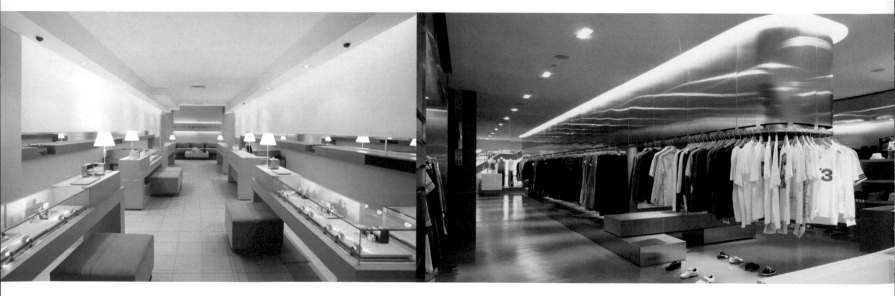

On one of Perth's most desirable fashion retail streets, the designer of a high-end clothing store has stripped retailing back to its fundamentals, producing a curious, yet beautiful space. On one of Melbourne's grittiest streets, a low-budget design for a record store has produced an equally discursive interior, where architecture meets music in an exciting symbiotic arrangement. In a Singapore shopping centre, a luxury lingerie boudoir teases passing shoppers with its curvaceous physique. Meanwhile, in high-rent, high-density Hong Kong, retailers are colonising more affordable upstairs units in aged buildings, capitalising intelligently on the accompanying sense of discovery experienced by their customers.

For an ever-expanding proportion of the world's population, the nature of shopping is changing from a life-sustaining activity to a leisure-based one. With the rise of the shopping culture, competition in the retail sector has never been stronger. The role of the designer is more crucial now than ever before in the race to attract customers, and there can be no argument that retail design has had to become smarter, edgier, even "sexier" to be able to capture consumer interest in a saturated selling environment.

Today's retail designer must compose an environment that not only satisfies the functional requirements of a selling space, but also ignites the imagination, seduces the mind, and generates desire for the products displayed. The shops and showrooms presented here achieve all this, successfully creating an "experience" that no doubt affirms strong memories of the space and the brand in the consumer's mind.

No matter the location, product or service on offer, in the shops and showrooms of this collection, style is always on the market.

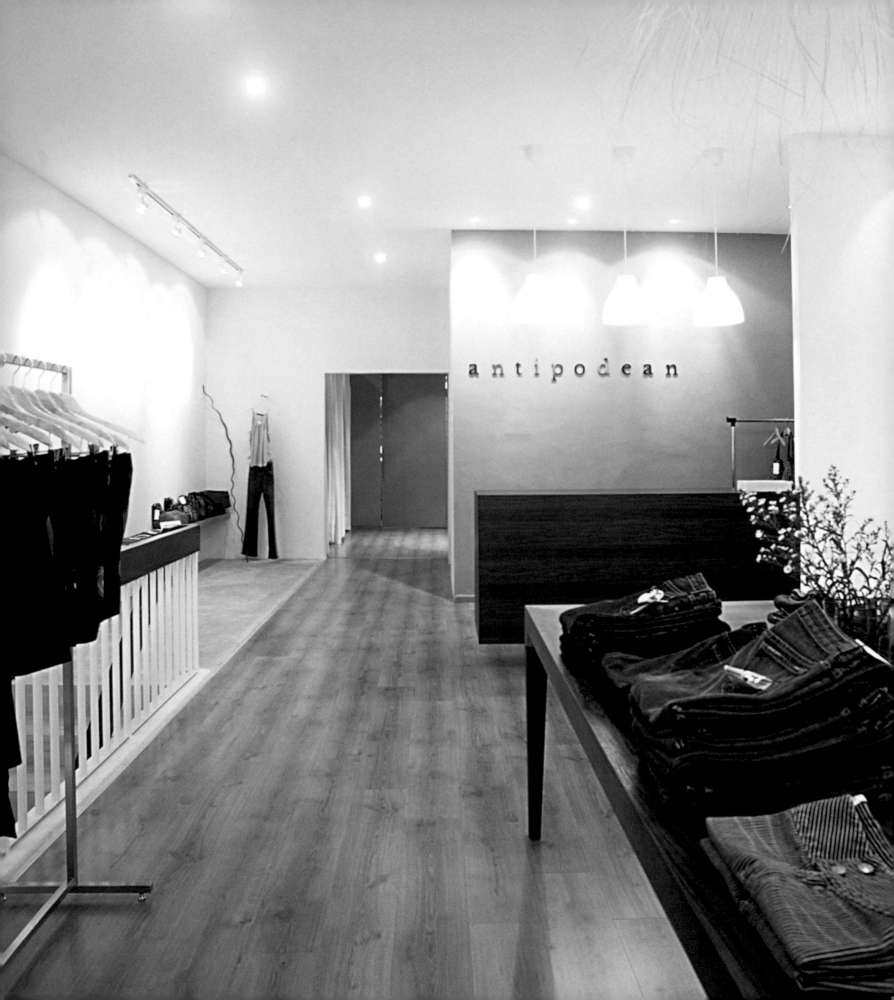

ANTIPODEAN:
SIMPLE STYLING

ANTIPODEAN: PERTAINING TO PARTS OF THE EARTH THAT ARE DIAMETRICALLY OPPOSITE; OFTEN USED OF AUSTRALIA AND NEW ZEALAND IN RELATION TO GREAT BRITAIN. IT IS CERTAINLY AN APT NAME FOR THIS SINGAPORE CLOTHING STORE, SINCE THE BULK OF ITS STOCK IS FROM THE TWO "DOWN UNDER" COUNTRIES. CLOTHING ASIDE, ANTIPODEAN MAY JUST BE THE ANSWER TO SINGAPORE'S OVERKILLED, OVER-SATURATED RETAIL INDUSTRY.

text Ethel Ong **photography** Kelley Cheng **designer** Grace Wong at Brim Design Pte Ltd **main contractor** Brim Design Pte Ltd **structural consultant** MABA Engineering Consultants
key materials timber laminate flooring, cement screed flooring, timber laminate display platforms **floor area** 120sqm **location** 27A Lorong Mambong, Holland Village, Singapore. P (65) 6463 7336

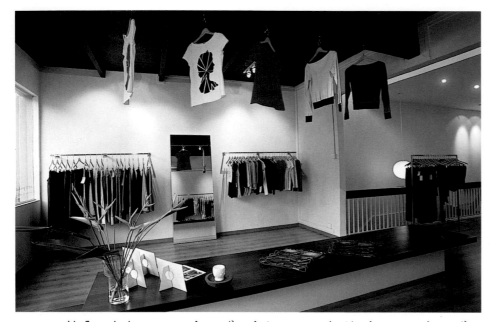

Helmed by a pair of sisters and their passion for clothes, Antipodean clearly illustrates how at times it is good to quieten down the design of the retail interior, and let the products do the talking.

Helmed by a pair of sisters and their passion for clothes, Antipodean clearly illustrates how at times it is good to quieten down the design of the retail interior, and let the products do the talking. A cure for the sisters' Australian longings, Antipodean is a breath of fresh air in Singapore, where almost every shop looks like the other, and where the design of the shop sometimes overpowers the actual products on offer.

Antipodean is situated in the quiet retail realm of Holland Village, hidden within a row of shophouses. And like its surroundings, the interior – conceived by Grace Wong of Brim Design – bears a distinctly un-Singaporean feel. Customers ascend a flight of stairs to enter the shop. Reminiscent of many Australian boutiques, its interior is simple and pared down to just its basic materials, with warm lighting and even warmer service. Also (thankfully) missing also from the quaint boutique is the loud music that so many shops in Singapore inflict upon their patrons.

Everything about this boutique, from its location, to its concept, design and implementation, is distinctly Australian. "I missed the shopping scene of Melbourne, where the shops felt warm and friendly, not cold and impersonal like Singapore's," said owner Tricia Lum. "I wanted Antipodean to feel warm and Australian – to bring a piece of Melbourne back with me, and for people to share that feeling when in my shop."

The establishment of the shop, helmed by Lum and her sister Weiling, was actually a natural progression from their long-lasting love affair with clothes. Ever since they chanced upon an up-and-coming Australian designer in Melbourne a couple of years ago, the sisters had toyed with the idea of opening a boutique. They were such huge fans of her clothes, that when they returned to Singapore in 2003, they decided to open a boutique to represent that group of up-and-coming Australian labels.

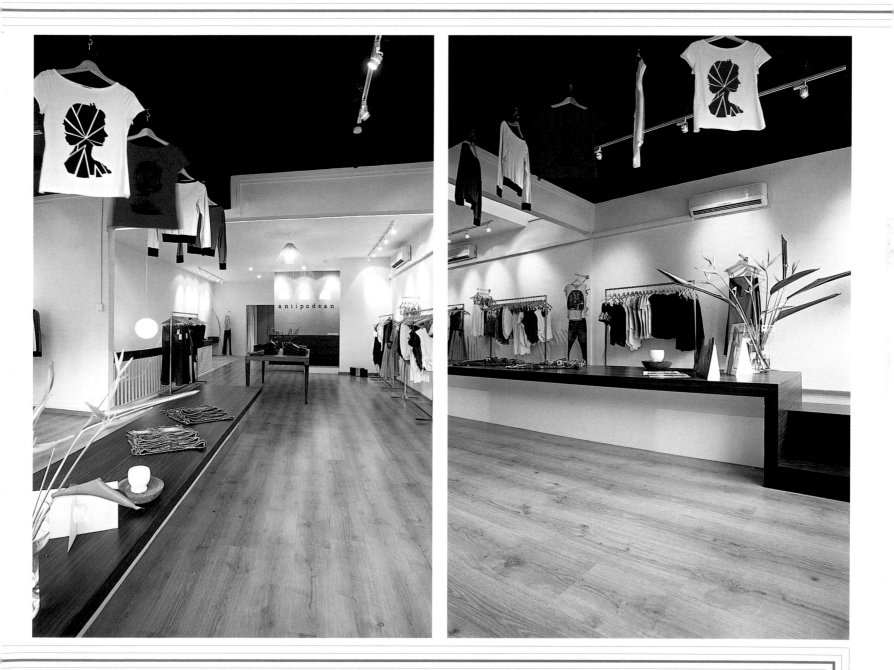

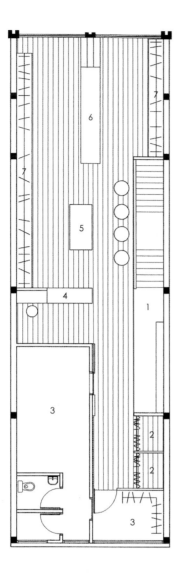

floor plan

1. entrance
2. changing room
3. storage
4. cashier counter

5. display table
6. display platform/catwalk
7. display rack

"We felt that the representation of Australian fashion in Singapore was rather narrow, and only consisted of labels that have been in the industry for a long time, such as Alannah Hill, Wayne Cooper, Zimmerman, etc. We wanted to bring in up-and-coming labels, which are not only more affordable than the established labels, but are also more willing to steer away from the tried and tested formula," explains Lum.

Antipodean manages the delicate task of retaining a sense of balance within a well-designed, yet endearing interior, which attracts without overpowering its products. Here, the clothes are the focal point, and garments are the true items on display. The fact that the boutique's simple lines and warm, earthy materials reflect the style and design of its clothes, makes it that much more sensitive. Almost all the walls within the shop are left bare, with the wall behind the cashier counter as the only exception. Painted a mellow olive, it enhances the friendly, laid-back atmosphere of the store.

Hung on plain-looking racks, clothes hug the walls in a simple, casual gesture. This style of display, intentionally playing up the casual air of the boutique, was also designed to allow its owners the flexibility of rearranging their layout for each season. A platform in the middle forms the only fixed display element in the store, but it too, has more than one purpose. Stained in the same deep walnut brown as the shophouse's exposed timber ceiling, the platform doubles up as a runway for in-house fashion previews.

The simplicity, honesty, and deep sensitivity of Antipodean's interior design are rarely found in Singapore's retail industry. After years of exposure to flashy, often pretentious boutiques, it is so refreshing to see a shop with such subtle, yet simple and effective styling. And though Antipodean carries labels of substantial fashion standing, the design and atmosphere of the boutique is in no way cold and impersonal. On the contrary, it is raw, unassuming, and intimate.

"I wanted Antipodean to feel warm and Australian — to bring a piece of Melbourne back with me, and for people to share that feeling when in my shop," said Tricia Lum.

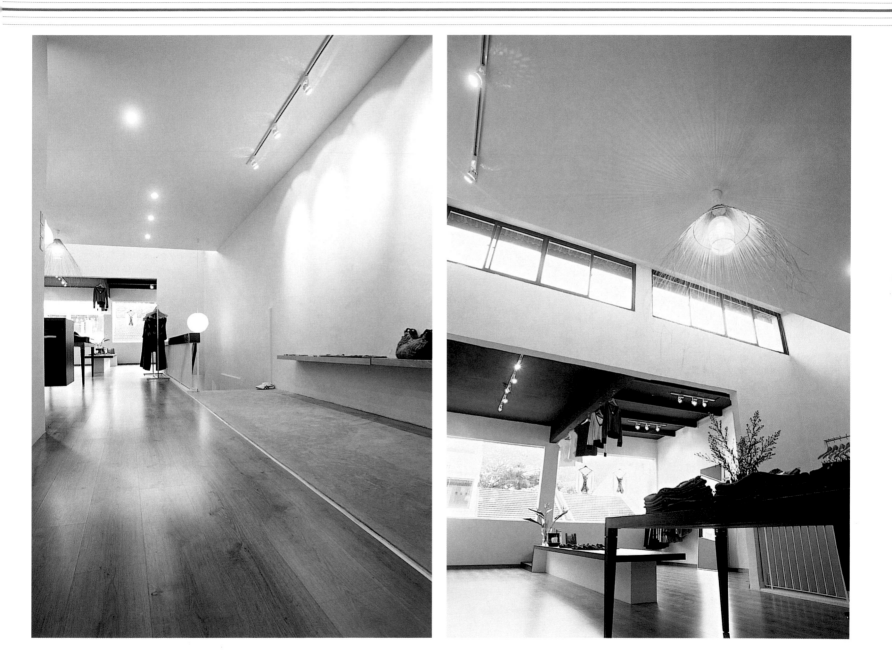

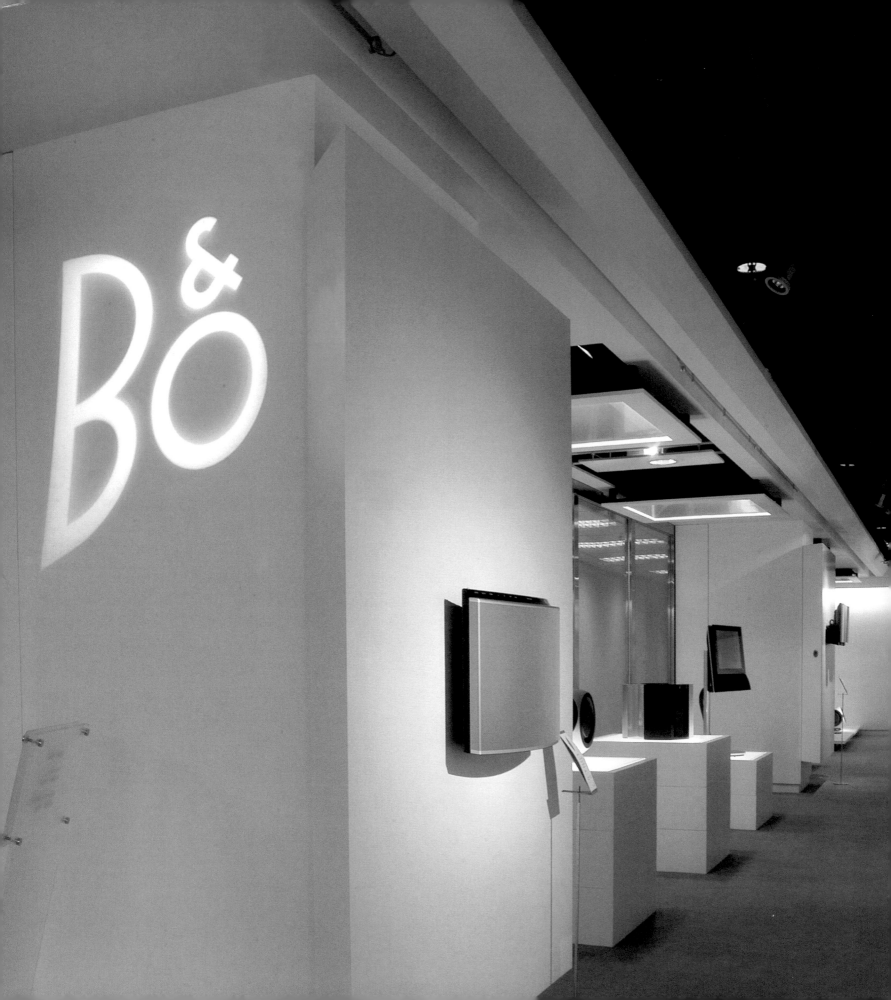

BANG & OLUFSEN SHOWROOM: HUSHED SANCTUM

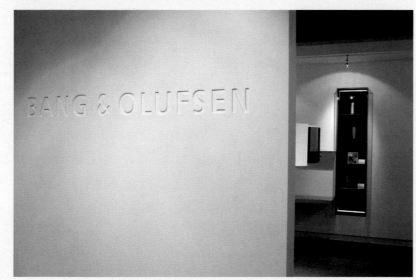

AS ONE OF THE WORLD'S FINEST PRODUCERS OF AUDIO AND VIDEO EQUIPMENT, BANG & OLUFSEN'S PENCHANT FOR SLEEK AESTHETICS NEEDS NO INTRODUCTION. BUT FOR THE DESIGNERS OF THEIR RETAIL SPACES, THE QUESTION OF HOW TO CREATE A RETAIL ENVIRONMENT THAT LIVES UP TO THE PROMISE OF THE BRAND, WITHOUT COMPETING WITH THE PRODUCTS FOR ATTENTION, PROVES TO BE AN ISSUE OF CONCERN. INTERIOR DESIGNER DANNY CHENG ROSE TO THE CHALLENGE.

text Catherine Cheung **photography** Elaine Khoo **designer** Danny Cheng Interiors Ltd **main contractor** Top Interest Construction Co **m&e consultant** Top Interest Construction Co **lighting** Lutron Lighting Control Systems **key materials** paint, glass partitions **floor area** 250sqm **location** Room 1102B, 11/F, West Wing, Hennessy Centre, 500 Hennessy Road, Causeway Bay, Hong Kong, PRC. P (852) 2882 1782

A showcase for Bang & Olufsen's quirky design philosophy, the interior of this new showroom in Hong Kong is purposely subverted for a focused contemplation of its products. When formulating the showroom design, Danny Cheng kept his eyes on the merchandise rather than the space itself. The showroom was conceived as a neutral canvas upon which Bang & Olufsen's creations can be appreciated at their best.

All interior ornamentation takes a backseat, allowing different proportions and volumes of space to take hold. With the showroom occupying the eleventh floor of a commercial building in Causeway Bay, it was expected that only those in the know would visit, and therefore the need to establish a conspicuous shop front was less pressing. This further reinforced the designer's intention for subverting the quality of the space to that of a museum – pristine, austere and purified.

With a predominantly monochromatic palette of white and grey, the showroom presents itself as an expansive, fluid space. Demarcations in the space have been introduced merely as a series of freestanding partitions anchored at different angles and positions. These partitions assume multiple purposes: firstly, they act as a backdrop against which merchandise, such as the range of telephones, is mounted in a perfect graphical composition; secondly, they act as an anchorage point from which a living room mockup is oriented, allowing customers to view the products in a "real" setting; and thirdly, they conceal storage spaces that house convertible components of the merchandise (for example, fittings in other colours) – another signature of Bang & Olufsen's design.

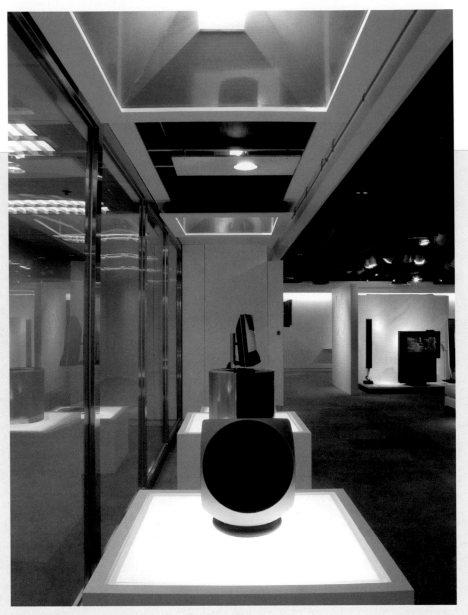

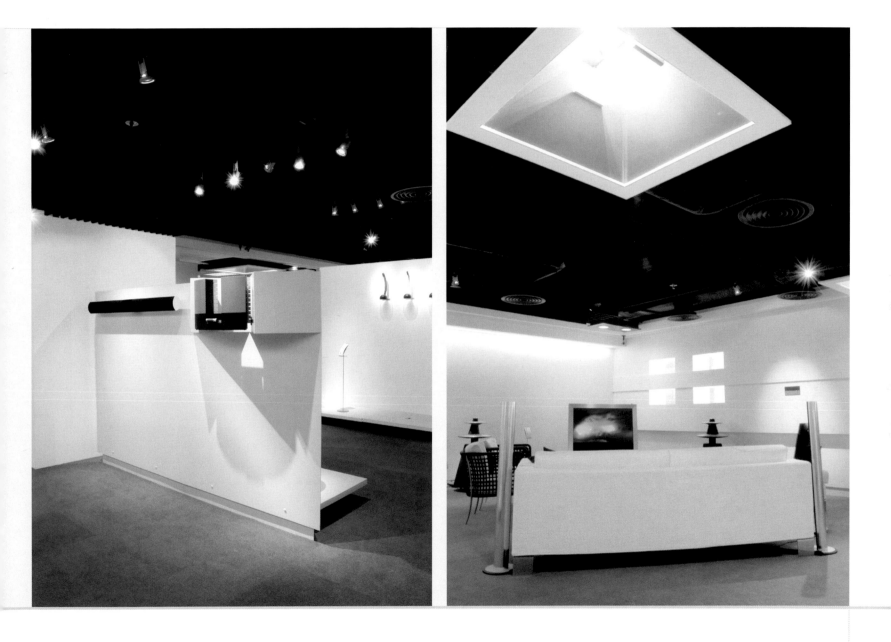

As such, varying volumes of space have been created. As one navigates through the flowing interior, a constant expansion and contraction of space can be experienced. However, the low height of the partitions ensures that visibility across the entire showroom is maintained. The floor plate is not particularly large, but each design piece has been afforded copious viewing space, which allows customers to examine the products from every vantage point. Much thought has also gone into the design of the display cases. For example, two glowing slits carved into an exaggerated white column accommodate the BeoCom 2 telephone. The verticality aptly accentuates the elegant contour of the phone.

As with all museums, lighting is a key issue here. Jonas Lillie, a photographer hailing from Denmark, has drawn upon his acute eye for light and shadow and devised a variety of lighting patterns that can highlight the colours imbued in each piece. While downlights are used to highlight loose, smaller objects, specially designed fixtures in the form of truncated pyramids flood the space with a uniform luminosity akin to sunlight. This reduces glare substantially, and has proven ideal for illuminating pieces arranged in a larger set.

With the showroom occupying the eleventh floor of a commercial building in Causeway Bay, it was expected that only those in the know would visit, and therefore the need to establish a conspicuous shop front was less pressing. This further reinforced the designer's intention for subverting the quality of the space to that of a museum — pristine, austere and purified.

Along the glazed store front, three mid-height light boxes throw an eerie glow onto the merchandise that sits above. Windows that puncture through the thick wall opposite offer a fragmented glimpse of the outside world. Such a configuration alludes fittingly to the fact that amid the urban hustle and bustle, the Bang & Olufsen showroom is indeed a hushed sanctum, offering an instance of purification with its pristine interior and slick, designed objects.

floor plan

1. lift lobby
2. entrance
3. main entrance
4. window display platforms
5. music system display
6. telephone display
7. loudspeaker display
8. storage
9. office
10. entertainment system display
11. telephone and hifi display
12. wall-mounted hifi display
13. display shelf

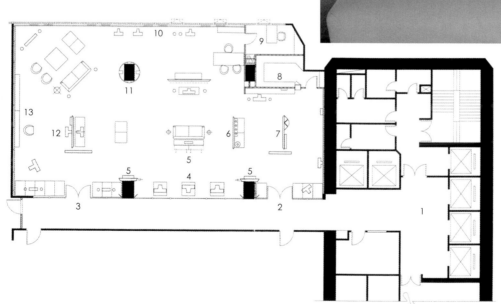

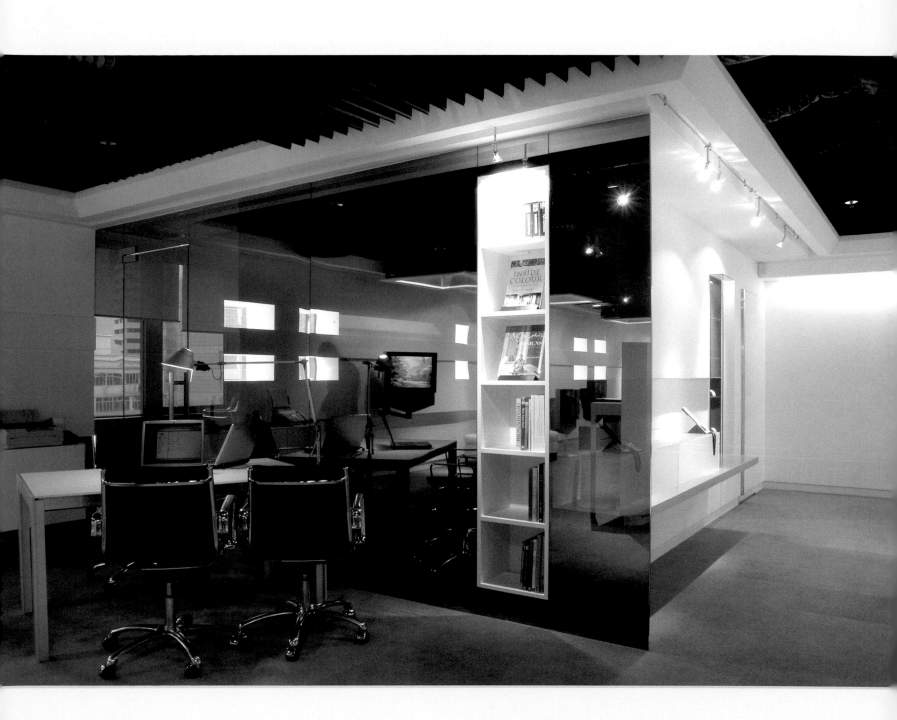

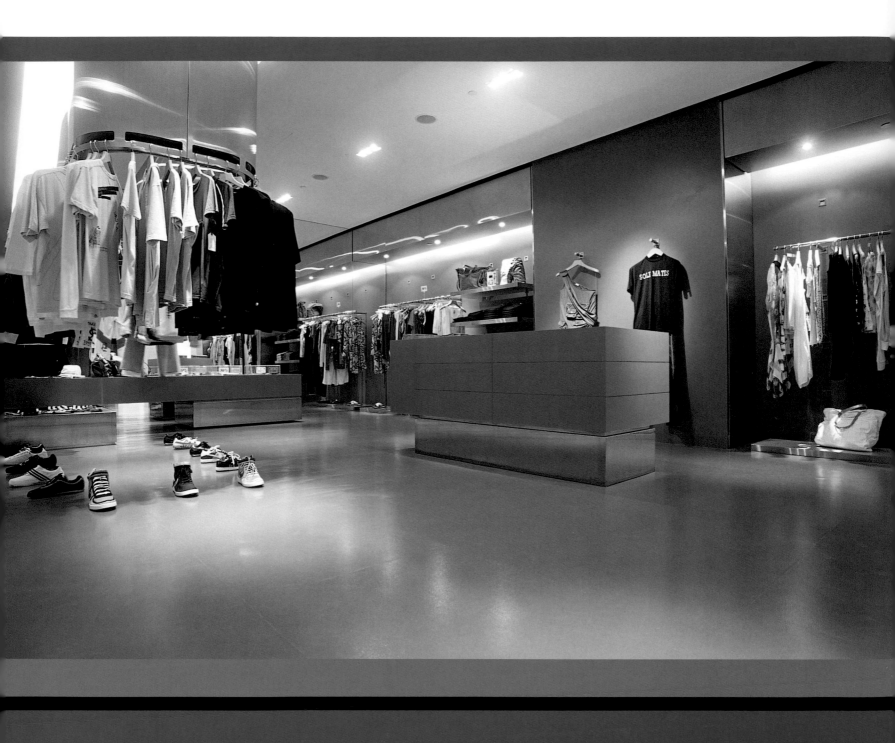

BLACKJACK: INDUSTRIAL WARE

SINGAPORE'S NEW BLACKJACK BOUTIQUE IS HIP, HOT AND HARD, AND EVERY BIT LIKE THE LINE OF CLOTHING IT CARRIES. THE BOUTIQUE'S BRIGHT ORANGE WALLS, JUXTAPOSED AGAINST ITS INDUSTRIAL STEEL FITTINGS, HINT AT THE "INDUSTRIAL" BEGINNINGS OF THE DENIM JEANS SOLD WITHIN, AND SPARK IMAGERIES OF EARLY INDUSTRIAL MANUAL LABOUR – THE WORK FOR WHICH JEANS WERE FIRST CREATED.

text Ethel Ong **photography** Kelley Cheng, Aaron Pocock **designer** Albano Daminato Studio **design team** Club 21 Projects Team **main contractor** Siatyun (S) Pte Ltd **m&e engineer** PCM Innovative (S) Pte Ltd **lighting** Bizlink Associate (S) Pte Ltd **key materials** orange rubber floor tiles, hairline stainless steel sheet, spray-painted shelves and wall panels, mirrors **floor area** 110sqm **location** 583 Orchard Road, #01-10/13/14, Forum the Shopping Mall, Singapore. P (65) 6735 0975

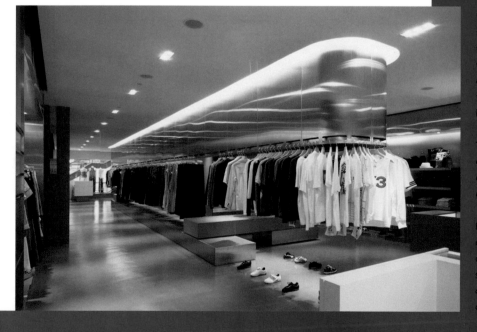

There is something insanely sexy about metal. Its cold, hard touch sends shivers down my spine, and when used in the interior with intentional historical symbolism, it gives a whole new dimension to the art of design. Such is the case in the new outlet for Singapore clothing retailer BLACKJACK – a "lifestyle" store in Forum the Shopping Mall, which stocks not only clothing, but also books, bags, jewellery, music CDs, an iPod docking station, and other objects. Brought to life by designer Albano Daminato, the store interior was designed to reflect the brand's alternative and energetic style.

"It was important for me that the store act as a dramatic backdrop and reflect the energy of this clothing," said Daminato. And the store's design does more than just reflect BLACKJACK's image. In fact, there is far more to it than its aesthetic; each element within the interior was carefully planned and designed as a metaphor or embodiment of the industrial past of denim, or to add to the store's dynamic concept. Simultaneously, each element functions within its own boundaries.

The initial design intent was steered towards an industrial look, which Daminato developed from several sources. Two of these were a laundromat hanging rail and a butcher's store display rack. From them spawned a flurry of inspirations and designs that soon became the main attractions of the boutique.

Bright orange forms the skin of the store, applied as sheet rubber on the floors, and on painted laminate panels for the walls, display units and fitting room doors. A combination of stainless steel – used for the central hanging rail and shelving – and mirror makes up the other main element in the boutique. In sharp contrast to this, a white spray-painted window display shelf, cash counter and ceiling plane form a dramatic "frame" to the electric orange interior.

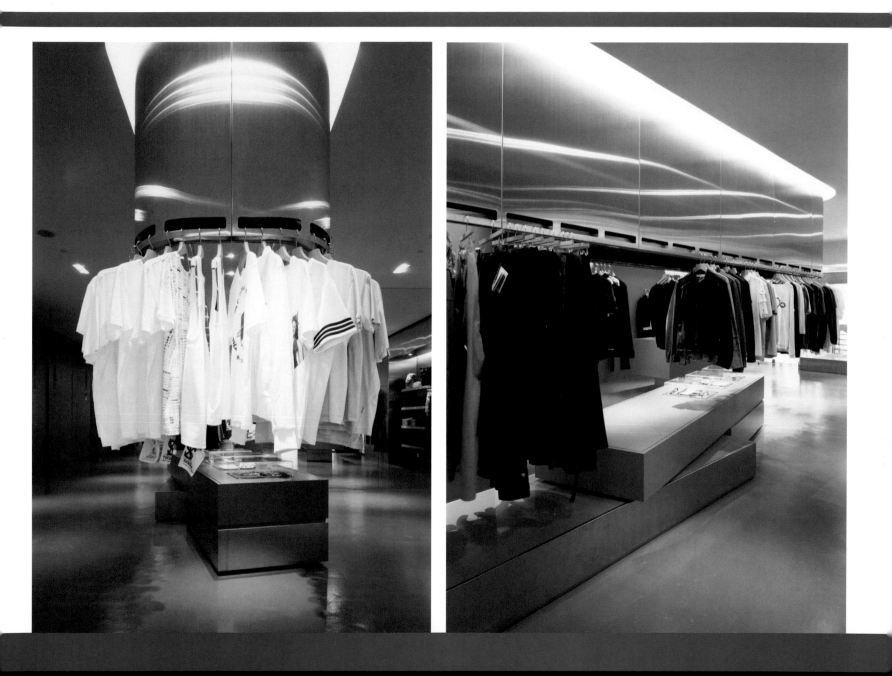

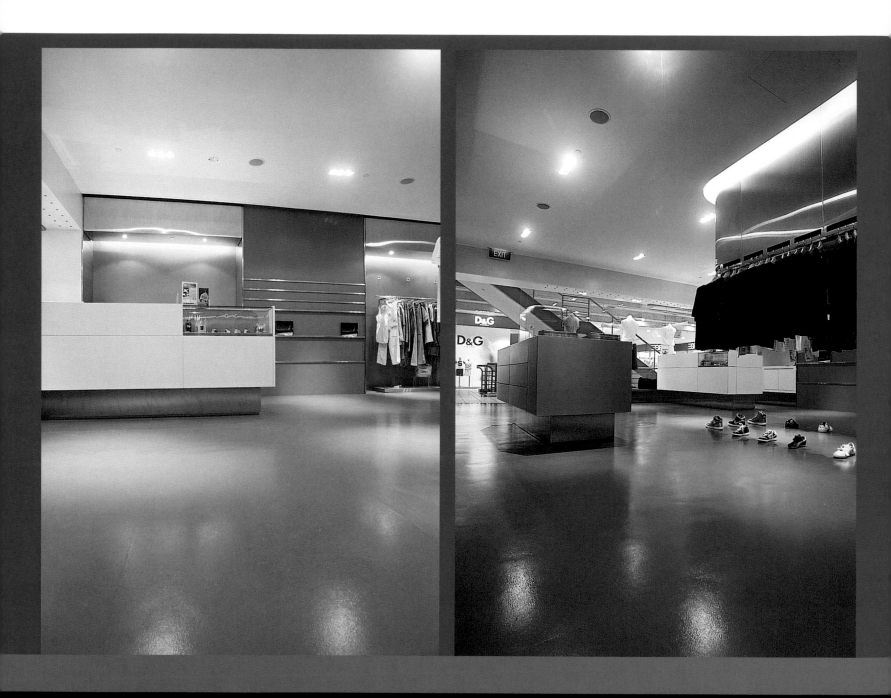

Orange is touted by the fashion industry as the new "it" colour, but it was chosen as the primary colour here not only for aesthetic purposes. Explained Daminato, "The colour orange has associations for me that are at once instantly recognisable as industrial and dynamic." Used widely in industrial applications and hazard signs, it seemed the perfect choice for the boutique.

Recessed display niches for clothing and products cover the side walls of the shop, but the focal point is the central clothing display system. The huge ceiling-mounted hanging rail occupies a considerable chunk of the interior space, and illustrates a radical concept for the display of fashion – putting clothes up on offer like "pieces of meat". Full-height wall mirrors at the rear create an illusion of an amplified space, and more importantly, dramatically complete the imagery of a laundry conveyor hanging system.

The industrial concept also worked its way into the many subtle details of the interior. Slots punched into the stainless steel centrepiece act as hanger rails, and folded stainless steel door handles, mounted within tall open slits in the fitting room doors, double up as "forked" clothing hooks. The shape and form of these punched slots and clothing hooks are by nature, industrial, and together, they lend subtle but edgy touches to the store's design.

And as if these details weren't punchy enough (or sufficiently clear translations of the industrial concept), Daminato designed one of the main display shelves to pivot on a large, fully-concealed wheel to add to the transient nature of the store. The moveable plane rotates like a huge articulated finger within the space, offering flexibility in the display arrangement, and enforcing the dynamic and powerful energy of the store's labels. BLACKJACK's new boutique, represents – in all its symbolism and physical attributes – our generation's creed of denim, sex and subversion.

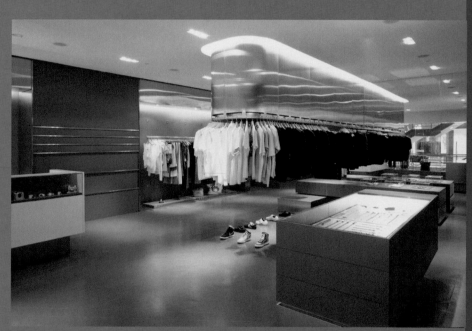

"It was important for me that the store act as a dramatic backdrop and reflect the energy of this clothing." Albano Daminato

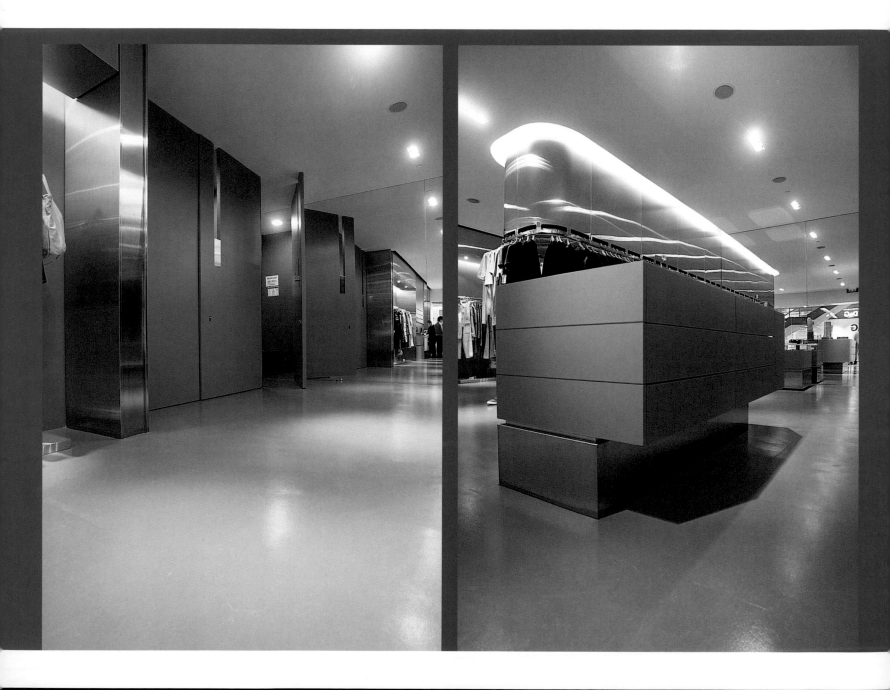

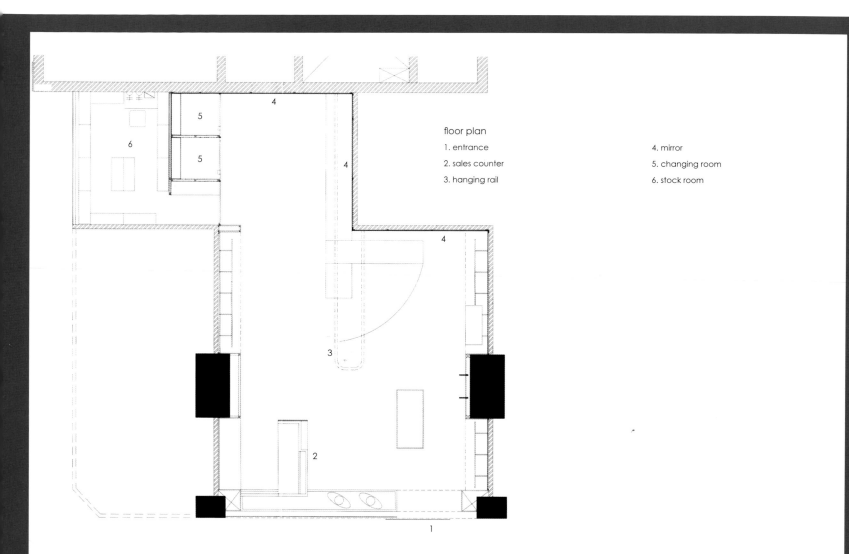

floor plan

1. entrance
2. sales counter
3. hanging rail
4. mirror
5. changing room
6. stock room

Orange is touted by the fashion industry as the new "it" colour, but it was chosen as the primary colour here not only for aesthetic purposes. Explained Daminato, "The colour orange has associations for me that are at once instantly recognisable as industrial and dynamic." Used widely in industrial applications and hazard signs, it seemed the perfect choice for the boutique.

CALIBRE, CHAPEL STREET:
MAN ENOUGH

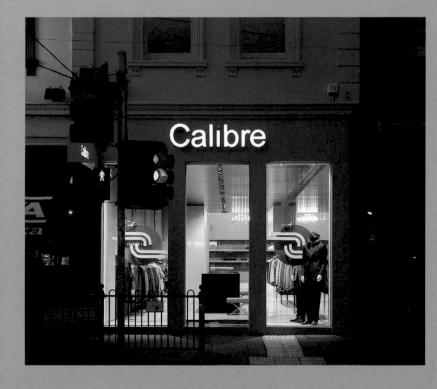

HOW DOES ONE REPRESENT "MASCULINITY" THESE DAYS? SIGNIFICANT CHANGES IN THE STRUCTURE OF GENDER ROLES OF LATE HAVE SPAWNED SUCH BIG QUESTIONS, AND DESIGNERS LIKE DAVID HICKS ARE (PERHAPS UNWITTINGLY) PROVIDING SOME ANSWERS. A STORE FOR AUSTRALIAN MEN'S CLOTHING RETAILER CALIBRE ON ONE OF MELBOURNE'S MOST BUSTLING SHOPPING STREETS PROVIDED A FABULOUS CANVAS FOR EXPLORATION.

text Narelle Yabuka **photography** Trevor Mein **designer** David Hicks Pty Ltd **main contractor** Easton Builders **structural consultant** David Landy and Associates **lighting consultant** Vision Design **furniture supplier** DeDeCe **key materials** insitu epoxy terrazzo flooring, Macassar ebony timber veneer, mirror, chromed metal, seagrass wallpaper, stained timber **floor area** 135sqm **location** 483 Chapel Street, South Yarra, Melbourne, Australia. P (61) 3 9826 4394

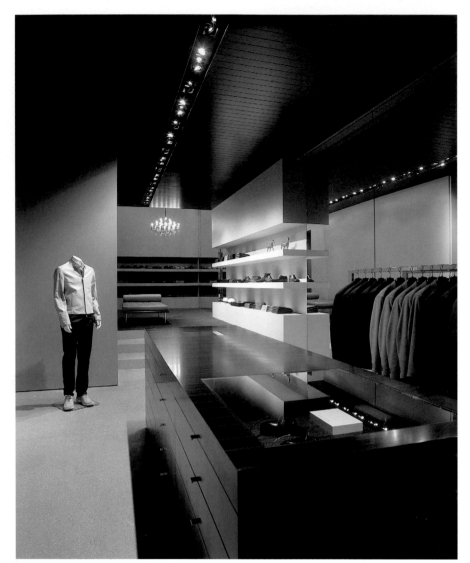

As well as a significant rise in the value of the image, the last ten to fifteen years have witnessed a general blurring of the divide between masculinity and femininity. The rise of feminist awareness has certainly had an impact upon the development of a popular masculinity that leaves behind direct sexism and overtly macho inclinations. But the media – in particular, the new world of men's lifestyle magazines – is largely responsible for the accelerated evolution of a new breed of man: one with a heightened aesthetic sense (traditionally regarded a female trait) and a keen interest in popular culture and style.

Realising that men's style involves more than simply knowing which tie goes with what shirt, the "new man" appreciates the importance of his appearance, and, one might say, has the self-confidence to pay more attention to grooming. Fashion retailers such as Calibre – who have spent twelve years on the Australian men's fashion scene – seem to have foreseen this trend, realising the importance of a well-designed store interior that will not only induce comfort by exuding a familiar "masculine" personality, but also provide the customer with a hip, exciting new shopping "experience".

"The new total Calibre concept is all about quality in clothing, architecture, lifestyle and of course, all about men," says David Hicks, designer of Calibre's new South Yarra total concept store. Calibre clothing is known for its slick, understated style, with designs distinguished by their wearability, luxe fabrics and interesting silhouettes. Fittingly, the store's interior embodies the same characteristics translated into built form. It is a stylish environment characterised by refinement, detail and quality. Though the interior is undeniably contemporary, it also evokes the sense of a 1950s bachelor pad-cum-tailor shop.

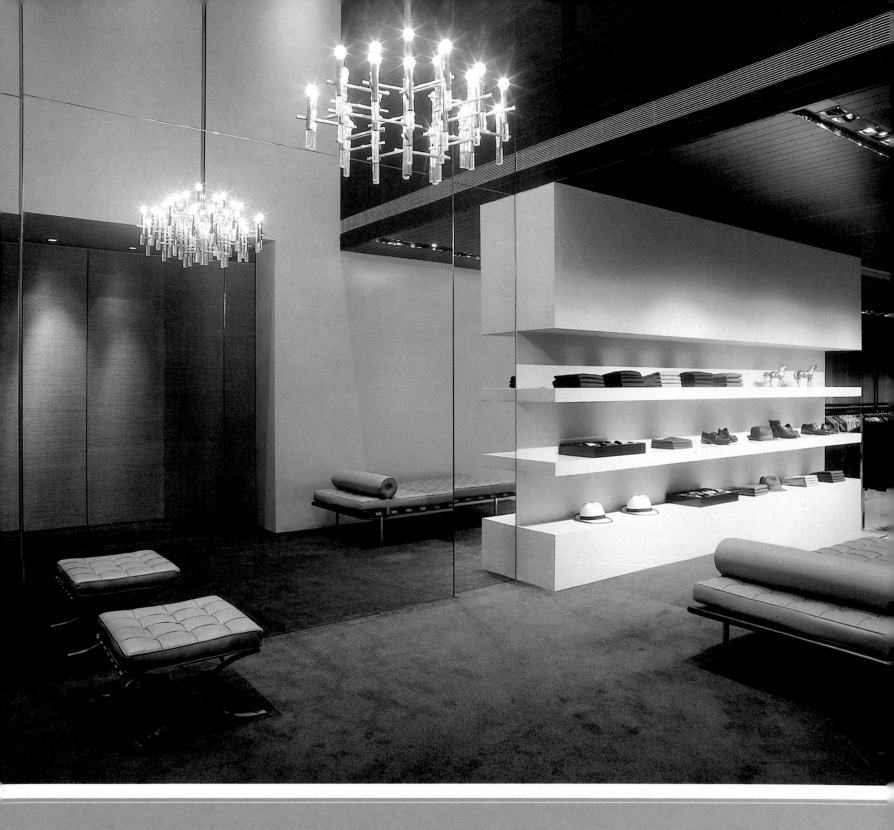

Aesthetically, the interior mediates between traditional notions of masculine expression and more contemporary trends – managing, one would expect, to appeal to a wide range of men in the process. Old definitions of "masculinity" prevail, for example, in terms of the selected materials and colours, but they are expressed in the most hip, stylish and contemporary of manners. The layout is structured by the regulating influence of a three-metre grid. Accordingly, feature benches and suspended shelves, clad with hand select-ed Macassar ebony veneer, are arranged with a three-metre dimension, as are polished chrome hanging rails. Suspended from the ceiling and rising from the floor, these painfully detailed and constructed elements seem to defy gravity.

A strict directional axis of recessed down lights runs the length of the store. Beneath it, contrasting materials, combined with a simple colour scheme, allow not only the clothes, but also the details of the interior to stand out. Terrazzo flooring – specially formulated and tinted to match the white paint – along with timber panelling, seagrass wallpaper and mir-ror form the basis of the material palette, creating an overall sensation of directness and self-assuredness. The curves and warm hue of a Mies van der Rohe Barcelona day bed and stools and punctuate the linear space, their imported tan-coloured Italian leather acquiring a new vividness in the relatively achromatic dark/light context.

The vibrancy of the furniture is visually balanced by a field of sur-prisingly coloured carpet that prefaces the change rooms. A linear, grid-like chandelier hangs overhead, bringing a touch of glamour to this important space within the store, where full-height panels of mirror facilitate a thorough scrutiny of one's appearance in the lat-est Calibre gear. The presence of two gleaming horse – or rather, "stallion" – statuettes on the shelves nearby provides an amusing addendum to Hicks' clever representation of contemporary mas-culinity and the Calibre objective; while factors such as comfort, quality and integrity are paramount, style is also crucial.

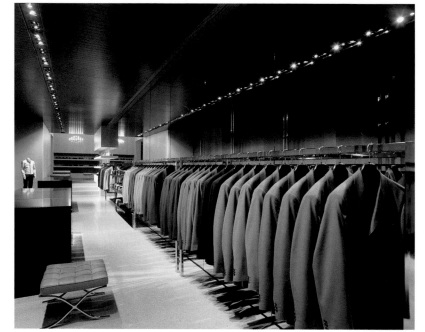

Fashion retailers such as Calibre – who have spent twelve years on the Australian men's fashion scene – realise the importance of a well-designed store interior that will not only induce comfort by exuding a familiar "masculine" personality, but also provide the customer with a hip, exciting new shopping "experience".

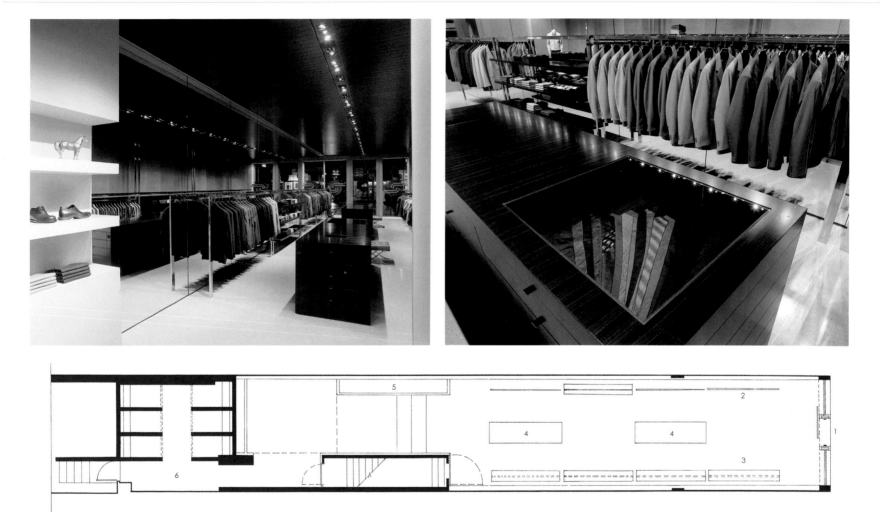

floor plan

1. entrance

2. hanging rack

3. shelf/hanging rack

4. counter

5. shelving

6. changing rooms

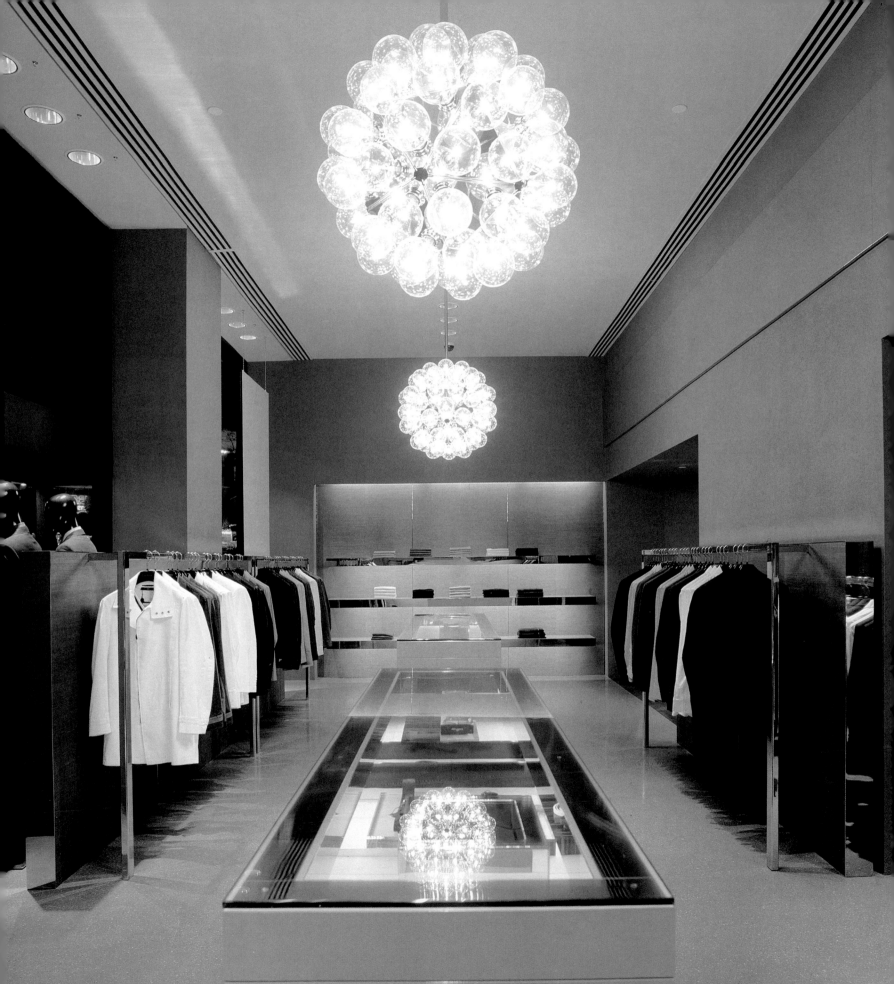

CALIBRE, COLLINS STREET:
MANIFESTO

HAVING EXPANDED THEIR COMPANY OVER TWELVE YEARS FROM A SINGLE STORE IN MELBOURNE TO A COLLECTION OF STORES NATIONALLY WITH A STRONG INTERNATIONAL PRESENCE, THE DIRECTORS OF AUSTRALIAN MEN'S CLOTHING LABEL CALIBRE FELT THE TIME WAS RIGHT TO DEVELOP A FLAGSHIP MELBOURNE STORE. DAVID HICKS HAS ONCE AGAIN PROVIDED A STYLISH AND EXPERIENTIAL INTERIOR FOR THE PRESENTATION OF CALIBRE'S QUALITY RANGE.

text Narelle Yabuka **photography** Trevor Mein **designer** David Hicks Pty Ltd **main contractor** Easton Builders **structural consultant** Connell Mott MacDonald **m&e consultant** Connell Mott MacDonald **lighting consultant** Vision Design **furniture supplier** Luke Design **key materials** insitu epoxy terrazzo flooring, two-pack polyurethane MDF board, mirror, chromed metal, seagrass wallpaper **floor area** 80sqm **location** Collins Place, 45 Collins Street, Melbourne, Australia. P (61) 3 9663 8001

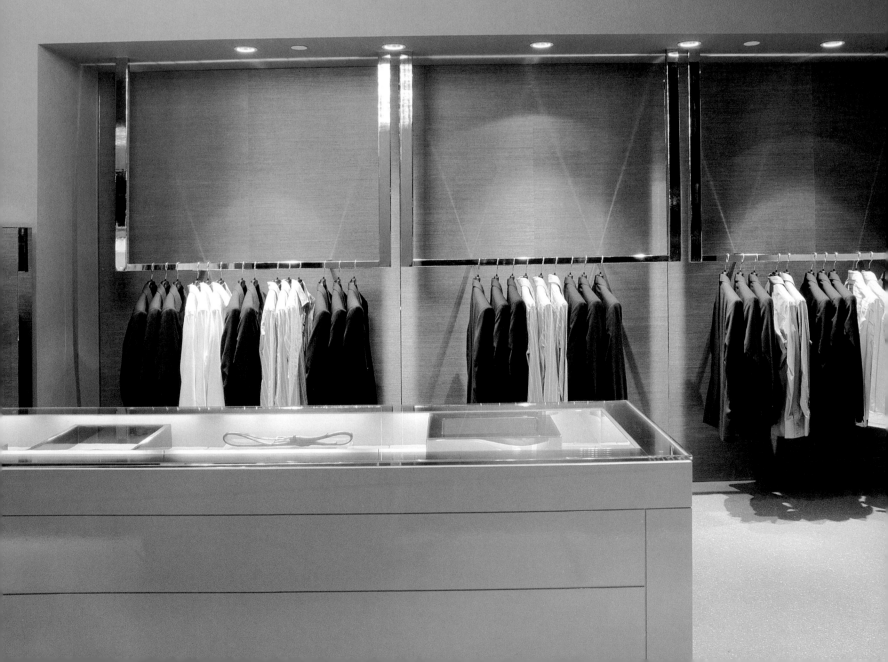

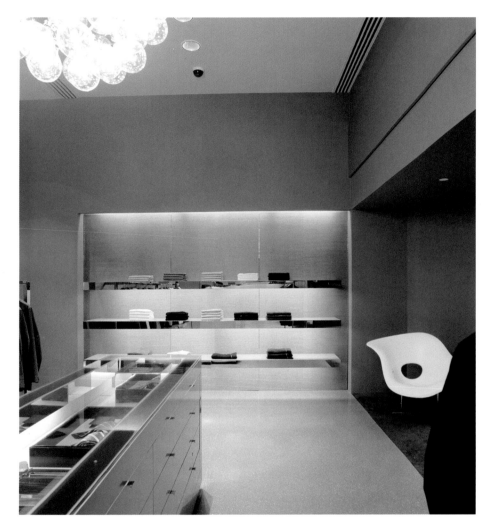

Along with the quality suits, casual wear and knits produced under its own brand, Calibre carries merchandise from some of the world's top labels, including Gucci, Yves Saint Laurent, Dolce & Gabbana and Costume National. It's little wonder, therefore, that a space in the so-called "Paris End" of central Melbourne's tree-lined Collins Street was selected for a new flagship store, where Calibre can flex its muscle beside stores belonging to high-end labels such as Chanel, Tiffany & Co and Louis Vuitton.

A space was obtained within one of the two pre-cast concrete towers of Collins Place – a mixed-use urban microcosm designed by Pei Cobb Freed and Partners, and completed in 1981. Distinctively set at a forty-five-degree angle to the street grid, the Collins Place towers circumscribe a public retail and entertainment plaza, which is grafted to the street by a paved forecourt. It is beside this forecourt that Calibre found its high-exposure ground level shop space.

Designer David Hicks, who previously assisted with the establishment of the Calibre concept store on Chapel Street in South Yarra, was again entrusted with the arrangement of the interior. While in the Chapel Street store he dealt with a long narrow space and a narrow street front, the Collins Street space presented a wide, heavily glazed frontage capping the prime corner site. He has used it to the utmost advantage.

The large feature windows overlooking the forecourt and Collins Street have been thoughtfully utilised as large canvasses for display. Calibre visuals occupy one bay of glazing, mannequins another, and the glass entrance door the other. Views into the interior are teasingly fragmented by display cabinets, and by a screen that shields a hanging rail, offering the shopper with a degree of privacy inside. A mirrored finish on the exterior-facing side of the screen confronts the window shopper with a reflection of himself beside the smartly-clad mannequins, and thus an image to contemplate.

Thematically, Calibre on Collins follows on from the Calibre concept store on Chapel Street. Again, the aim was to create a stylish new "boutique" shopping experience with a "masculine" personality. The signature rectilinear chrome racking, hand woven seagrass wall panels and custom terrazzo flooring used at Chapel Street return, reinstating the focus on quality interior features, and paying homage to the integrity of the Calibre range. With a paler, warmer palette, and the infiltration of more curved forms, the feel of the Collins Street store is more gentle, but Hicks' design manoeuvres are by no means less cutting edge.

The atmosphere is plush, modern, and surprisingly intimate given the expansiveness of the glazing. Seemingly in continuation of the theme established in the window display, reflection is also a dominating concept within the store, with a mirrored finish lining the edges of shelves and screens (in addition to the hanging racks), and a glossy white finish applied to the cabinets. Simultaneously creating reflected images and dissolving edges, the tenuity of these reflective materials is echoed in bulbous feature light fittings that hover overhead like collections of bubbles.

With curved forms traditionally regarded as belonging to the "feminine" realm, the inclusion of *La Chaise* certainly seems to nod towards the contemporary blurring of the masculine/feminine divide.

The delicacy and glamour of the pendants is reinforced by a classic curvaceous chair that sits before a full-height panel of mirror outside the changing rooms. *La Chaise*, a modern icon designed by Charles and Ray Eames in 1948, is characterised by its thin moulded fibreglass shell atop slender iron legs and a wood base. The chair's organic, body-friendly biomorphic form provides not only a point for physical respite within the store, but also visual relief from the dominating linearity that orders the interior. With curved forms traditionally regarded as belonging to the "feminine" realm, the inclusion of La Chaise certainly seems to nod towards the contemporary blurring of the masculine/feminine divide.

Calibre on Collins Street carries itself with an air that surely appeals to the corporate populace of the vicinity, as well as the dedicated shopper. True to the character of the Calibre brand, the interior is keenly detailed, stylish and sophisticated in nature. Hicks has made the most of the highly visible location, yet also managed to ensure a scale of intimacy for the customer, all the while continuing to explore the possibilities for representing contemporary "masculinity".

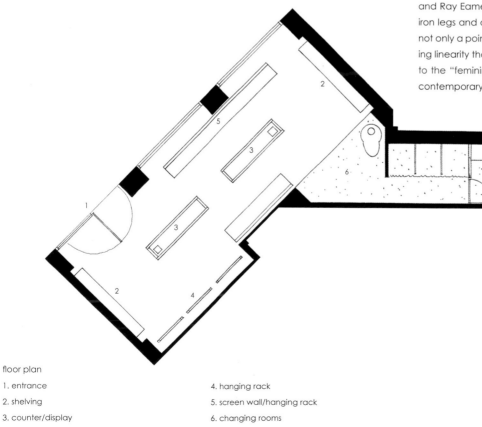

floor plan

1. entrance

2. shelving

3. counter/display

4. hanging rack

5. screen wall/hanging rack

6. changing rooms

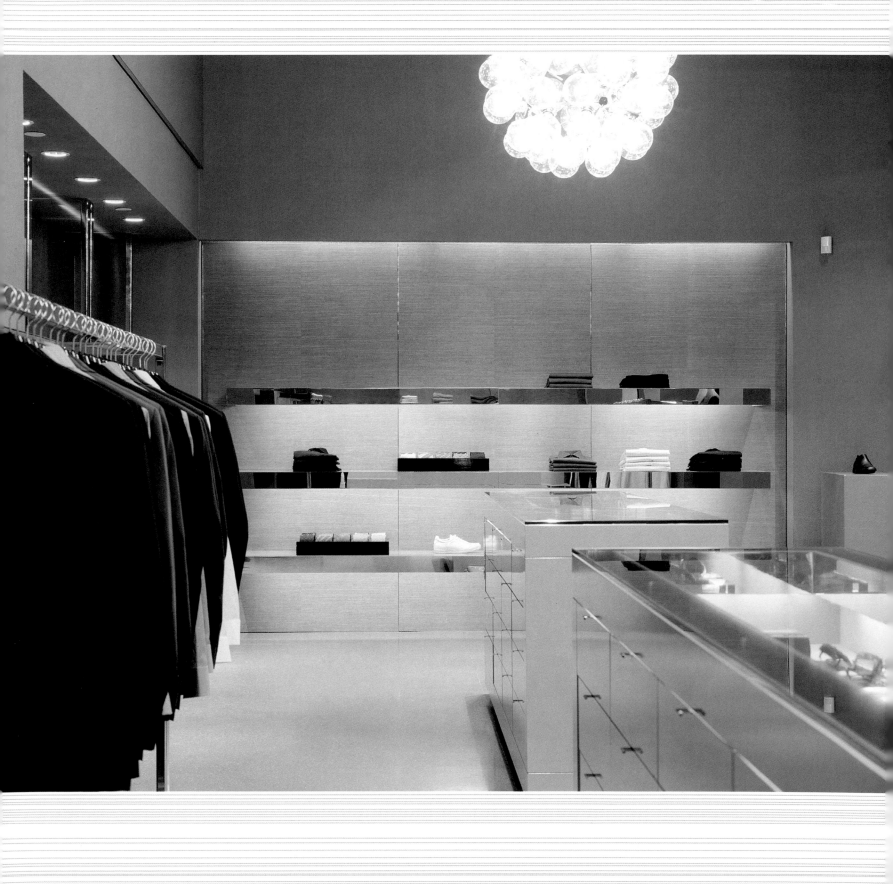

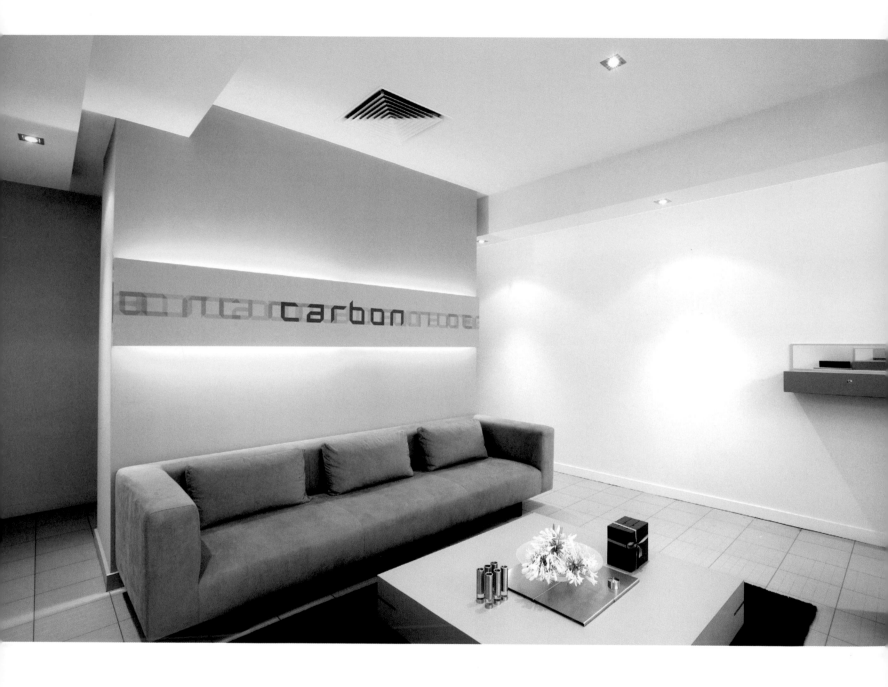

CARBON CHEMISTRY OF DIAMONDS:
THE ARCHITECTURE OF SEDUCTION

ALONG THE STRING OF TYPICAL GLAZED FACADES THAT LINE A BUSY SHOPPING STREET IN THE INNER PERTH SUBURB OF SUBIACO, THERE IS ONE STOREFRONT AMONG THE MANY THAT SEEMS TO HAVE PERFECTED THE ART OF CUSTOMER SEDUCTION. FURTHERMORE, IT IS THE PERFECT PREFACE FOR THE PRECIOUS STOCK FOUND WITHIN.

text Narelle Yabuka **photography** Robert Frith **interior designer** Carol Anne Cassidy and Associates **graphic designer** John Pallett of Chemistry Design **marketing assistants** Petria Jeffries, Morgan Lewis, Kate O'Hara **main contractor** Ferguson Corporation **electrical contractor** Bertrams Electrical Communications **signage** Sign Enterprises **key materials** alloy-brushed stainless-steel mosaic tiles, glass-look vinyl floor tiles, low-sheen-finish concrete, lustre textured laminate, suede, metallic vinyl, rubberised vinyl **floor area** 120sqm **location** 112 Rokeby Road, Subiaco, Perth, Australia. P (61) 8 9381 6855

CARBON Chemistry of Diamonds punctuates the footpath with a human-scale box that thrusts imposingly beyond the recessed line of the store's glazing. Its glittery tiles captivatingly render the day's gentle changes in light, as well as the bright flashes of vehicle headlights at night. At any time, the form commands attention. It has undeniable sex appeal.

CARBON Chemistry of Diamonds punctuates the Rokeby Road footpath with a human-scale box that thrusts imposingly beyond the recessed line of the store's glazing. Simultaneously embodying the immense and the minute in scale (by way of its size and the gauge of its stainless-steel mosaic tile cladding), the box both confidently pronounces itself, and shyly beckons a close-up viewing of the delicate items contained within its display niches. The glittery tiles captivatingly render the day's gentle changes in light, as well as the bright flashes of vehicle headlights at night. At any time, the form commands attention. It has undeniable sex appeal.

This seductive mixture of coquettishness and unabashed appeal is not only the dream of many in search of love; it is the stuff of a retailer's dreams. Even more so, it could be conceived of as the pure essence of a diamond jeweller's dreams. For many, the purchase of a piece of diamond jewellery is a "once in a lifetime" event. And just as the purchasing of a diamond is special, the wearing of such a precious item surely conjures the same feelings of distinction and delight. If the purchasing environment could, firstly, both consciously and subconsciously herald these feelings before the credit card has registered the impact of the purchase transaction, and secondly, make the journey to the cash register a comfortable jaunt (rather than a tortured march), then the optimum environment for selling a diamond would have been achieved. This is precisely where CARBON succeeds.

After the flashiness of the entrance, the mood of the store interior is contrastingly low key. A softer and more sensual quality emanates. This, says designer Carol Anne Cassidy, "was developed to heighten the pleasure of purchase." The interior, punctuated with subtle branding references, is a physical comfort zone with its gentle colours, courteous textures and unobtrusive configuration. The clients had simply asked for "a store with distinction" – clean-lined, sophisticated, and relevant to the niche business and its clientele. Several thoughtful strategies from Cassidy have more than catered to their request.

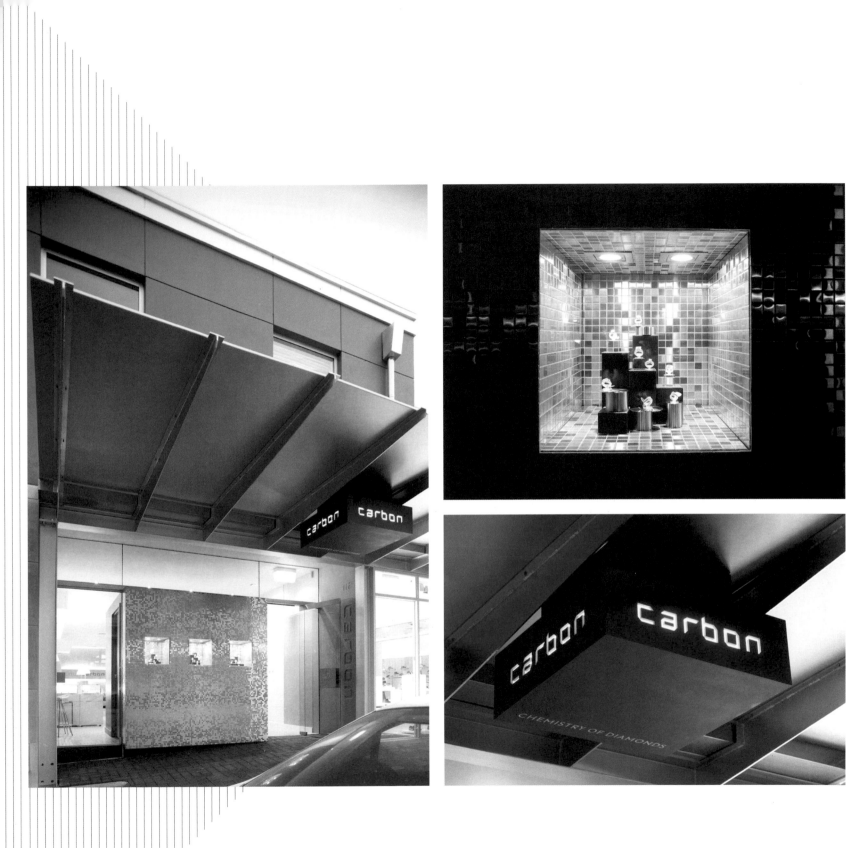

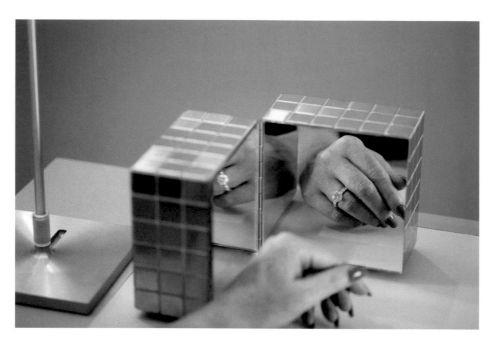

After the flashiness of the entrance, the mood of the store interior is contrastingly low key. A softer and more sensual quality emanates. Punctuated with subtle branding references, the interior is a physical comfort zone with its gentle colours, courteous textures and unobtrusive configuration.

The most immediate feature of the interior is the subtle use of colour. From the metallic paint that guides one through the entrance, the paint colours slip into a wistful play of chalky white against soft green tones. These shades mesh with the colours of interior textiles and surfaces so that a subtle, soothing range of colour reigns. The arrangement and detailing of the furniture and display accessories reinforces the sense of lull. The deep space is emphasised with the symmetrical use of a long, narrow and low proportion. The counter design, more narrow than usual, encourages a closer relationship between staff and customers. Non-visible locking mechanisms offer security assurance. The furniture is mobile, allowing the interior to be "re-tasked" for special events, such as fashion parades.

Meanwhile, slim, unobtrusive strips of mirrors on both side walls reflect the interior into infinity. Positioned at the height of the counter lamps, the mirrors also bounce more light around the space, and the repeated reflection of the lamps gives them a jewel-like appearance. Downlights contained in boxed bulkheads throw illumination gently down the side walls, while counter spotlights focus on the jewellery. Custom-designed, mosaic tile-clad cube mirrors split open on a hinge to provide multiple reflections of a ring undergoing scrutiny. The ability to hold and manipulate these glittery cubes is a satisfying play on scale, and one that cements the conception of the facade box as a jewel itself.

From the "come hither" facade, to the first embrace of the customer beside the protruding exterior box, to the gentle touch of dense-fibre carpet underfoot at the display cabinets, the store design courts the customer all the way from the footpath to counter. With refined lines that achieve an instant chemistry, Cassidy seems to have mastered the architecture of seduction.

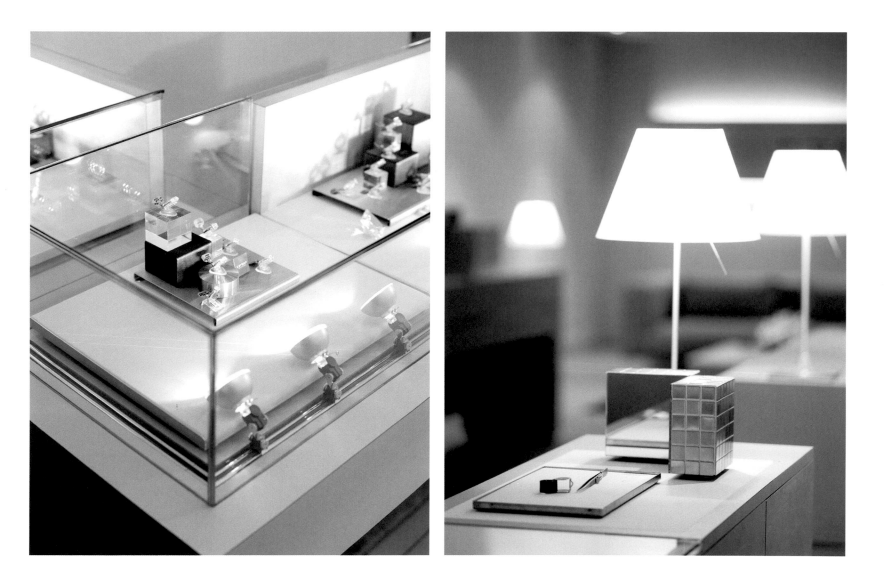

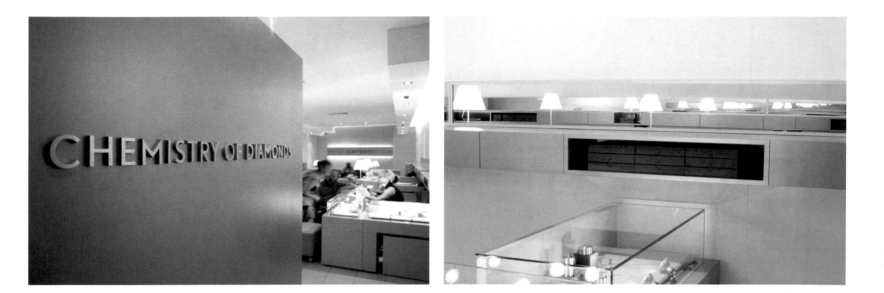

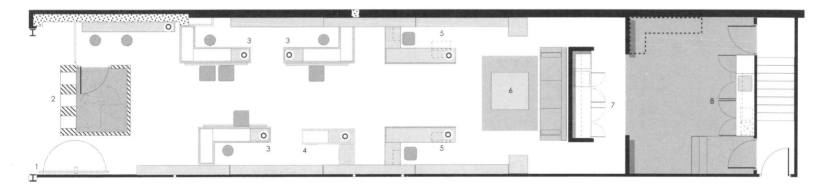

floor plan

1. entrance

2. facade display box

3. sales counter

4. cashier/service counter

5. work station

6. meeting area

7. administration area

8. galley kitchen

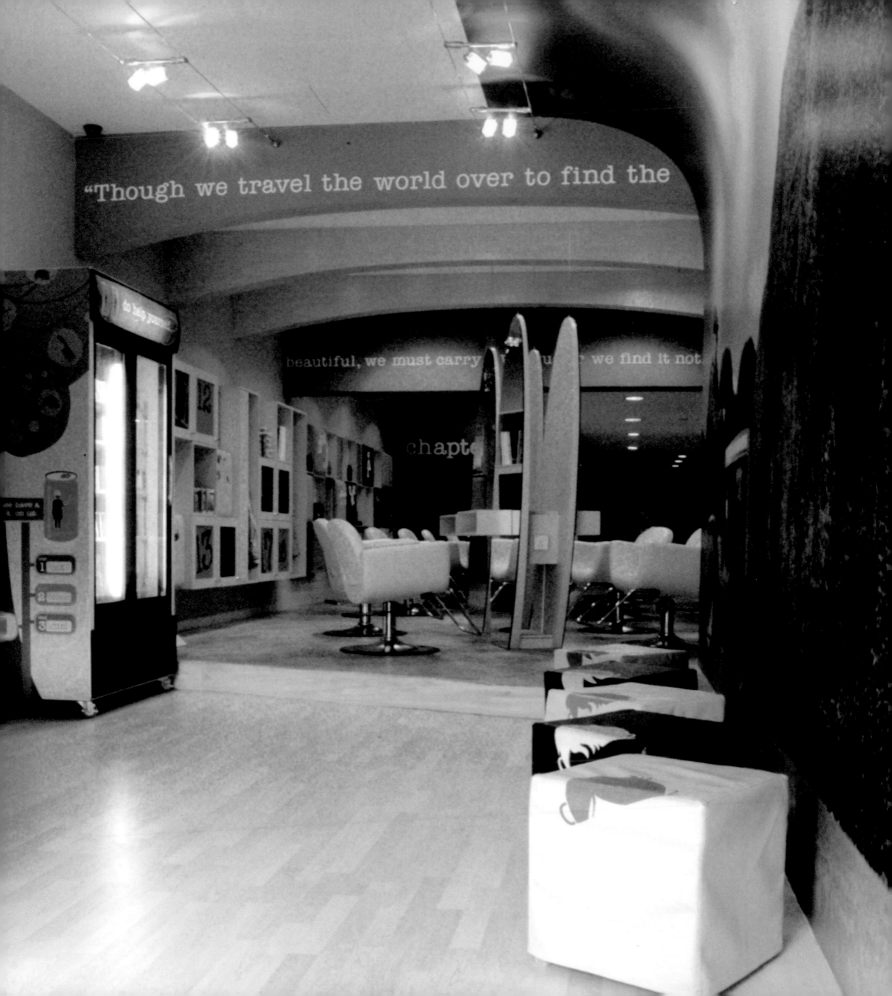

CHAPTER 2:
THREE STORIES

OBSCURED BY THE JAPANESE QB (QUICK BEAUTY) SALON $10-PER-CUT REVOLUTION WAS SINGAPORE'S QUIETER, BUT LONGER-STAYING IMPORT OF COLOUR BARS. AFTER THE OUT-BLEEDING OF THEIR CLIENTS, CORPORATE SALON KIMAGE HAIRDRESSING HAS STRUCK BACK WITH A BRAND NEW CONCEPT, MADE MANIFEST IN CHAPTER 2. CONTAINED WITHIN A THREE-STOREY SHOPHOUSE, THIS SALON, AS PER ITS NAME, BEGINS A NEW CHAPTER FOR KIMAGE.

text Elaine Khoo **photography** Elaine Khoo **interior designer** Shermaine Lee at EDF + Space Planners **brand consultant/consultancy** A.S. Louken Branding/A.S. Louken Group **branding team/consultant** Chong Ten Yee **creative team/graphics team** Lee Chew Yen, Aw Jet Chin **main contractor** Mic Marco Contract **lighting supplier** Light Image **key materials** concrete, timber flooring, plywood, acrylic, murals **floor area** 275sqm **location** 235 Victoria Street, Bugis Village, Singapore. P (65) 6339 2212

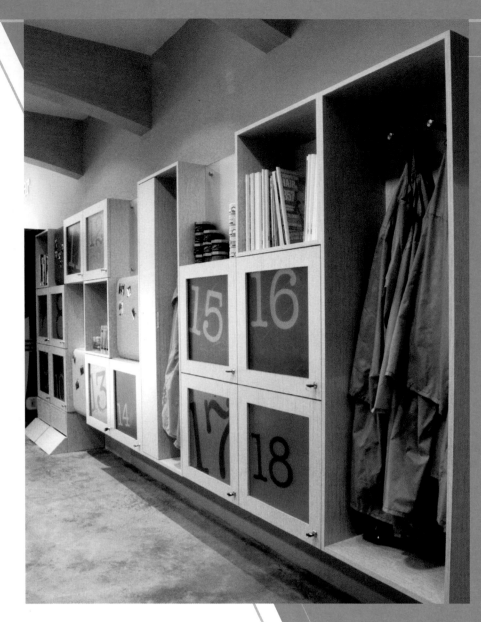

In order to reinvent itself within Singapore's saturated hairstyling industry, Kimage Hairdressing found it necessary to undertake some intensive research. Senior branding consultant Chong Ten Yee of A.S. Louken was commissioned to do research on salons worldwide, detailing even the various methods by which drinks were served and how belongings were taken care of. Chong subsequently formulated a strategic business direction and started to build the creative team, looking for a set of like-minded people who could create something entirely different from the existing market. With the help of interior designer Shermaine Lee, and graphic designers Lee Chew Yen and Aw Jet Chin, chapter 2 was eventually successfully developed as a trendy hair salon that boldly experimented with cool new ideas best described as intelligent "lifestyling".

The three floors are used as a demarcation for the different services – first floor for cut, second for colour, and third for curl. Each floor has an individual concept, tied across the levels by a similar means of expression. On the ground floor, cutting hair is likened to lawn mowing. Ten Yee explains that your hair, like grass, is always growing, and will end up unkempt if uncut. So while they "work on the turf above", you can enjoy the views within the painstakingly detailed cutting station. The oval mirrors, for example, are amplifications of hair-ends when cut at the correct angle. These fully customised counters tilt dynamically, easing themselves into a concrete platform.

To one side is a row of bent plywood stools, with graphics stenciled into the finish. The opposite wall holds a variegated shelf that is part robe hanger, part magazine rack, part storage shelf, part pin-up cushion for sketches, and part lockers. The lockers used for storing your belongings each possess a different graphic. If you are thirsty, simply help yourself to drinks over at the fridge. The generosity of the business concept extends over to its flat-pricing system – should you choose to customise your hair in five different colours, the charge is still a flat rate.

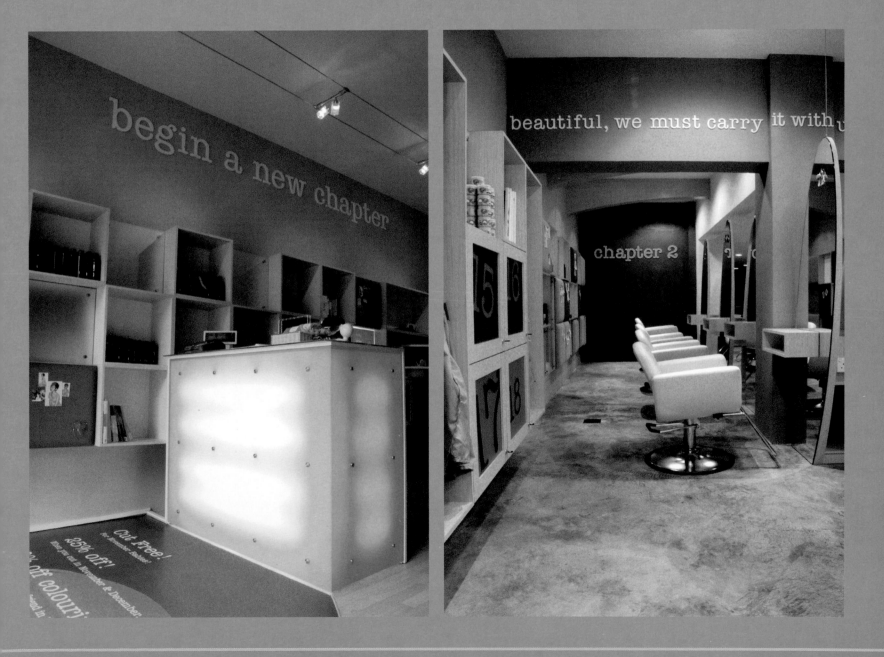

A long waiting time often accompanies the colouring process on the second floor. Other than a "cosy room" in the back equipped with a pin-up board for your thoughts, there is a casual lounge around the floor's perimeter where you can relax while the colour creeps in. The seating of clients around an oval table allows them to interact freely with friends, acting also as a business stratagem as clients can see and explore techniques that are being applied to their neighbours.

The three floors are used as a demarcation for the different services – first floor for cut, second for colour, and third for curl. Each floor has an individual concept, tied across the levels by a similar means of expression.

Covering one wall is a large sticker mural of a hit squad that blasts colour bombs into your face. Custom-dyed towels carry the thematic red of the level, just as towels on the first floor are dyed to grass green, and those on the third floor, a chill-out black. On this top floor, the tongue-in-cheekiness is articulated by the extreme curls of an afro-hairstyle that repeats itself across the murals, puckishly echoed by a jet engine.

As associated with the concept of a book, quotes on beauty related to the different hair processes abound on all three floors. The typographically literate would appreciate the corporate font that is common across stencilled quotes, name cards, lockers and even press releases. All three storeys convey a sense of openness – an anti-claustrophobia created through the use of natural colours and images that depict vastness of space. Ten Yee impishly adds that the whole of chapter 2 becomes a haven for people to "space out".

To cut off the alienating effects of commercialisation, the team has designed their own furniture whenever possible. Rather than using ready-made display cupboards from L'Oreal, they have taken the extra effort to design displays that are still congruent to L'Oreal's corporate image. Designing an entity as complete as chapter 2 demands much detailing. The team has even gone shopping for an unbeatable range of books and magazines, having also recommended videos for screenings on the second and third floors. If this does not convince you, time will steal itself away nevertheless while you unwittingly converse to the backdrop of funky music.

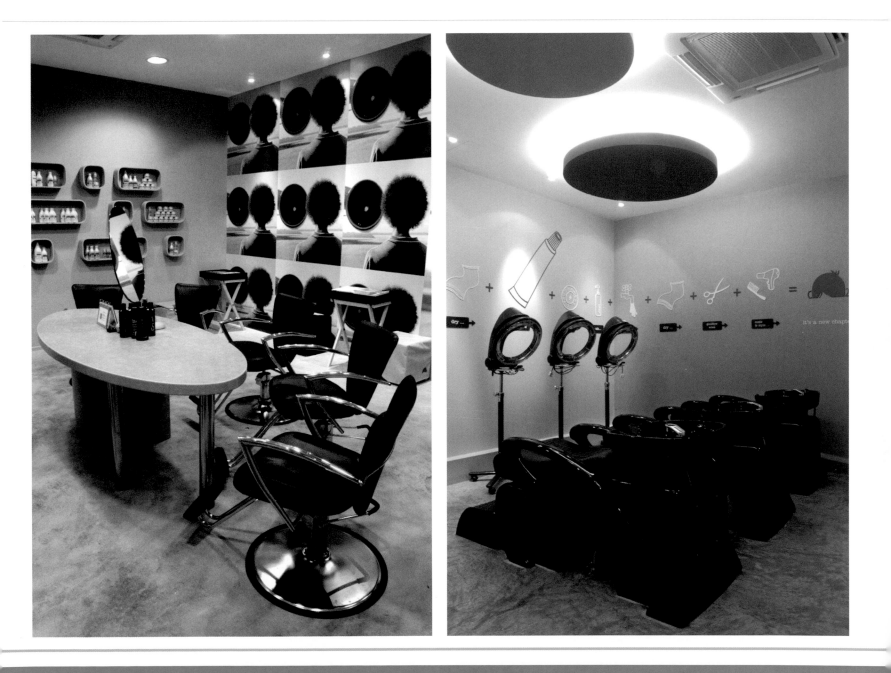

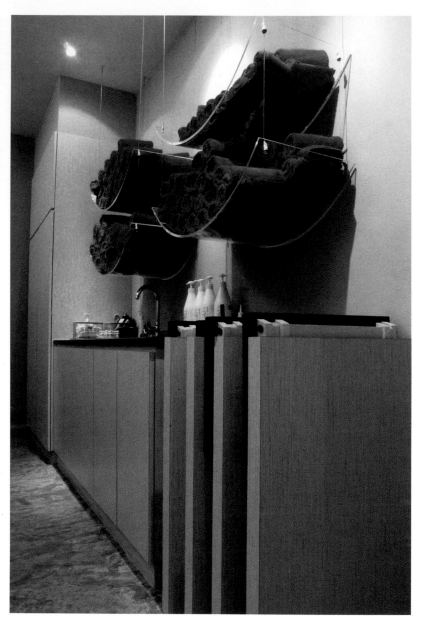

"The moment one ... ose attention to anything, even a blade of grass, it becom... a mysterious, aweso... indescribably magnificent world in itself."

The typographically literate would appreciate the corporate font that is common across stencilled quotes, name cards, lockers and even press releases.

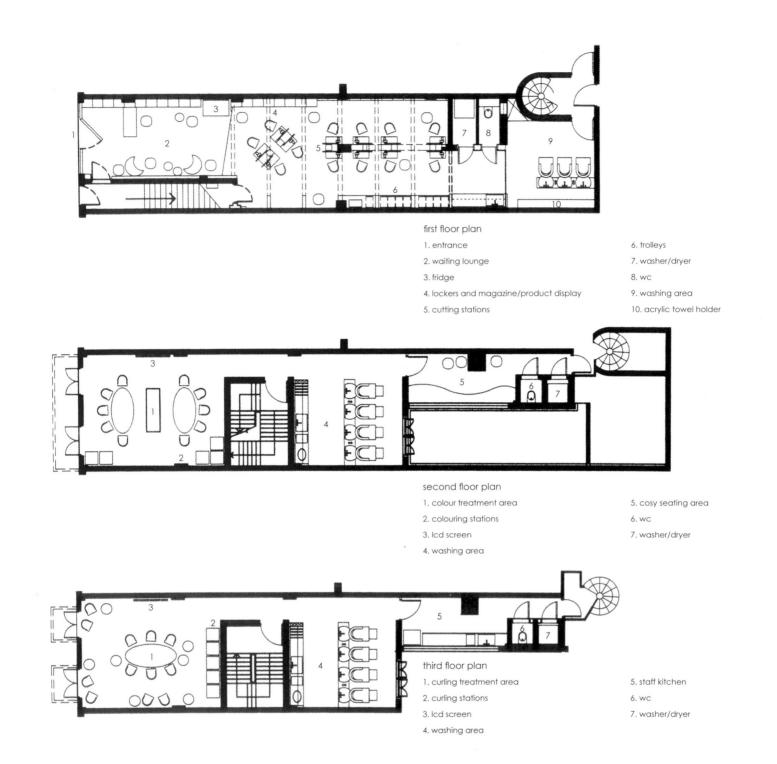

first floor plan

1. entrance
2. waiting lounge
3. fridge
4. lockers and magazine/product display
5. cutting stations
6. trolleys
7. washer/dryer
8. wc
9. washing area
10. acrylic towel holder

second floor plan

1. colour treatment area
2. colouring stations
3. lcd screen
4. washing area
5. cosy seating area
6. wc
7. washer/dryer

third floor plan

1. curling treatment area
2. curling stations
3. lcd screen
4. washing area
5. staff kitchen
6. wc
7. washer/dryer

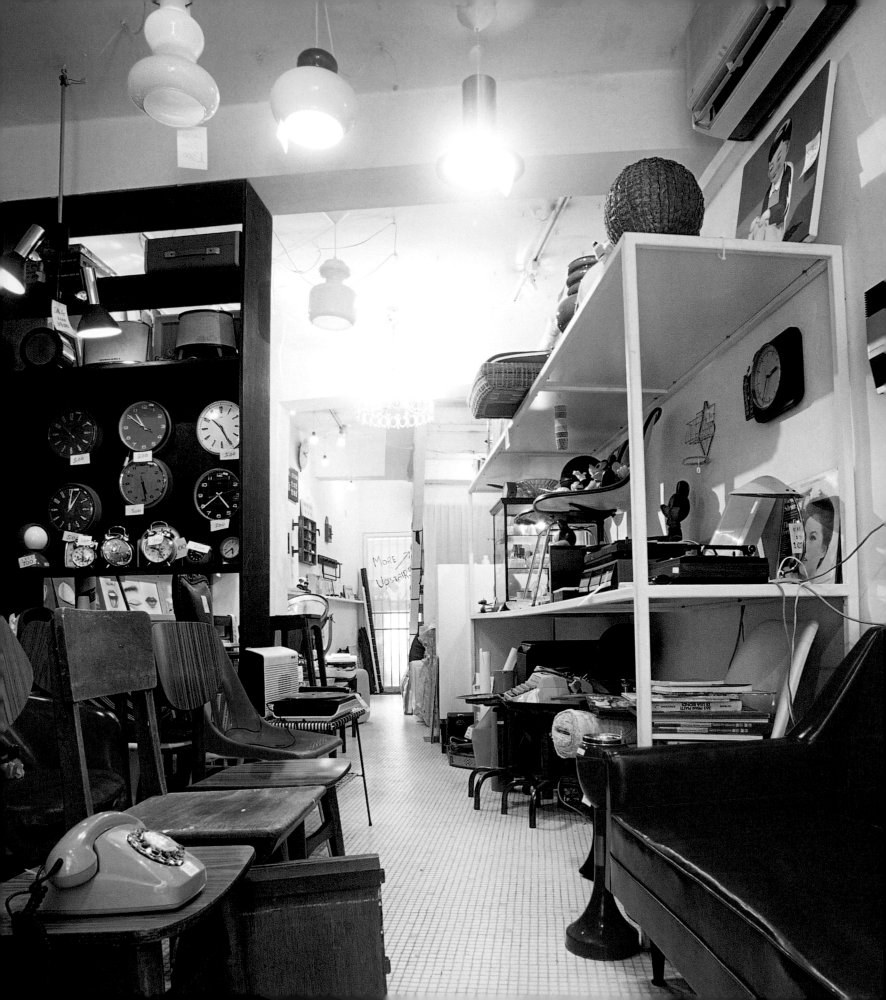

CHEN MI JI:
SEARCH AND RESCUE

THERE IS A LITTLE FANTASYLAND AT CHEN MI JI. ENTERING THIS HONG KONG FURNITURE AND HOMEWARE SHOP GIVES ONE THE FEELING OF BEING TRANSPORTED BACK TO A BYGONE ERA. CHOCK-FULL OF ECLECTIC SECOND-HAND FINDS AGAINST A COARSE, HUMBLE BACKDROP, THIS TWO-STOREY RETAIL SPACE IS LITERALLY AN INTERNALISED FLEA MARKET. RAIN OR SHINE, WELCOME TO CHEN MI JI.

text Catherine Cheung **photography** Kelley Cheng **designer** Mike Chen **key materials** custom-made racks, plaster **floor area** 110sqm **location** 51 Staunton Street, Central, Hong Kong. P (852) 2179 5388

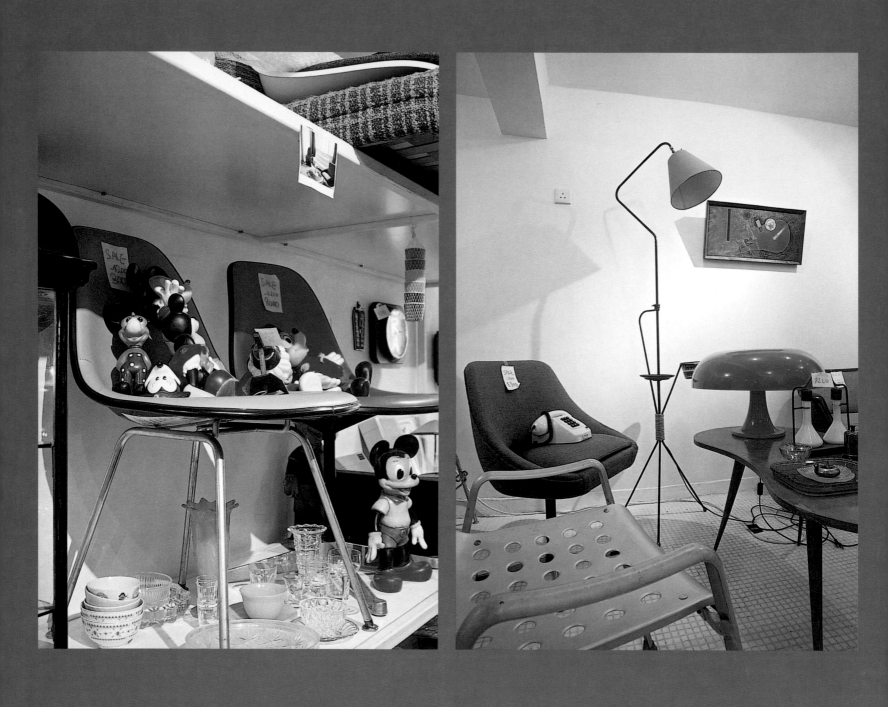

Rather than labelling it a "retro" shop, which inevitably evokes an impression of an outlet that is funky and fashionable, a more apt description of Chen Mi Ji would be "an indoor flea market". The owner, Mike Chen, had never wanted the shop to represent a fad that just comes and goes. In fact, when the shop was opened several years ago, nostalgia was not a popular trend. Most people in Hong Kong merely desired the newest and latest goods.

Everything stocked in Chen Mi Ji looks familiar. It might be a rusted door handle rescued from a demolished old building, or a cracked leather sofa that has been passed down from generation to generation. Whether it be a table, chair, clock, flask, mug, or record player, each piece can be read like a narrative of the glory of a bygone era.

These are mostly everyday objects that have stayed unnoticed in the corner of your kitchen, or on the shelf in your living room. They used to be consumed extensively, assuming a prominent part of your daily life. As soon as they became unfashionable, they were discarded, leaving no trace, as if they had never existed. However, these objects are given a new lease of life at Chen Mi Ji. Here, you can savour the experience of treasure hunting in a flea market, albeit one enveloped by walls and a roof.

Here, you can savour the experience of treasure hunting in a flea market, albeit one enveloped by walls and a roof.

The two-storey space is raw and unpretentious, with only a simple coat of plaster and white paint lightly touching the walls. Hooks and wires are candidly visible throughout the shop, and they are vivid reminders of how such things as pendants and chandeliers were positioned previously. The exposed fabric of the architecture stays true to the spirit of the products. Indeed, the display of goods here is random and spontaneous; it literally requires customers to rummage through the piles for hidden treasures, just as people would normally do in a flea market.

Metal bi-folding doors, with their white paint beginning to peel off, mark the entrance of Chen Mi Ji and subsequently set the tone for the journey that is to come. A porch-like space follows, which is a prelude to the bulk of treasures arrayed behind the portal frame. Custom-made racks line one side wall, where larger items are stacked up vertically, reaching to the ceiling. Opposite, an eclectic collection of furniture and homeware from the 1950s and '60s is scattered nonchalantly across the floor. This encourages customers to engage with the products from a variety of perspectives.

Ascending to the first floor, via a seemingly ramshackle wooden staircase at the rear, one is presented with more and more flea market finds. Filled to the brim with aged knick-knacks, local artists' creations and books published by Chen Mi Ji, this floor also serves as the studio/office for Edward Lam Dance Theatre and Zuni Icosahedron, two cultural groups active in experimental theatrical performance in Hong Kong. The two endeavours might seem distant, but both settle in peace with each other within this space. Doubling as a gallery and tripling as a theatrical studio, this furniture/homeware shop is indeed a place where anything can happen.

The two-storey space is raw and unpretentious, with only a simple coat of plaster and white paint lightly touching the walls. Hooks and wires are candidly visible throughout the shop, and they are vivid reminders of how such things as pendants and chandeliers were positioned previously.

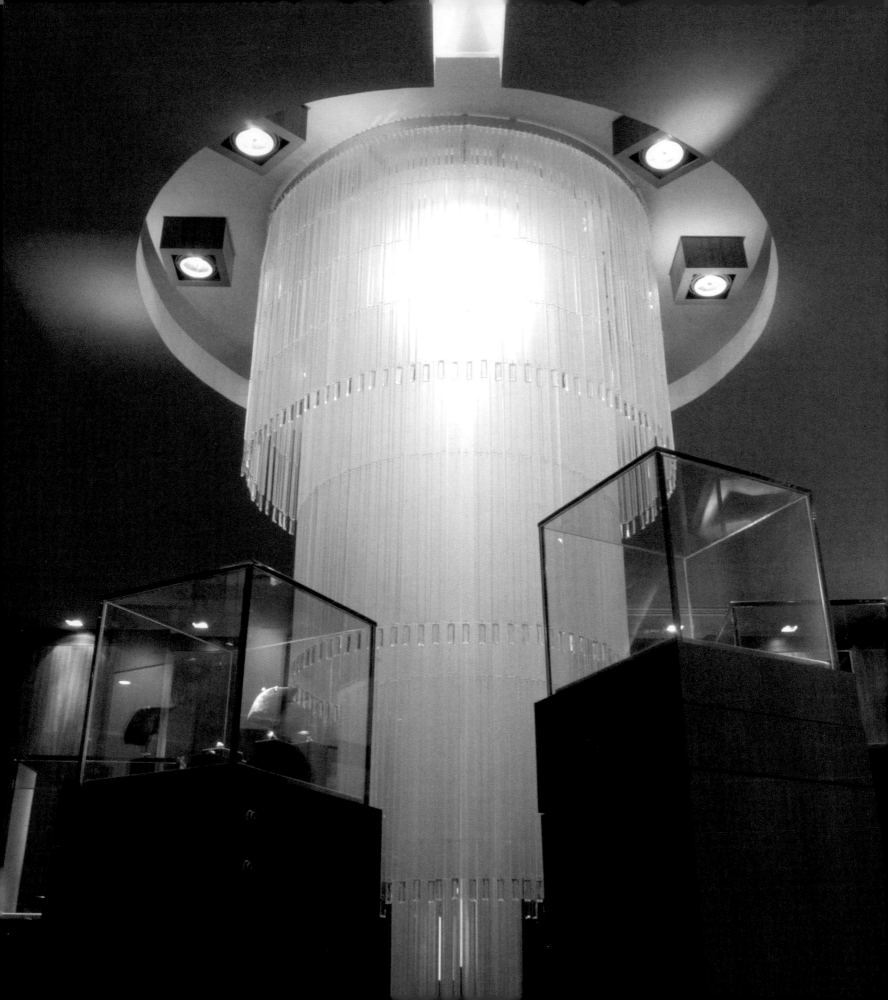

DE STIJL:
IN FINE STYLE

AT HIGH-END SINGAPORE JEWELLERY STORE DE STIJL, A DEVOTION TO DETAIL AND CAREFUL CRAFTING OCCUPIES THE MIND NOT ONLY OF THE JEWELLERY DESIGNER; IT IS ALSO A DRIVING FORCE IN THE RETAIL PHILOSOPHY OF THE STORE'S OWNER. LITTLE WONDER, THEN, THAT A LIKE-MINDED INTERIOR DESIGNER WAS SELECTED FOR THE COMPOSITION OF DE STIJL'S NEW SHOP SPACE.

text Narelle Yabuka **photography** Elaine Khoo **designer** Fluxus Interior **design team** Alex Kwan, Gerard Hsiung **chandelier artist** Willy Tan **main contractor** Octagon Construction (for ceiling, painting, electrical), Century Design (for carpentry) **building materials supplier** Hock Hua Building Material Pte Ltd **key materials** walnut veneer, acrylic, crystal beads, resin, mirror, glass, wallpaper **floor area** approx 55sqm **location** 390 Orchard Road, #B1-05, Palais Renaissance, Singapore. P (65) 6536 4906

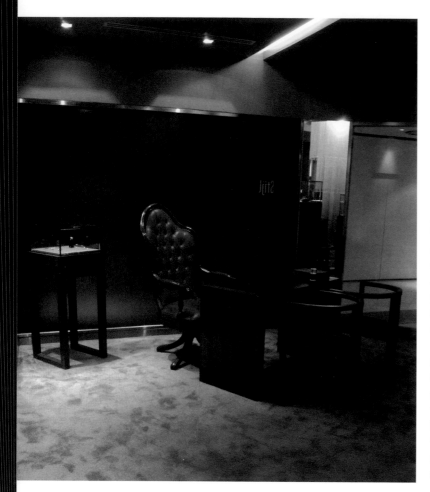

Aside from an evident aesthetic focus upon the square, you would be correct in concluding that there is little in this high-end Singapore jewellery store to reflect its namesake – the rigorous Dutch art movement of the early twentieth-century that favoured strict linearity and primary colours. That is, of course, except for the minimally embellished, efficiently detailed works of jewellery designer Suzan Lee. The discipline with which she crafts each piece sold in De Stijl has been echoed uniquely by the designers at Fluxus Interior. They have provided the perfect setting for her beautiful collection, whose pieces embody a crafting period of up to three months each.

De Stijl's owner was both aware of and disheartened by the fact that many jewellery stores in Singapore adhere to a repetitive mould for their interior design. Fuelled by his passion for something new and different, he approached seven designers and asked them to present proposals for the interior of his store, which is situated in the upmarket Palais Renaissance shopping centre. The seventh designer was Fluxus Interior. Alex Kwan, the firm's principal designer, was professedly not at all confident about attaining the commission, and submitted only hand sketches. With his background in fine arts, however, he did not fail to impress.

The chandelier, positioned immediately opposite the entry doors, beckons with stately magnificence. Composed of individually cut acrylic strips and custom-made crystal beads, its streamlined and contemporary aesthetic prevents it from overpowering the small shop space.

Kwan's scheme envisaged an intimate, timber-clad sanctum that celebrated both the square and the curve. Though rectilinearity was to dominate the immaculately detailed display cabinets, the focal point of the scheme was an enormous circular chandelier, which was to dominate the central area of the store. The owner was unable to resist the prospect of this hand-made masterpiece, which would undoubtedly become a jewel in itself – and a beacon in the basement-level space that is denied a ready supply of natural light and views.

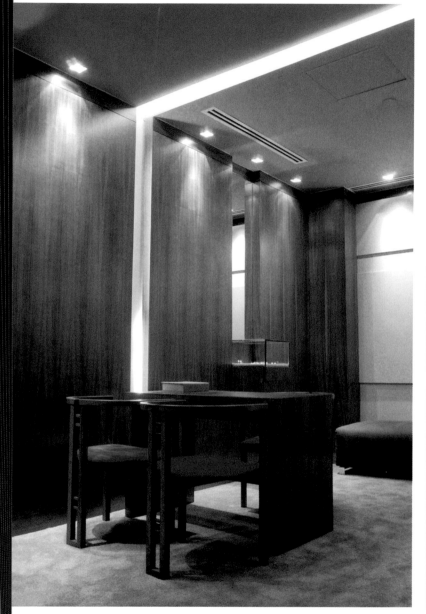

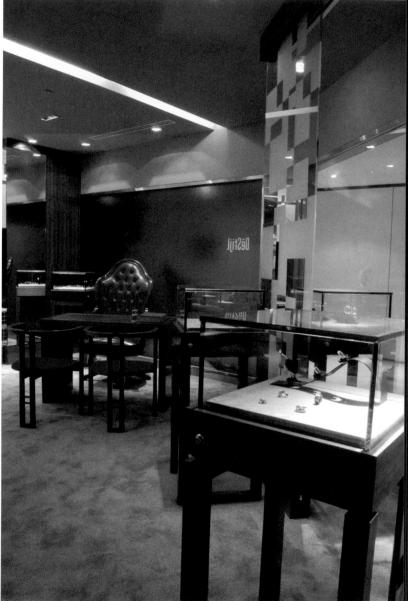

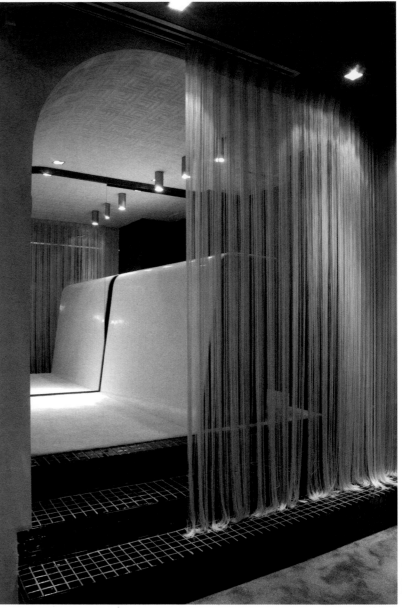

Indeed, the completed chandelier, positioned immediately opposite the entry doors, beckons with stately magnificence. Its concentric sheaths drape like delicate stalactites past a circular cut-out in the shallow dropped-ceiling, which forms a node in an internally-lit recessed channel that traverses the width of the store's ceiling. It is lit from within and from without by square-boxed downlights that establish an unmistakable formal dialogue with a ring of square display cabinets around the chandelier's base. Composed of individually cut acrylic strips and custom-made crystal beads, the chandelier's streamlined and contemporary aesthetic prevents it from overpowering the small shop space. It comes as no surprise that commissioned artist Willy Tan and ad-hoc assistants spent forty-eight non-stop hours stringing this art piece together.

An appropriate backdrop to the store space is provided by the "Mondrian wall" – a planar composition of square panels that protrude by various amounts. It is as though a Mondrian painting has been transformed into three dimensions. Kwan has dexterously fashioned the wall to conceal the cash register and storage space. Beside it, by contrast, the curvaceous realm of the raised VIP area casts stealth aside in favour of unabashed theatricality. Three glossy black mosaic-tiled steps above the surrounding floor level, a curved resin counter echoes the curve of a single wall-ceiling plane clad with embossed wallpaper. Sliding mirrored panels at the rear of this alcove conceal a small office, while also enlarging the feeling of spaciousness on this curtained "stage".

Within its carefully crafted display cabinets, De Stijl's premium jewellery is exhibited upon trays of three-layered organza, which bring a note of delicate texture to the streamlined timber and glass cases. The display cabinets arranged around the chandelier rise to varying heights, adding dynamism to the viewing experience. Thoughtfully, their entire height is utilised for storage space. Such is the attention to detail that so fittingly characterises the interior of De Stijl, making it the perfect container for its precious cargo. As the store owner declares, it is unethical to show a non-premium work to the customer. At De Stijl, the retail interior, along with the products, is art.

floor plan

1. entrance
2. chandelier
3. display cabinet
4. glass screen
5. discussion area
6. "Mondrian wall"
7. storage/cashier
8. vip area
9. office

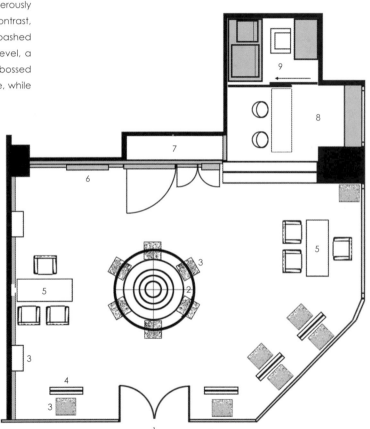

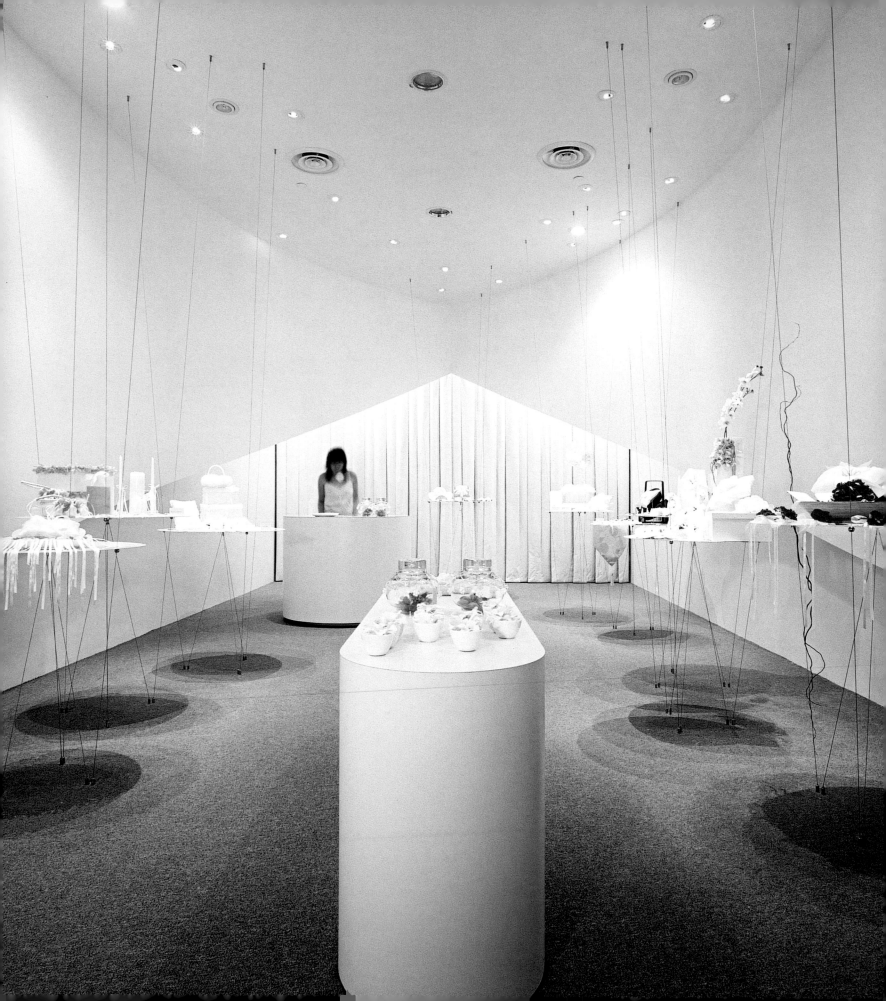

DREAMWEAVERS:
A VISION IN WHITE

CHIC SINGAPORE WEDDING CONCEPT STORE DREAMWEAVERS WAS CONCEIVED TO FACILITATE MARITAL CELEBRATIONS THAT WOULD FLOW WITH THE EASE OF THE MOST ROMANTIC DAYDREAM. DESIGNER WILLIAM CHAN'S DREAMY STORE INTERIOR IS TRUE TO THE CAUSE, COMBINING INTELLIGENT SIMPLICITY WITH ELEGANT WHIMSY. IT IS A FINE ROMANCE, INDEED.

text Lisha Ojun **photography** Rupert Kingston **designer** William Chan at Spacedge Designs **lighting consultant** Gina Low **main contractor** Stema Furniture **key materials** epoxy-coated steel, stainless steel wire, painted particle board, fabric **floor area** 55sqm **location** 9 Raffles Boulevard, #01-50, Millenia Walk, Singapore. P (65) 6336 2505

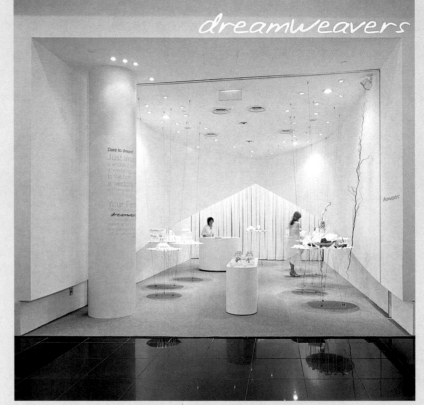

Weddings have a tendency to be fussy affairs, often with marathon preparations daunting enough to put one off ribbons and chiffon for life. In an entirely contrary manner, the wedding concept store Dreamweavers, located in central Singapore's Millenia Walk shopping centre, makes things wonderfully simple. The first of its kind in Singapore, the store supplies themed wedding accessories for couples who want to add that special touch to their big day. Each collection is available for six months and consists of eight-to-ten sets of accessories, ranging from invitation cards and ring pillows to wrist corsages for bridesmaids.

Even more delightful for the preparation-weary, however, would be the Dreamweavers interior. Conceived by William Chan of Spacedge Design, it is about as minimalist as a wedding-themed store could possibly get. A sophisticated vision in white, it presents the stock with clarity and spacious ease. Refreshingly, Dreamweavers carries itself with black-tie elegance, catching the eye, without resorting to superfluous design gestures and over-decoration.

The store's frontage is open and inviting. With its two curved walls arching gently to the rear, the interior resembles a hybrid between an inverted ship's hull and the womb-like enclosure of a spaceship. However, as described by Chan, the actual intention was create an abstraction of the Gothic arch – the symbolic shape which the bride and groom would traditionally pass under during their wedding march.

Weddings have a tendency to be fussy affairs, often with marathon preparations daunting enough to put one off ribbons and chiffon for life. In an entirely contrary manner, the wedding concept store Dreamweavers makes things wonderfully simple.

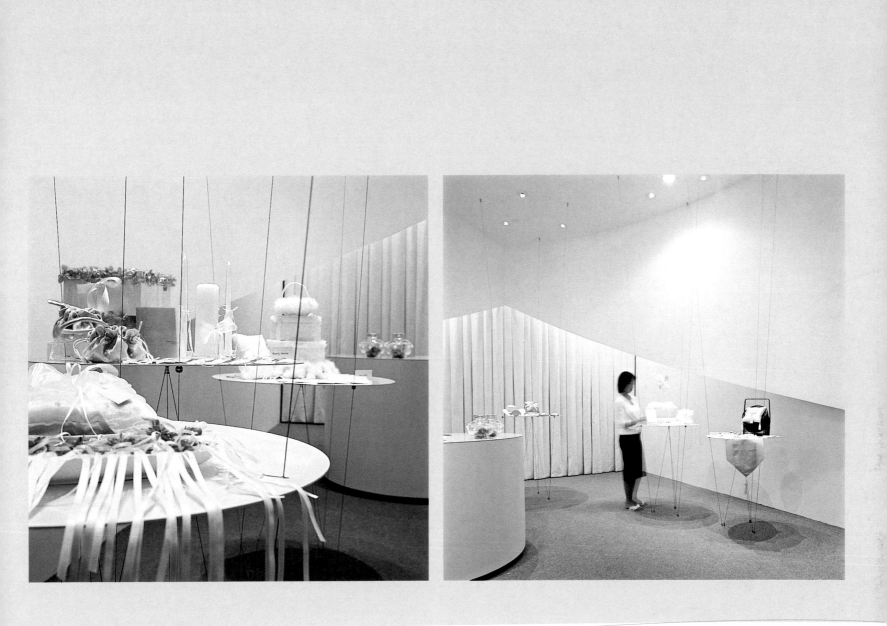

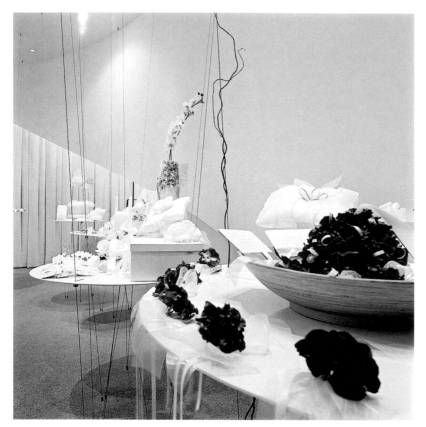

As if to emphasise the performance-like nature of this ritual, a set of curtains peeps out from under the arch in the distance. One almost expects these beautiful white drapes to part dramatically to reveal the bride and groom in their impeccable outfits. There would be nothing as dramatic as that, of course. Instead, the heavy curtains sweep apart to reveal a floor-to-ceiling shelving system that acts as a "vertical storeroom". In a narrow 55-square-metre space, the only way to go is up.

With the exception of the skin-toned carpet, white is the colour used predominantly in the store. Apart from white's appropriate marital association with purity and innocence, the colour also serves to visually open up the narrow space. Furthermore, it provides a neutral backdrop for the colour co-ordinated displays of items that are laid out on "floating discs". Suspended from the ceiling by stainless steel cables, these white epoxy-coated steel plates seem to hover above the ground in a surreal, gravity-defying manner. Under the carefully constructed lighting, they appear like little UFOs casting dappled mushrooms of shadow onto the floor.

Spacedge Design's honest and minimal approach is perhaps best summarised by the lone column left standing at the entrance of the store. Instead of taking the typical approach of attempting to conceal this odd structural element, the designer has given it a functional use – that of displaying signage. At night, when the store closes, it remains the only visible element of the interior that is not hidden by the roller-shutters, becoming a twenty-four-hour advertisement.

"Whether we're designing an apartment or a commercial space," says William Chan of Spacedge Design, "our philosophy is to create pure and simple spaces."

"Whether we're designing an apartment or a commercial space," says Chan, whose clients include the food and beverage chain Han's, "our philosophy is to create pure and simple spaces." In line with this declaration, it was revealed that the entire conceptualising, sourcing and construction process was completed in a mere eight weeks. Now, if only weddings were that uncomplicated!

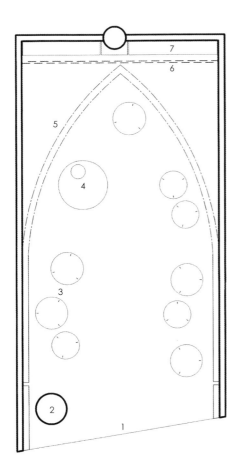

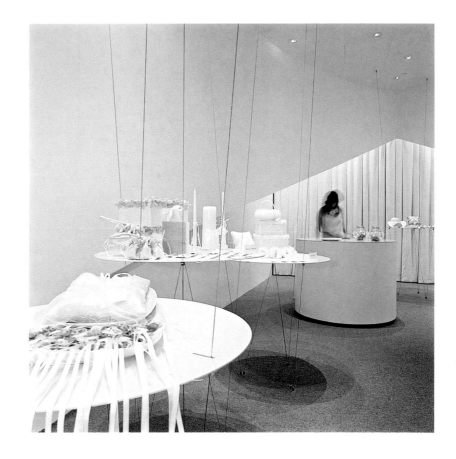

floor plan

1. entrance

2. column

3. suspended display plates

4. service counter

5. arched wall

6. curtain

7. shelving

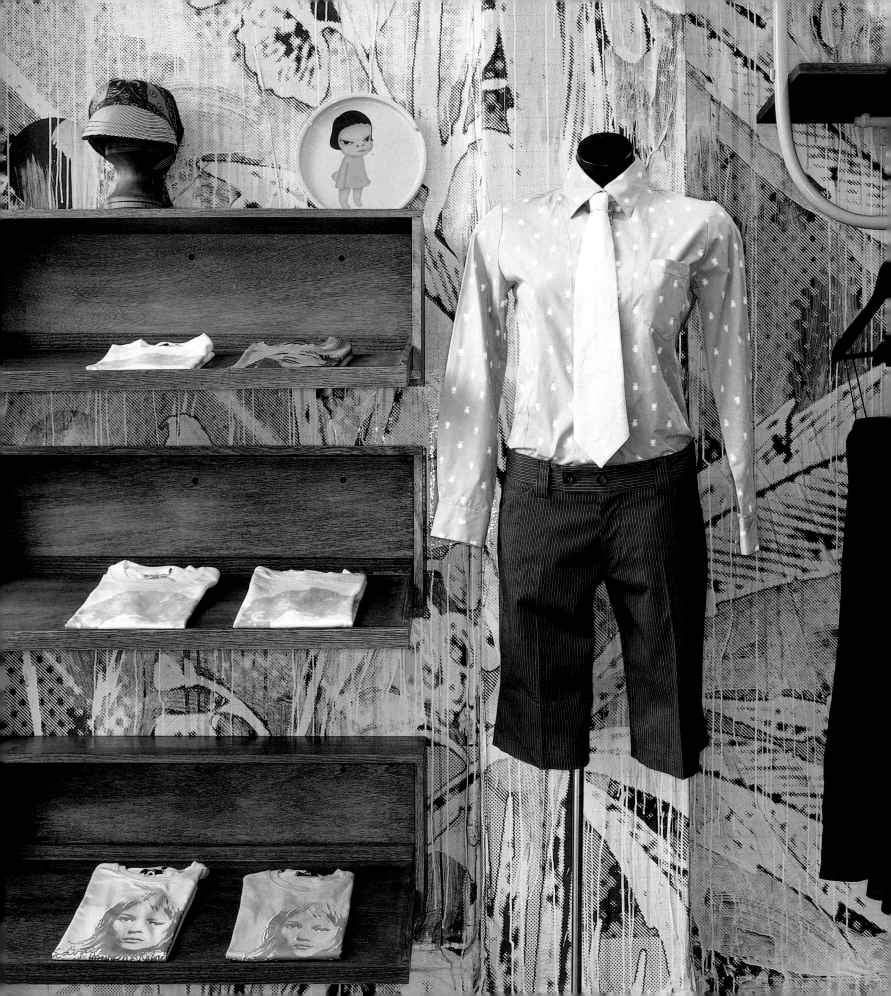

FAT: MESSING WITH CONVENTION

FAT IS AKIN TO A LITTLE OASIS IN THE HEART OF ONE OF SYDNEY'S BUSIEST SHOPPING AREAS. OPENED BY A YOUNG RETAIL COMPANY THAT MOVES IN A DIRECTION ALL ITS OWN, FAT FOCUSES ON THE CREATION OF AN "EXPERIENCE" RATHER THAN THE USE OF MAINSTREAM SELLING TECHNIQUES.

text Narelle Yabuka **photography** Ben Glezer **designer** Fat 4 Pty Ltd (Sarah Hamilton, Rachael Cotra, Kym Purtell, Bianca Wiegard) in collaboration with Amanda Moore **design team** Sarah Hamilton, Alex Brown-Graham, Chris Summons **wallpaper artist** Misha Hollenbach **ceiling mural artist** Matt Griffins **key materials** powder-coated metal railing, saddlery leather mats and curtains, black and white photocopy wallpaper, concrete slab, "skinny wood" flooring, timber deck, 1930s jewellery cabinet, recycled timber floorboard display boxes **floor area** 75sqm **location** 18 Oxford Street, Woollahra, Sydney, Australia. P (61) 2 9380 6455

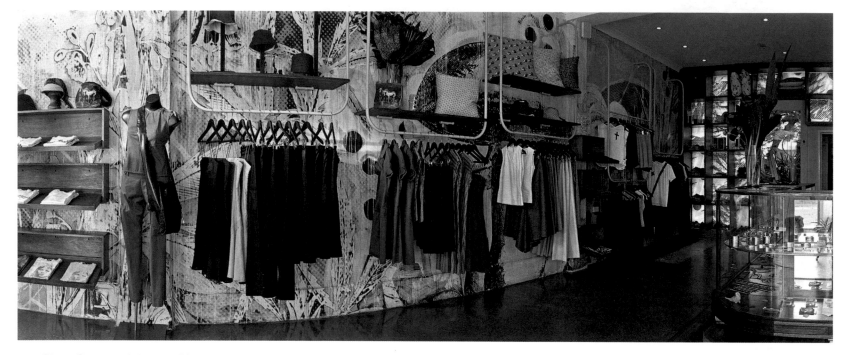

The long side wall has been entirely wallpapered by artist Misha Hollenbach. Her spectacular panorama of Mother Nature's joys — leaves, flowers, mushrooms and clouds among them — was handmade through the application of colour to photocopied paper.

"As a company, one of the most important aspects of our retail existence is the architecture of our stores. We feel it is important to create a space that takes you out of the normal shopping environment and puts you into another world," says Bianca Wiegard, one of the members of the anti-conventional creative retail group, Fat 4. Based in Melbourne, Fat 4 was conceived by four innovative young women who saw the need to create a platform for the sale of products by young local designers. Two members of the group are jewellery designers, and two carry their own skin care and clothing lines. All choose not to play by the rules.

Inspired by an aversion to sterile and conservative retail space design that embraces conformity and favours overseas designers, Fat 4 encourages, nurtures and celebrates young Australian and New Zealand design. With the help of a wide circle of creative friends, the group has opened several clothing and lifestyle shops in Melbourne, each a unique space containing equally unique stock. Fat on Oxford Street marks the group's foray into the Sydney market. With its leafy courtyard garden, its abstract wall depicting a selection of nature's delights, and its arresting ceiling mural – not to mention the quirky collection of clothing and accessories on sale – Fat is certainly a unique environment.

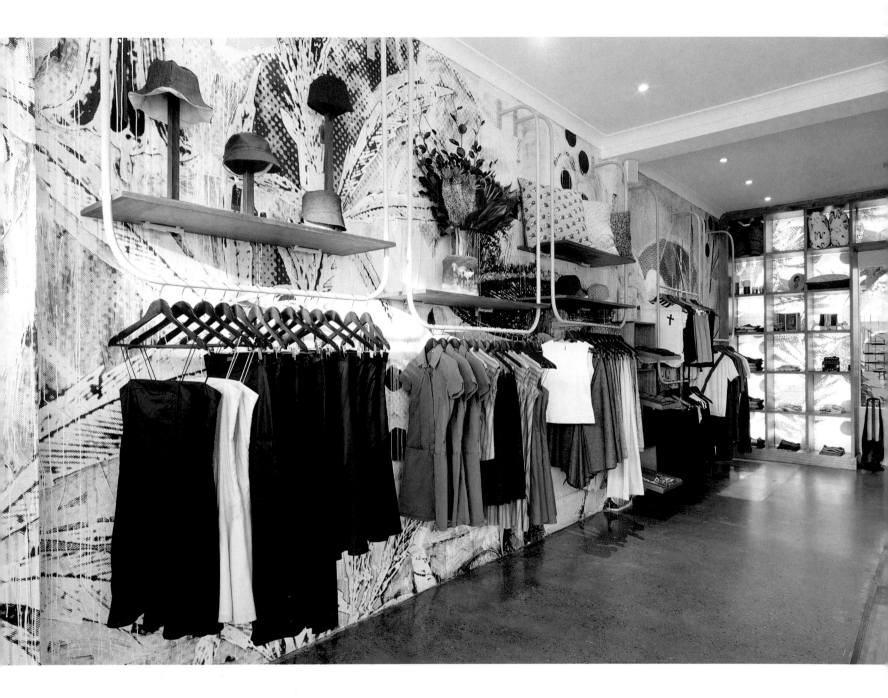

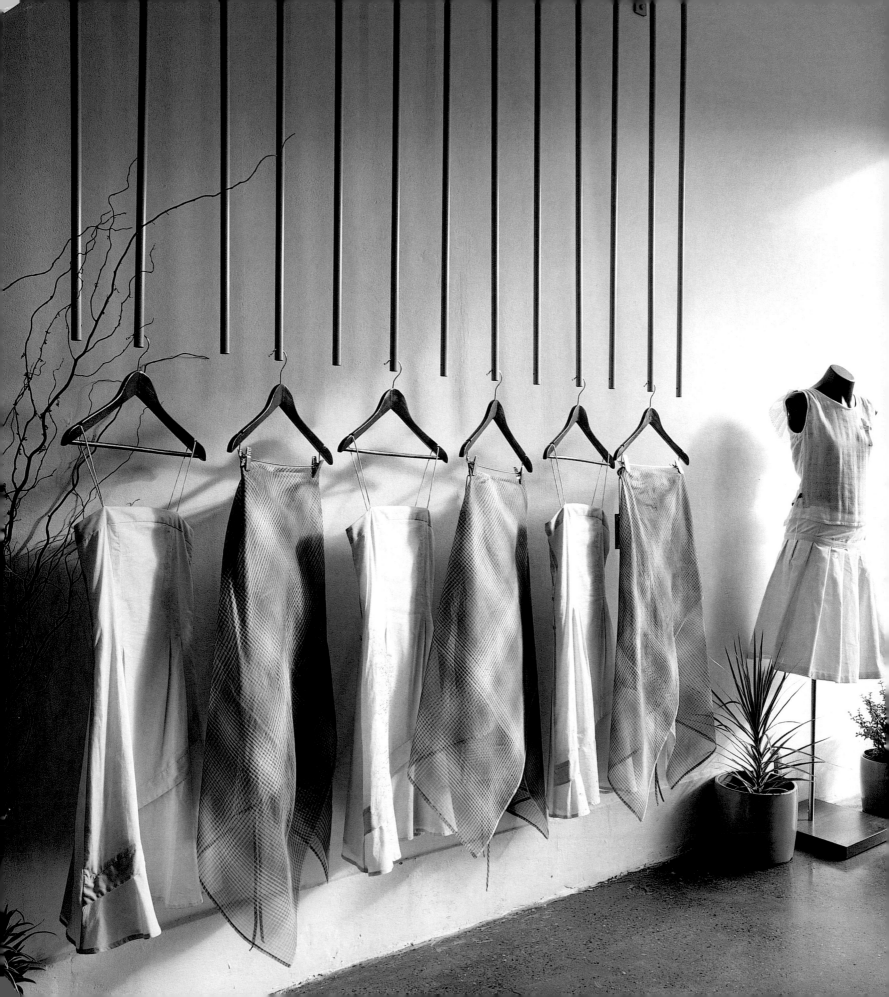

The shop is located in one of Sydney's most popular shopping areas, on a strip that is becoming home to an ever-increasing number of the "sterilised" international outlets to which Fat 4 is averse. Thriving on its individuality, Fat punctuates the strip with a shop space that is decidedly akin to a sanctuary. A large front window bears the iconic Fat 4 logo, featuring a deer and a menacingly seductive, swirling version of an old English-style typeface. Beneath a gathering of mannequins in the window, a raised block of striped timber floorboards draws the eye of the passer-by inside.

After the customer's eyes make an initial vehement dart around the eclectic collection of clothing and other objects, they may momentarily come to rest on the long side wall, which has been entirely wallpapered by artist Misha Hollenbach. Her spectacular panorama of Mother Nature's joys – leaves, flowers, mushrooms and clouds among them – was handmade through the application of colour to photocopied paper. Its subtle tones of minty green hint at the courtyard, which appears further towards the rear of the shop. Powder-coated metal rails, attached to the wall at some height, dip to various depths in U-shapes, echoing the drips of paint that streak down the wallpapered surface. The timber grain of wall mounted display boxes, which are constructed with recycled floorboards, plays off interestingly against the pixellated texture of the wallpaper. The warm, solid timber tones create focal points for the display of the designated items.

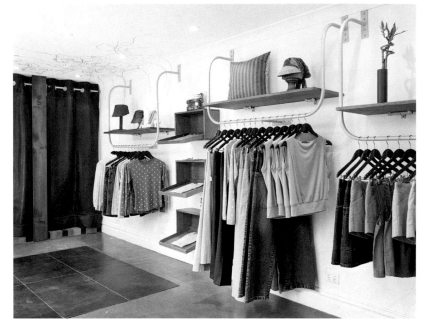

The line between art and fashion is reduced to a mere thread in Fat.

One's progression through the space reveals the sanctuary of the courtyard, beside which lies a second room – a small haven away from bustling Oxford Street. Matt Griffin's artwork sweeps across the ceiling, beckoning the customer to the very rear of the space. Rich brown saddlery leather curtains and matting carry on the timber-toned aesthetic established in the front room, and bring warmth and depth to this more subdued area.

The line between art and fashion is reduced to a mere thread in Fat. The shop interior is a piece of art in itself, as well as a unique environment. A retail interior with views and a cross-ventilating breeze is rare indeed. Furthermore, the imaginative retail setting is a superb reflection of the ingenuity of the products on sale. "Messing with convention has put Fat firmly on the map," offers Fat 4.

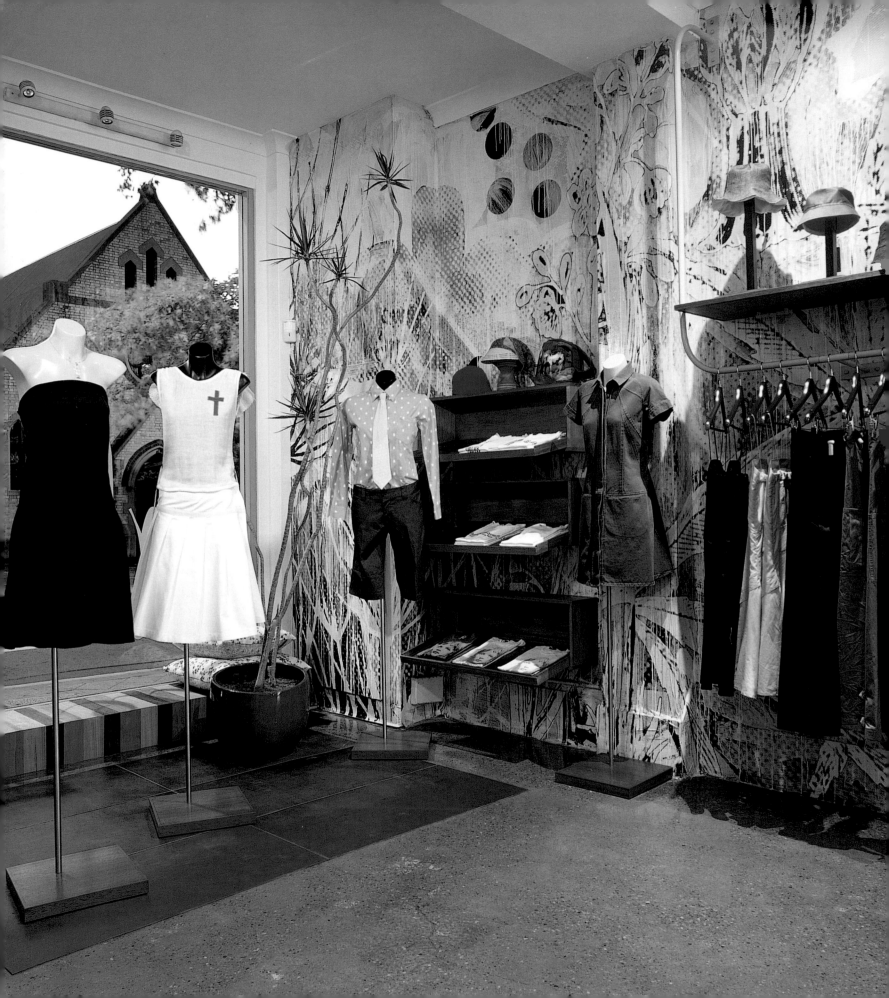

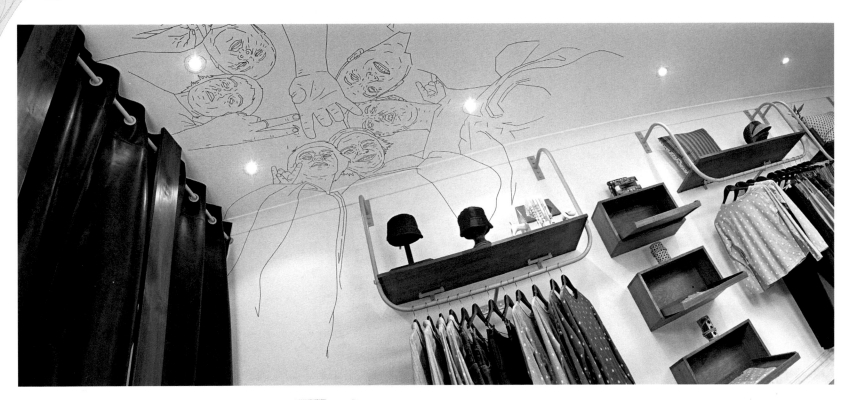

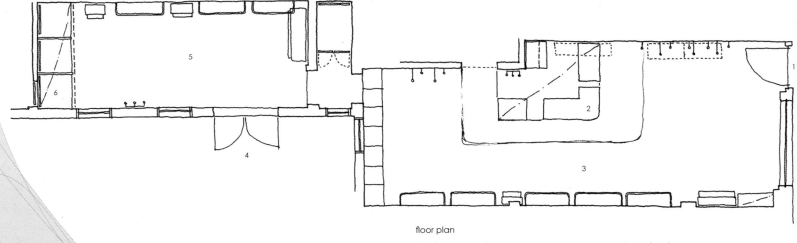

floor plan

1. entrance
2. counter
3. front room
4. courtyard
5. rear room
6. changing rooms

FLEA + CENTS:
AWAITING DISCOVERY

HOUSED INSIDE THIRTY-YEAR-OLD PREMISES, THIS VINTAGE HOMEWARE SHOP IN HONG KONG RECREATES THE EXPERIENCE OF TREASURE HUNTING WITH AN ECLECTIC COLLECTION OF DESIGN OBJECTS AND AN INTERIOR THAT EXUDES A UNIQUE NOSTALGIC CHARM. A JOURNEY OF DISCOVERY AWAITS.

text Catherine Cheung **photography** Elaine Khoo **designer** Flea + Cents **key materials** mosaic floor tiles, paper blinds **floor area** 280sqm **location** 1/F, 34-38 Queen's Road East, Wanchai, Hong Kong. P (852) 2528 0808

To the uninitiated, the journey into Flea + Cents is akin to an exciting voyage of discovery and exploration. The shop is tucked away on the second floor of an old building, and except for a large expanse of glazing on the front facade, there is no obvious signage on the street to beckon customers inside. Only the observant will catch a glimpse of a small white sign spelling the name of the shop in a casual black font. Adorable graphic prints of a finger crop up on the walls, pointing the way into the nondescript entrance of the premises.

Across the threshold lies an entirely different world. Very much like a cleansing ritual, moving through the dimly-lit, white-washed staircase that follows is eerily surreal, ridding the customer of any trace of worldly concerns that may linger behind. The ritual culminates with a full-height glazed showcase. A prelude to what is sold inside, designer chairs, light fittings, vintage toys, clocks, homewares, gadgets and collectibles are thrown together spontaneously behind the glass, sculpting a homely composition of variegated colours, forms and textures.

As a prelude to what is sold inside, designer chairs, light fittings, vintage toys, clocks, homewares, gadgets and collectibles are thrown together spontaneously in a glass showcase, sculpting a homely composition of variegated colours, forms and textures.

Through a glass door on the left, one enters an intimate enclave stuffed with objects from the last century. It is clear from the outset that the objects will be the main attraction, so the interior is kept muted. Treated merely as a neutral envelope, the perimeter walls are painted white and the floor is tiled with beige mosaics. There is nothing polished or sophisticated about the interior; the long glass facade is the only luxury in the space.

Even so, the shop appears to bask in an otherworldly atmosphere devoid of natural lighting; white paper blinds are drawn to cut out the distracting urban view. The potential of these large portals as a marketing ploy is also explored, with promotional prints mounted and new arrival items displayed to grab attention.

Befitting the concept of discovery, the shop adopts an open plan, with merchandise loosely scattered across the shop space. Customers are guided and oriented not by racks and shelves, but by the way the merchandise is arranged. Merchandise even doubles as display units. Books and magazines are placed on designer coffee tables, and a Chinese chest of drawers accommodates a variety of glassware and ceramics – all of which are ready to be sold. This optimises the use of space, and lends a welcoming sense of randomness. Moreover, by keeping a low-height display format, a flea market-style shopping experience is created in which customers are encouraged to browse and rummage through the piles of knick-knacks to find treasures.

The eclectic mix of products showcased is overwhelming. Scandinavian design classics from the 1960s are juxtaposed against Chinese antique furniture and quirky objects designed by upcoming talents, but none of the pieces are overshadowed by each another. As the owner explained, all products are selected for their originality and individuality, and there is a tendency to source not only collectibles from the last century, but also designs which have the potential to become classics in the future. Therefore, it is no wonder that Flea & Cents has become known as a treasure trove of inspiration for those engaged in the creative industry.

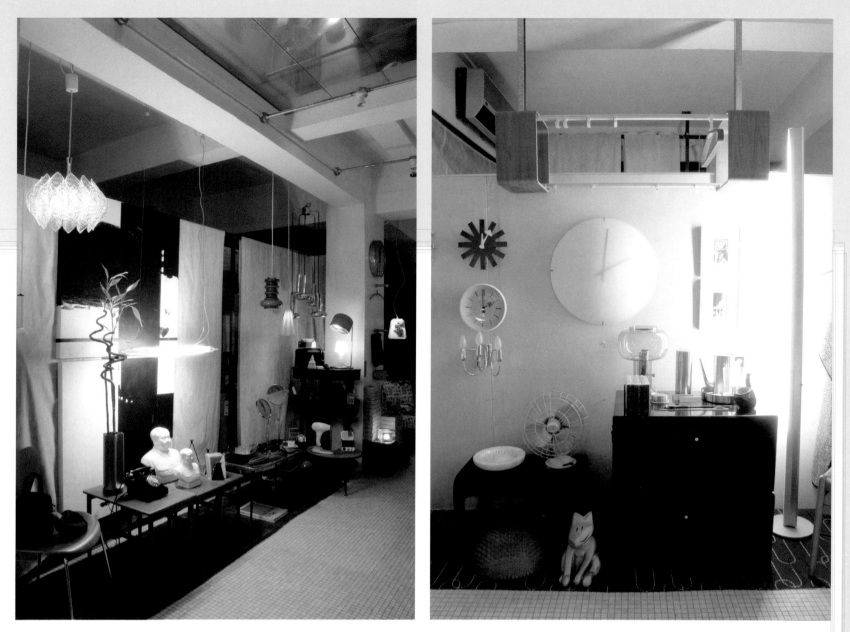

Customers are guided and oriented not by racks and shelves, but by the way the merchandise is arranged. Merchandise even doubles as display units. This optimises the use of space, and lends a welcoming sense of randomness.

G.O.D.: DIVINE LIFESTYLE

FROM ITS MODEST OPERATIONS IN FURNITURE SALES AT INCEPTION, HONG KONG ENTITY G.O.D. HAS EVOLVED IMPRESSIVELY OVER A DECADE, AND TODAY BOASTS A WIDE RANGE OF LIFESTYLE MERCHANDISE. THE RENOVATION OF ITS ORIGINAL OUTLET HAS SEEN A CHINESE-INSPIRED DISPLAY SYSTEM, INDUSTRIAL INTERIOR ELEMENTS AND THE SPIRIT OF VINTAGE CLASSICS WORK IN TANDEM TO DEFINE G.O.D.'S NEW CORPORATE IDENTITY.

text Catherine Cheung **photography** G.O.D. Ltd **designer** G.O.D. Ltd **principal designer** Douglas Young **main contractor** G.O.D. Ltd **key materials** epoxy, cement render
floor area 420sqm **location** 48 Hollywood Road, Central, Hong Kong. P (852) 2805 1876

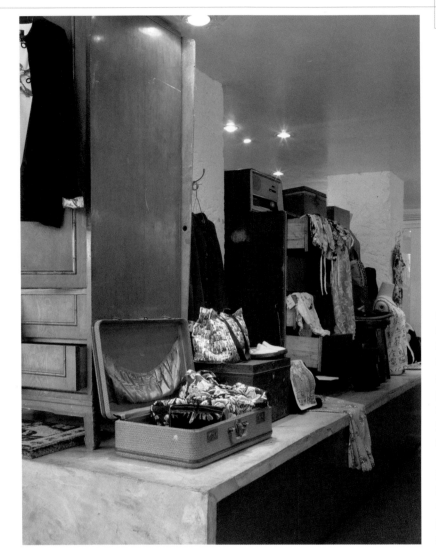

Recently, G.O.D. decided to go back to the place of its humble beginnings on Hollywood Road in Central, and update it with a design that signifies its new direction towards an all-encompassing lifestyle concept.

G.O.D.'s evolution in the last ten years has been a dramatic one. From a modest furniture shop, it has grown to become a fully-fledged lifestyle brand that boasts four branches located across the territory, and a dramatic 2,040-square-metre flagship emporium at Causeway Bay – what is probably one of the busiest corners of the world. To date, not only has G.O.D. sold furniture and household items, but also clothes, bags, stationery and gifts. With a new array of merchandise, comes a need to project a new brand image. Recently, G.O.D. decided to go back to the place of its humble beginnings on Hollywood Road in Central, and update it with a design that signifies its new direction towards an all-encompassing lifestyle concept.

Formerly with a first-storey location, the shop has been reworked into a two-storey lifestyle boutique, thereby gaining a prominent street-level frontage. The new image projected through this giant aperture now evokes a casual industrial aesthetic, with G.O.D.'s clean-lined products juxtaposed against a rough-surfaced envelope. It all begins with an epoxy coated floor, in G.O.D.'s corporate colour maroon, which repeats itself on planes and volumes throughout the entire space. To contrast this, the expansive cabinets that line the walls are rendered in white. Completing the look are the sporadic splashes of cement-finished elements in the form of the cashier counter and low-lying display platforms. The mix of epoxy, cement and simple paint lends itself to an unfinished feel, which keeps in line with the intention to create a fun and unpretentious shopping atmosphere for customers.

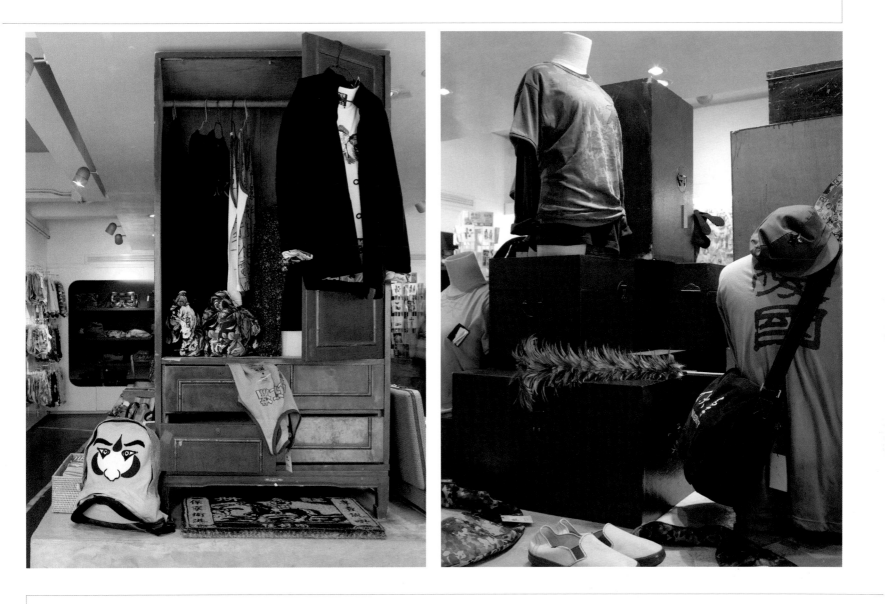

Considering the wide variety of merchandise sold in the shop, as well as the need to change the displays on a regular basis, the display concept here was designed with flexibility in mind. Rather than stacking up the merchandise vertically, the display systems are kept low to allow customers to examine the entire profile of each product. Another unique feature is the series of large openings carved into the thick wall cabinets. Borrowed directly from a landscaped garden in Suzhou, China, these openings are Chinese in essence, yet their manifestation is undoubtedly contemporary. Steering away from the stereotypical Chinese motif, the conventional circular geometry has been modified into a spontaneous free-form, which gives a sense of dynamism to the display.

While the ground level is more "boutique" in style, with an emphasis on clothes, accessories and gifts, the upper level holds more furniture and utilitarian home products. Due to the different nature of the products, the upper floor appears to be more congested, literally requiring customers to rummage around and explore for themselves. This floor resonates with a similar industrial quality – floors are cement rendered, walls are left unplastered, electrical conduits are exposed, and columns are peeled back to reveal the texture of concrete. Yet with the addition of a few objects found in junkyards, such as discarded wardrobes or cupboards, the shop takes on a new layer of vintage flair.

In a way, the pared down space has become an ever-morphing landscape, where the merchandise has become part of the embellishment, setting the tone and identity of the shop.

A unique feature is the series of large openings carved into the thick wall cabinets.
Borrowed directly from a landscaped garden in Suzhou, China, these openings are Chinese in essence,
yet their manifestation is undoubtedly contemporary.

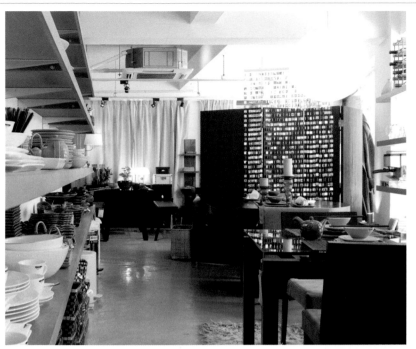

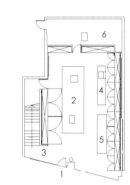

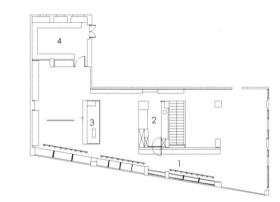

lower floor plan

1. entrance
2. display platform
3. display cabinet
4. cashier counter
5. display cabinets and clothes rack
6. store room

upper floor plan

1. display shelves
2. cashier counter
3. display cabinet
4. store room

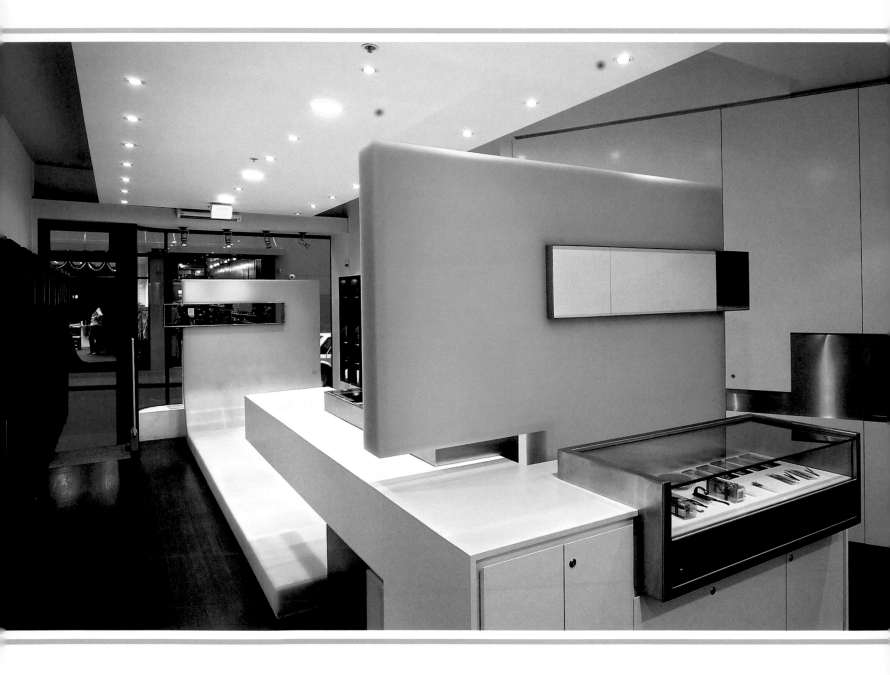

IKASU MAN:
UNDER COVER

IKASU MAN IS A STYLISH INNER-MELBOURNE STORE SELLING MEN'S GROOMING PRODUCTS – ONE OF THE FIRST OF ITS KIND IN AUSTRALIA. WITH THEIR SENSITIVE DESIGN FOR THE INTERIOR, BURO ARCHITECTS HAVE SHOWN A GREAT UNDERSTANDING OF THE MALE PSYCHE WHEN IT COMES TO SHOPPING. IKASU MAN COULD NOT HAVE DIFFERED MORE GREATLY FROM THE TYPICAL OPEN-PLAN FEMALE EQUIVALENT OF THE STORE, IN WHICH PRIVACY IS NEARLY ALWAYS PRACTICALLY NIL.

text Melissa Cameron **photography** Shannon Pawsey, Dianna Snape **architect** BURO Architects Pty Ltd **main contractor** BD Projects **key materials** polymeric sheeting, timber veneer joinery, stainless steel and factory applied paint finish joinery **floor area** 60sqm **location** 184 Little Collins Street, Melbourne, Australia. P (61) 3 9650 1177

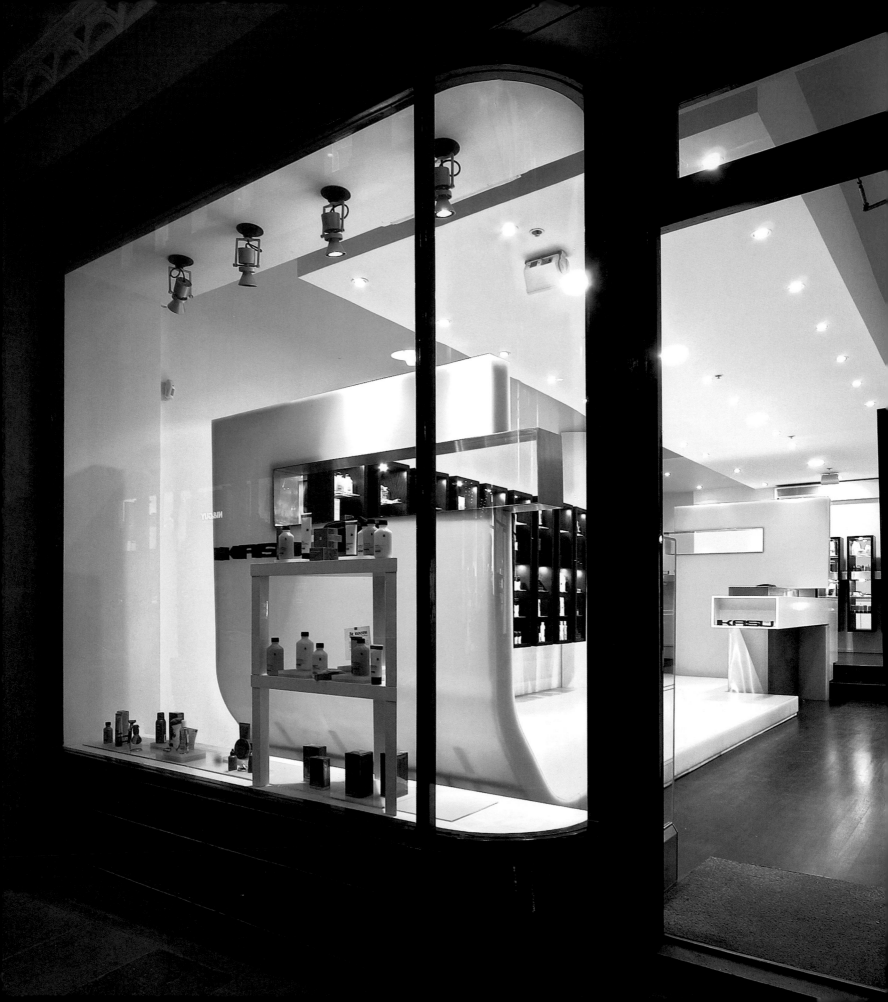

The market for men's grooming products has surfaced only relatively recently in Australia, where the commonly touted male image largely remains one of macho ruggedness – a notion aligned with the prevailing national image of the "Aussie battler" whose life is tied to the rural landscape. In reality, most of Australia's population dwells in the coastal cities. Yet, despite urban lifestyles, commonly held notions remain as psychological currency, and it is arguable that the average Australian male is not entirely at ease with the idea of personal pampering.

It is with recognition of this that BURO Architects have carefully crafted the retail space for Ikasu Man – a small outlet in the men's fashion precinct of central Melbourne, selling quality grooming products for men. "Ikasu" is a Japanese term, translating as "stylish", or "sharp" (in appearance). While the products on sale within the shop promise to aid in the attainment of such an appearance, the shop design certainly reinforces the cause. Dominated by a single curving floor-wall entity of translucent polymeric sheeting, the interior is modern, luxurious and serene, but also, and most importantly, it is private.

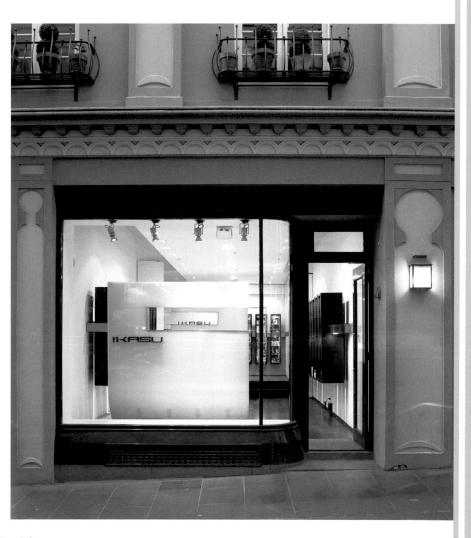

The floor-wall element stretches along the length of the shop space, curving up smoothly at the street front to perform as a curtain – the backdrop to the window display. The screen separates the stage of the window from the shop sales area, with a narrow slot cut into it offering a select slice through which passers by may sneak a view of the products on sale. Internally, this screen continues down in the opposite direction, across the floor and on to the rear, where it turns up again to act in the same fashion, this time blocking the view from the main shop floor to the rear corner – the testing and analysis area.

At the rear of the shop space, one travels behind the other end of the curved screen, which comes to resemble a half-pipe. Behind is the intimate demonstration area, where the products are tried and tested on the customer. This second curtain wedges the sales counter into the main space, providing it with a boundary, while keeping it out of the main circulation area between product displays, allowing customers to circulate unfettered.

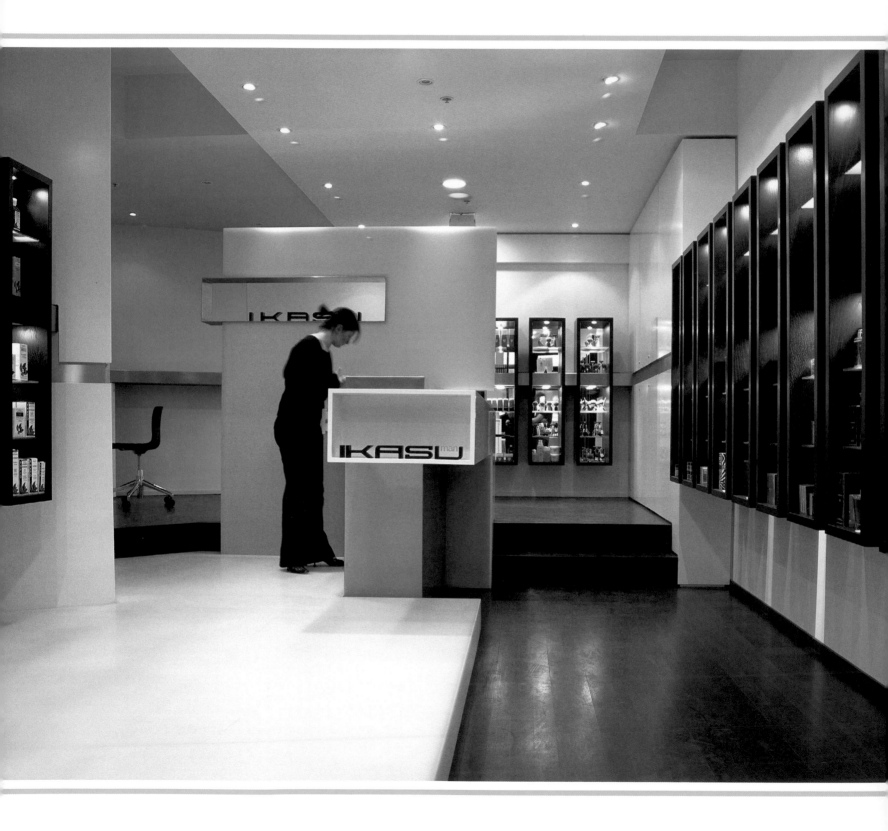

Products are framed in finely executed relocatable display boxes. Upon their glass shelving, surrounded by dark timber veneer, both the illuminated products and their beautiful packaging are put on display. Such a presentation of the finely detailed product packaging acts as an allegory to the space, as the wrapping of the interior in a beautiful manner is an integral part of shaping the shop as a product.

There is a layering of space both horizontally, with the screening effect of the half-pipe, and vertically, as one steps onto the first plinth deeper into the main sales area, and then up two steps to the rear of the store. This simple stepping mechanism allows the customer time to adapt to the layout before being nudged to move up into the main thoroughfare area, which also hosts the point of sale. Once there they are then able to move further towards the rear demonstration area. This staging allows a gradual move from the safety of the street entrance to what becomes the new safe zone, behind the last curtain, when one wishes to further engage with the products away from the prying eyes of the street.

"Ikasu" is a Japanese term, translating as "stylish", or "sharp" (in appearance).

To suit the intent of the store and in an effort to impact on the customer, the space is rendered in soothing tones – white lacquer-finish paint, light green tones, and cool stainless steel. The grain of the timber floor and veneered display boxes keeps the space from becoming too austere. The lighting is theatrical as a play on the drama of revealing the store section by section – working well with the ramp that "unwraps" itself continuously, like an unfolded package. The space, dramatic yet soothing, is symbolic of the transformation that the products sold are purported to effect on the consumer.

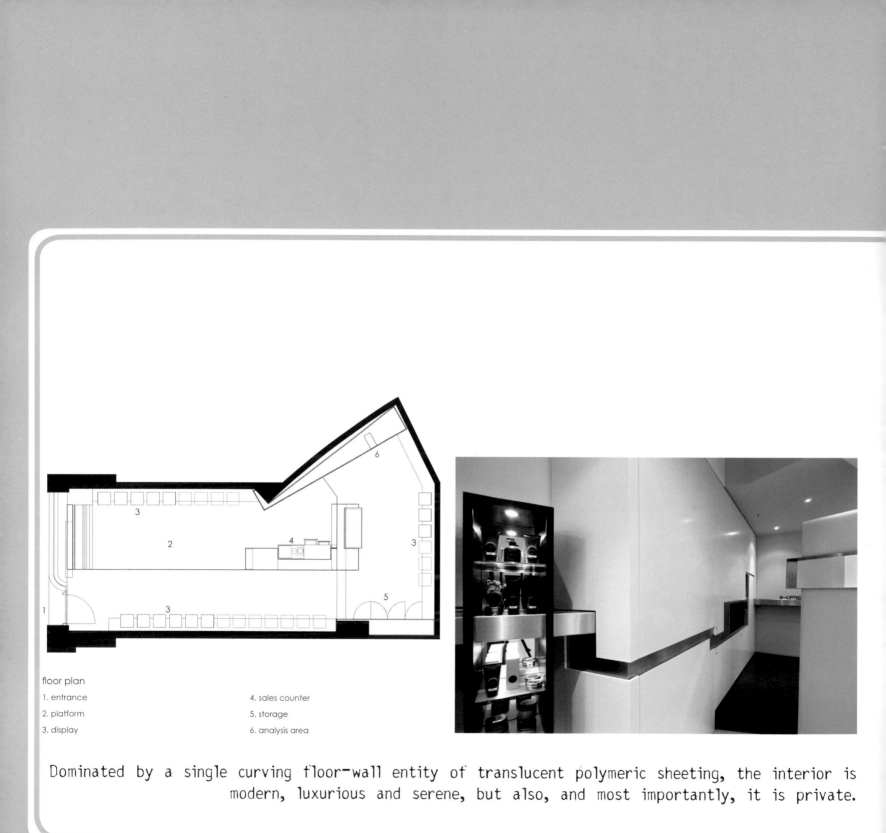

floor plan

1. entrance
2. platform
3. display
4. sales counter
5. storage
6. analysis area

Dominated by a single curving floor-wall entity of translucent polymeric sheeting, the interior is modern, luxurious and serene, but also, and most importantly, it is private.

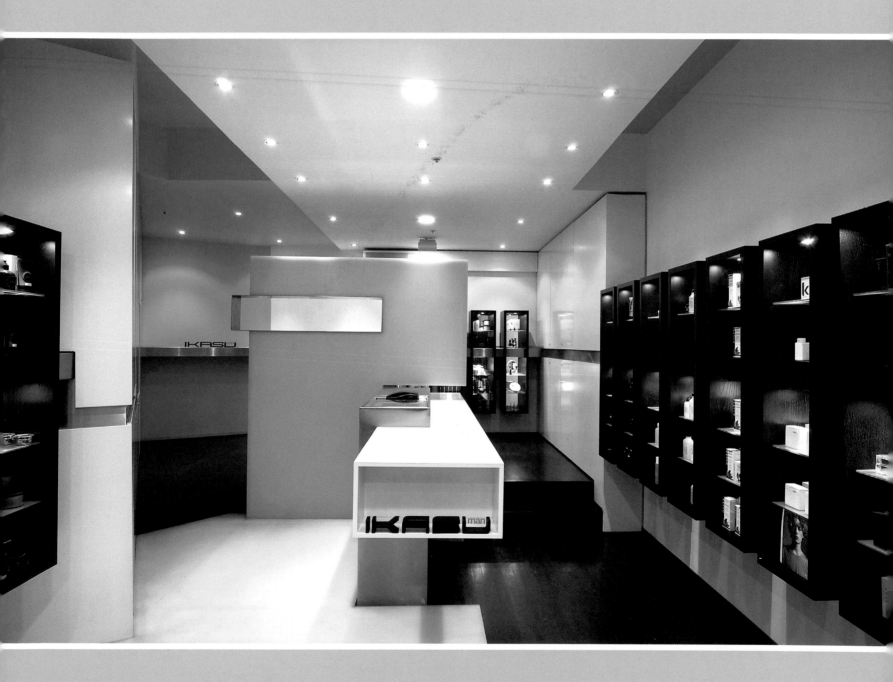

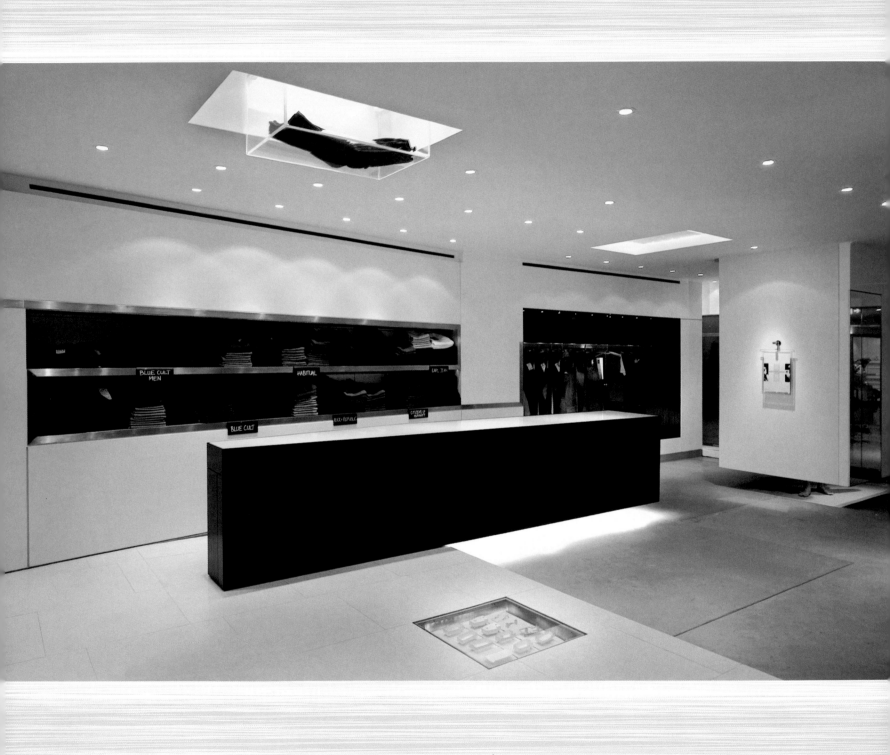

INHABIT:
MODERN MUSEUM OF (X)

IN WHAT WE TERM AS OUR CONTEMPORARY METROPOLITAN CULTURE, THE INTELLIGENCE OF AN OBJECT IS, SADLY, NOT ALWAYS SYNONYMOUS WITH ITS APPEAL. THE DELIGHT OF THE NEW OFTEN ENCOURAGES THE PROLIFERATION OF IMPROVISED, AND HARDLY ORIGINAL GESTURES. AT INHABIT, HOWEVER, ARCHITECTURAL DESIGNER ERIK L'HEUREUX URGES US THINK FASTER AND DEEPER ABOUT THE COMMERCIAL INTERIOR.

text Elaine Khoo **photography** Amir Sultan (Khasfoto) **design firm** 212box LLC (New York/Singapore) **principal designer** Erik L'Heureux **main contractor** Eng Hua Manufacturing Pte Ltd **m&e consultant** Mr Goh Yong Ping, LKH Singapore Ltd **lighting consultant** Filament 33, New York, NY **graphic consultant** 212box LLC with Omnivore, New York, NY **optical film** Glass Film Enterprises Inc, USA **key materials** ebonised wenge, stainless steel, one-way mirror, optical film **floor area** 90sqm **location** 390 Orchard Road, B1-03, Palais Renaissance, Singapore. P (65) 6235 6995

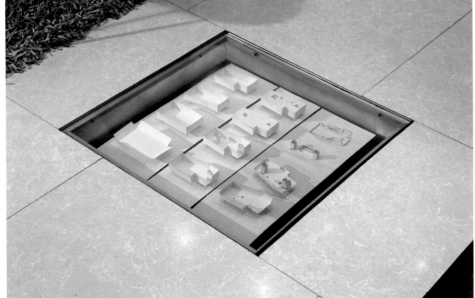

In the basement of the Palais Renaissance shopping centre in Singapore, one store takes the guise of an intelligently wrapped gift, seducing the unwary. The glass facade of Inhabit is clad with a layer of optical film, such that passers-by are only granted a view of the interior when perpendicular to the film. Acting to narrow the field of vision, the film blurs images at the periphery. The store's designer, Erik L'Heureux, is a practicing architect with New York firm 212box LLC, which recently expanded to Singapore. For L'Heureux, the display window is the "idealised image" of the shopping experience. The film – a veil – is strategically placed before our eyes to act as a catalyst for the sensationalism of the picture-perfect display. Impressively, the shade of subtle black humour introduced here colours the rest of the space.

A two-inch-wide stainless steel ribbon, tracing around the edge of the interior, soon becomes the focal point of the shopping experience. From within, the store envelope is experienced as an "architectural dress". L'Heureux parallels the steel ribbon to the stitching of the dress. The ribbon bends, extrudes and recedes, never straying far from the envelope to tie up the gift of the store. Fundamental objects and events within the shopping activity grow out of the ribbon. For example, it grows perpendicular branches to form display knobs, and it is the bar from which clothes are hung, with custom-made, folded stainless steel hangers appearing as organic outgrowths.

And the cause for this elaborate dress sense? Inhabit itself. Inhabit carries labels made famous by the Hollywood A-list, and spreads the cult of couture denim. One could say that the experience of high-end fashion shopping, with the glitter of limited edition pieces, bears a striking resemblance to the experience of visiting a franchised museum, which seems to flaunt its perhaps-not-so-covert agenda in full, exhibitionist display. In a similarly toned critique of the neutral white gallery that stands silent despite the seeming subversion of art into a manifested commodity, L'Heureux paints the ceiling of Inhabit in a generic museum white, the top half of the walls in pearl-finished white, and the walls below the ribbon in a differentiated egg-shell-finished white. This is the "display dress" – the wrapper that unfolds to contain the displayed objects.

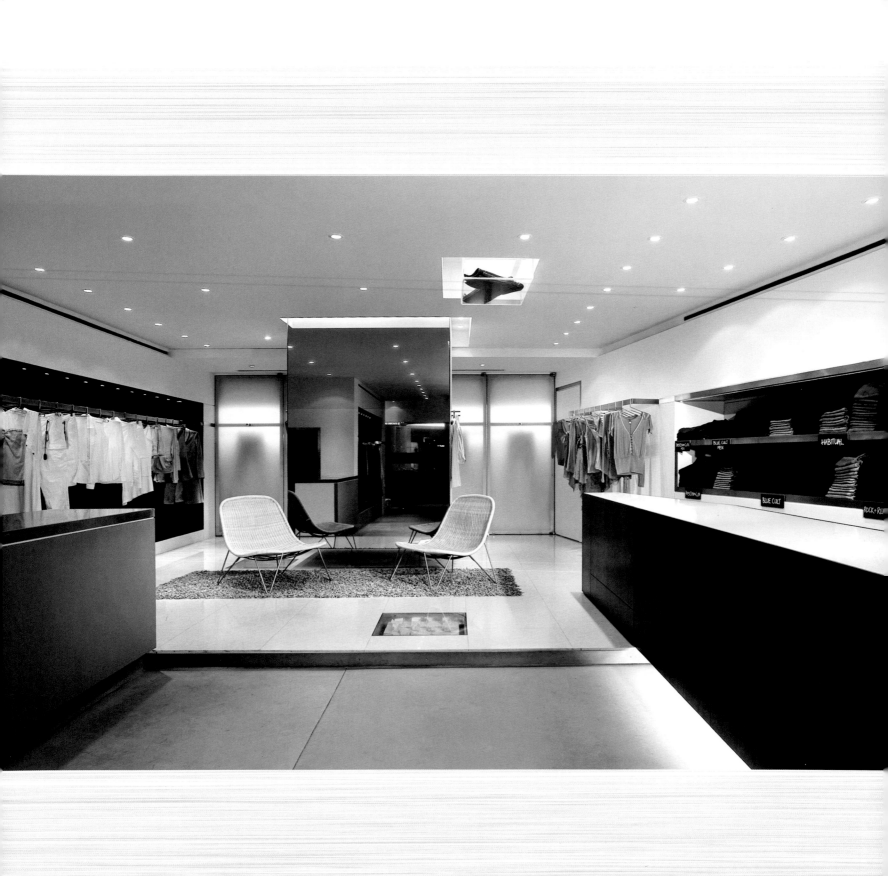

Where the seams of the wrapper peel back to reveal display niches, a polarised black finish appears. Various other display cases are built into the floor or descend from the ceiling. Their size thoughtfully echoes that of side tables, and the expected trinkets are replaced by merchandise – made to seem even more desirable through the analogy. Scaled architectural models and illustrations are displayed throughout the store, not sparing the very design of Inhabit in the quest for a critical display space that critiques even itself.

At the denim bar, jeans nestle into a display case defined by the ribbon, which snakes around its edge. The design labels are indicated by chalk on black cards, functioning as would a curator's blurb for an artwork. Two dressing rooms at either end of the shop are stylishly suspended off the floor, taking the appearance of the disinterested but flamboyant display case. Behind a one-way mirror, the changers are put on display, at least in their eyes. It is this idea of the person displayed, and of self-exhibitionism, that is the common celebration of haute couture.

> Scaled architectural models and illustrations are displayed throughout the store, not sparing the very design of Inhabit in the quest for a critical display space that critiques even itself.

In a personal gesture, L'Heureux inserts a personal version of Marcel Duchamp's last piece – Étant Donnes: 1 La Chute D'eau, 2 Le Gaz D'éclairage. The original installation allows the viewer to look through two peepholes in a door to see a naked woman on the other side. However, due to the viewing angle, the desiring audience fails to ascertain her identity. On the walls of Inhabit's dressing rooms, L'Heureux reinvents Duchamp's project by creating a physical stopper within a circular peephole, replicating the effect of two viewing apertures. Around its circumference, we are able to see an unfocused image of a person changing, but the eye is prevented from focusing on the desired mid-point. Any art lover would seize this as a conduit to understand L'Heureux's work, but for L'Heureux, it is perhaps a tongue-in-cheek signifier of this modern museum.

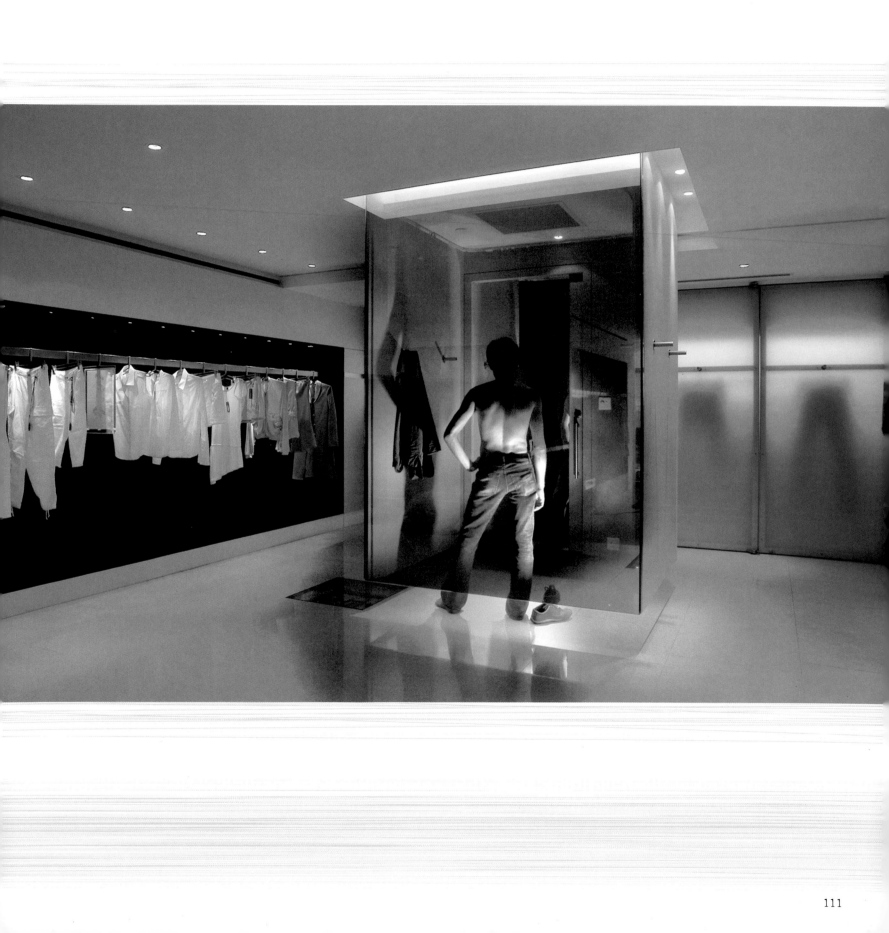

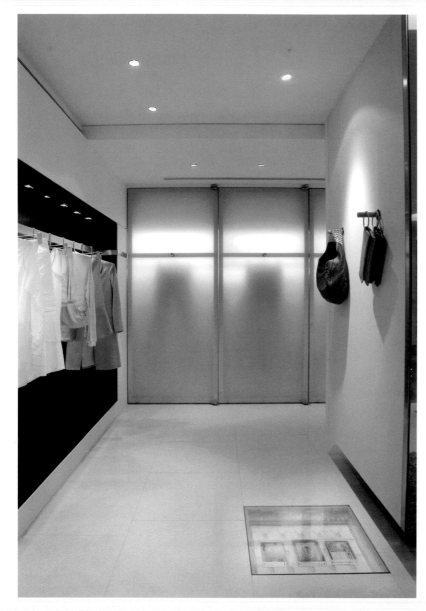
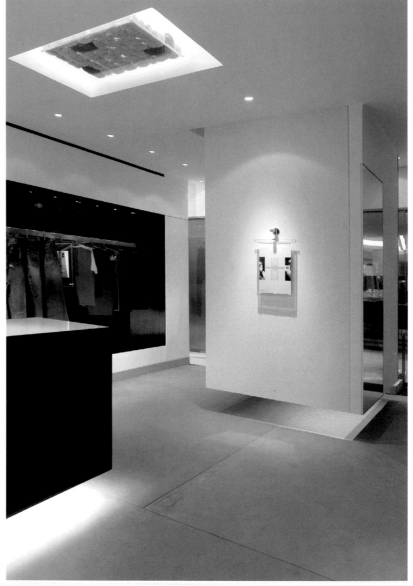

floor plan

1. entrance
2. window display
3. display racks
4. stock room

5. storage
6. changing room
7. sales counter
8. jeans bar

A two-inch-wide stainless steel ribbon, tracing around the edge of the interior, soon becomes the focal point of the shopping experience. From within, the store envelope is experienced as an "architectural dress". Designer Erik L'Heureux parallels the steel ribbon to the stitching of the dress.

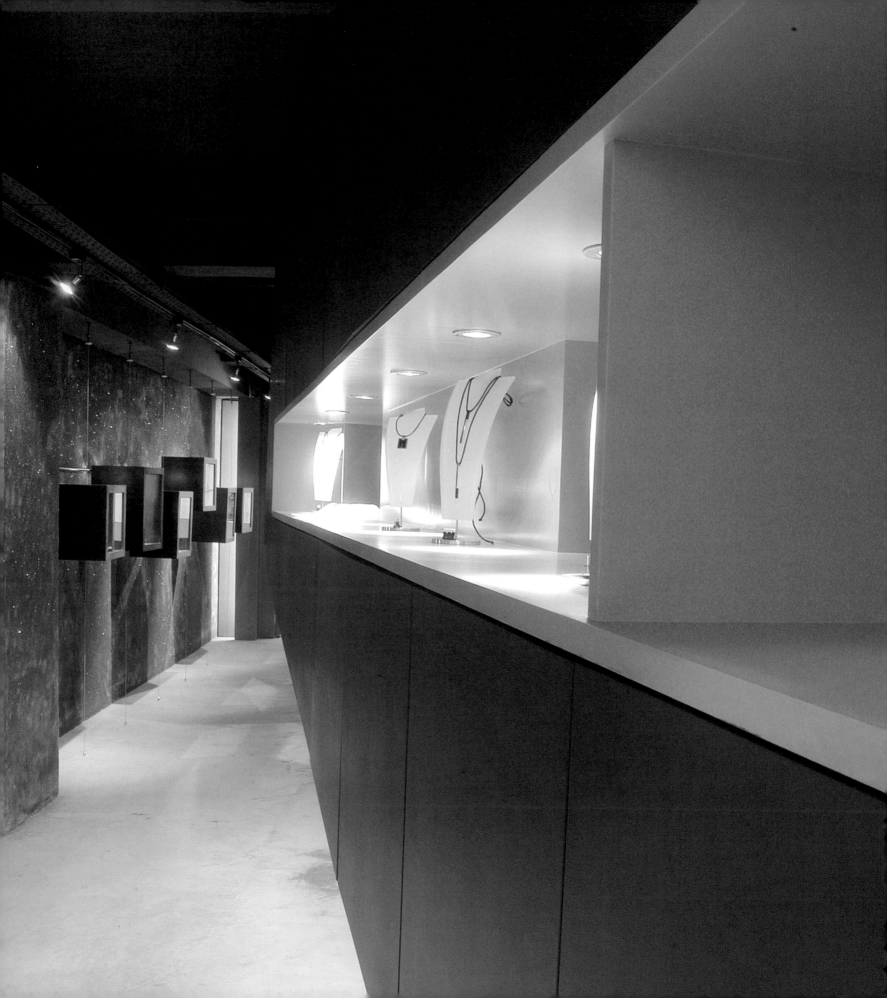

LUNA: A SPARKLING GEM

LUNA, A NEW JEWELLERY BRAND AND STORE IN HONG KONG, MAY HAVE ACQUIRED A LESS-THAN-IDEAL RETAIL LOCATION, BUT ITS STYLISH, SUBDUED INTERIOR IS A FAR CRY FROM ITS CONVENTIONAL COUNTERPARTS. DESIGNER CAROL LEUNG OF ASSOCIATED ARCHITECTS HAS COMPOSED A DYNAMIC INTERIOR, WHICH REFLECTS THE BRAND'S UNIQUE STANCE IN THE MARKET.

designer Associated Architects Ltd. **design team** Carol Leung **main contractor** One Design. **key materials**
Central, Hong Kong. T (852) 2858 2988.

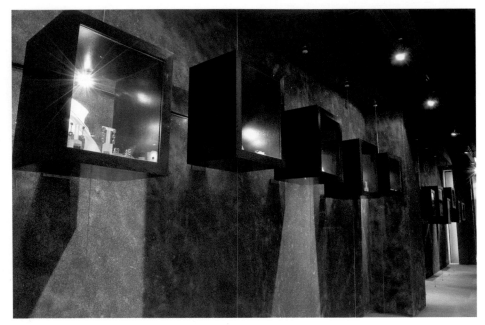

At first sight, the location of Luna appears to be most advantageous. It sits conveniently on steeply sloping Elgin Street within the thriving Hong Kong neighbourhood of Soho. The conglomeration of hip bars and restaurants that surround the shop almost assures a constant stream of potential customers. But take a closer look and you'll notice that one thing is missing – a prominent frontage. The shop is obscured by a sea of open hawker stands, which reduces its visibility from the street. So a major part of the designer's work was to establish the shop's presence, as well as the jewellery brand's identity, through a series of interior manipulations.

Despite a petite footprint, the clients envisioned the shop to be more than just an ordinary jewellery showcase. For example, a casual resting area was to be incorporated where customers could take a break while browsing the collection. Moreover, they felt that the shop could double as a video gallery, and so they required enough flat surfaces to function as a backdrop for one of the partners' video creations. The site is long and narrow, with a rather confined feeling. Squeezing all the programmes into the shop thus required the designer to maximise the space and define different functions in the most non-intrusive way.

The designer has, so to speak, killed two birds with one simple architectural manoeuvre – a suspended screen painted in the company colour of violet. Floating in mid-air without touching the ground, the screen stands at an oblique angle to the axis of the shop, and provides a focal point around which other functional areas are orientated. The movement of customers is guided subtly by this screen, starting from the linear display area on its left, then to the video projection zone on the right, and finally terminating at the timber-lined service counter.

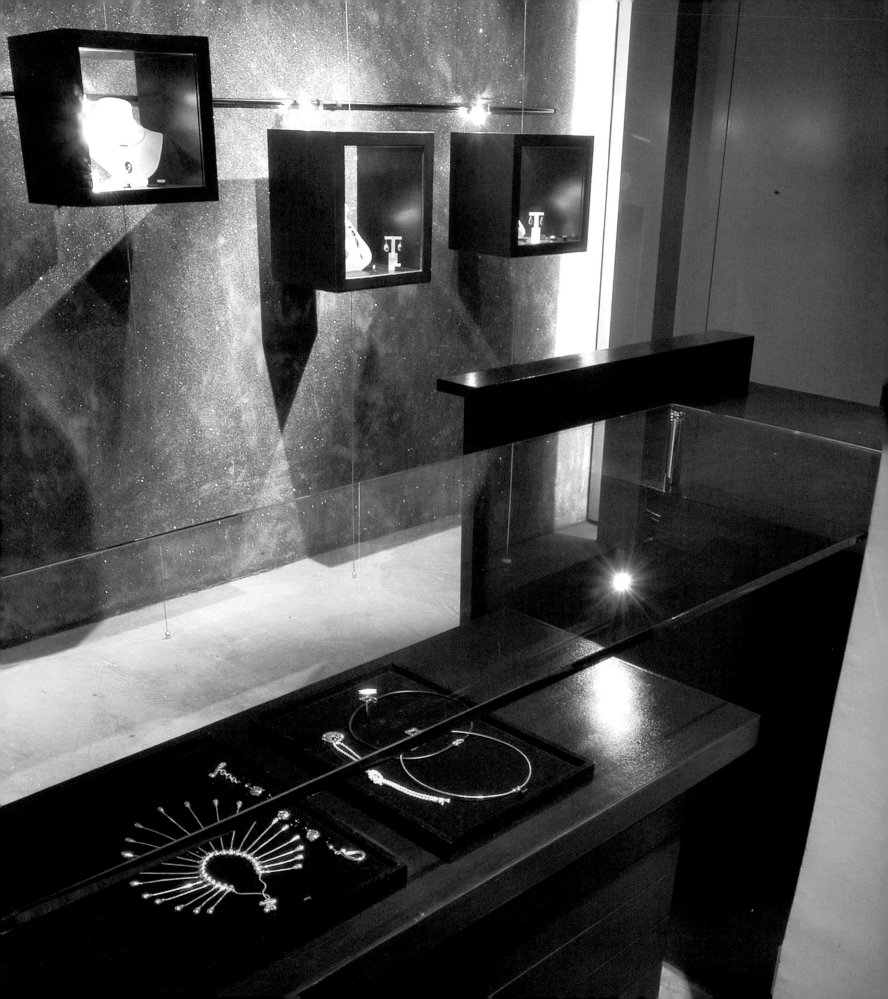

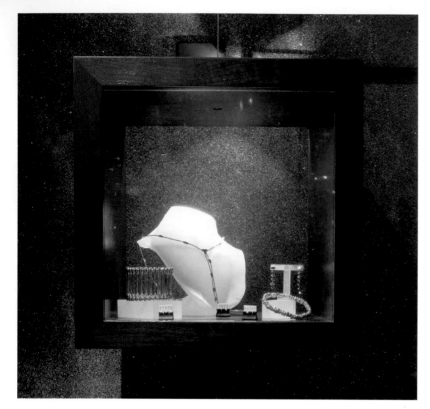

The screen even protrudes outwards through the glass facade, making a necessary but discrete statement to the outside world in order to attract the curious. Internally, a narrow recessed band is carved into the screen at eye level for the display of merchandise. With the exception of this, the screen remains one expansive planar surface upon which video projections can be cast. It also affords a significant amount of storage behind the smooth floating planes.

The jewellery showcases demonstrate an ingenious twist of the wire track system commonly used to display paintings in galleries. The glass cabinetry wall typical to most jewellery shops has been condensed into individual display boxes, which are composed of teak and suspended from the ceiling by metal wires. Fixed at varying heights, the series of boxes create an interesting rhythm in the space. The system also allows the number of boxes stacked on each wire to increase as the brand's collection grows with time, creating the opportunity for an ever-changing interior-scape.

The choice of materials hinges largely on the design of the jewellery. Produced by craftsmen in Bali, Luna's silvery collection has a distinctly raw, textural and unpretentious edge to it. This very quality has been transported loyally to the floor and walls, which are rendered in rough cement screed. Steel grit, normally used to create a non-skid finish on highways, is employed here for its shimmering effect. It is infused with cement and epoxy to lend a silvery lustre to the wall behind the display boxes. The finish doesn't sparkle brightly like a diamond; the effect is more subdued and sophisticated. Balanced by a sombre palette of dark violet, olive green and grey, the shop sparkles like a rare gem in the dark, waiting to be discovered.

Luna's silvery collection has a distinctly raw, textural and unpretentious edge to it. This very quality has been transported loyally to the floor and walls, which are rendered in rough cement screed.

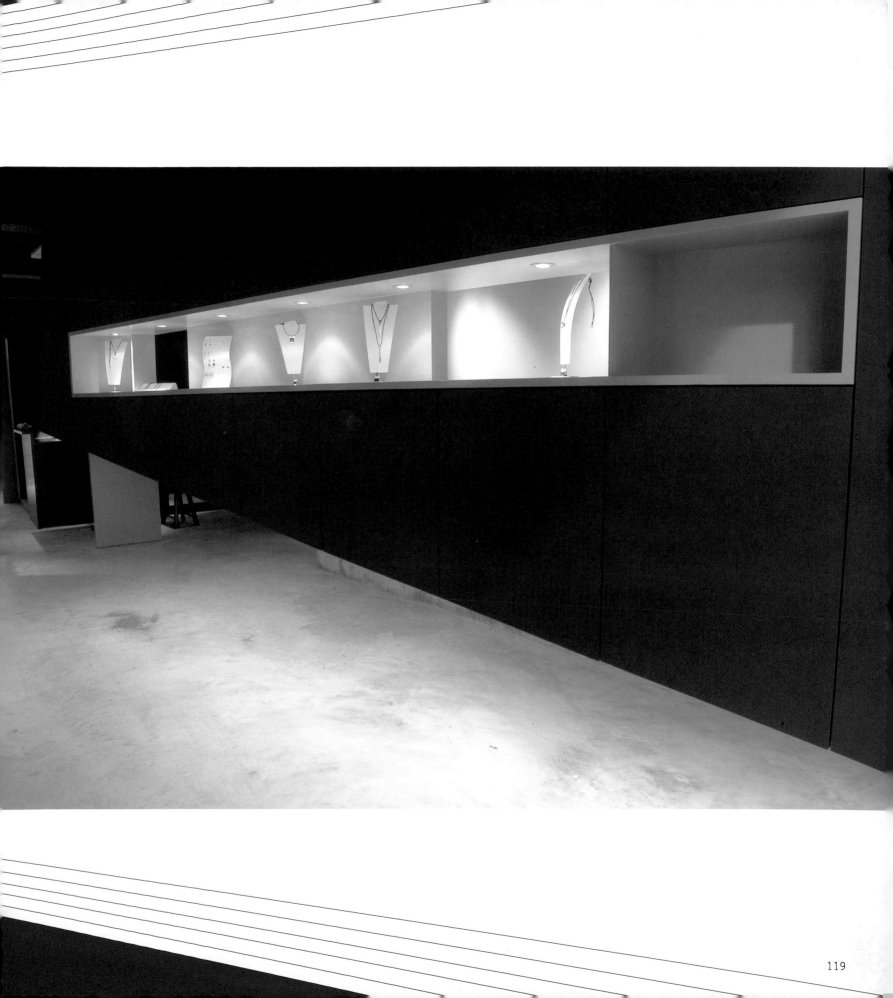

Balanced by a sombre palette of dark violet, olive green and grey, the shop sparkles like a rare gem in the dark, waiting to be discovered.

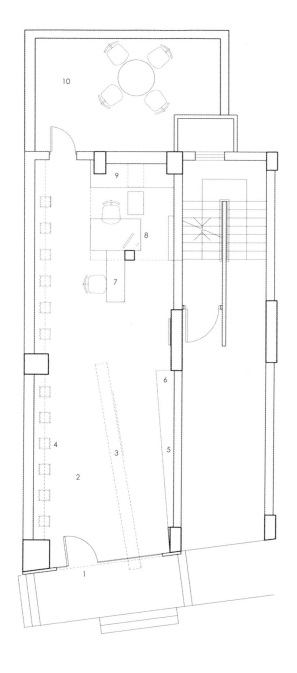

floor plan

1. entrance
2. gallery zone
3. display cabinet
4. display box
5. future projection system

6. bench seat
7. display table
8. work station
9. storage
10. outdoor seating area

MAYMAYKING: STREET PARADE

THE HIGH RENT IN HONG KONG HAS GIVEN RISE TO A UNIQUE RETAIL PHENOMENON – SMALLER NEIGHBOURHOOD SHOPS COLONISING OLD URBAN WALK-UP APARTMENTS. MAYMAYKING, A QUAINT LITTLE RETRO STORE IN HONG KONG'S SOHO AREA, MIGHT BE SMALL IN FOOTPRINT, BUT A SUNKEN FORECOURT THAT SERVES AS THE SHOP WINDOW MAXIMISES ITS EXPOSURE AND PRESENCE ON THE STREET.

text Catherine Cheung **photography** Elaine Khoo **designer** May Yang **key materials** concrete, plaster, corrugated metal sheeting, metal rods, antique tinted glass screen, timber racks
floor area 75sqm **location** G/F, 67A Peel Street, Soho, Central, Hong Kong. P (852) 2445 5655

Many Hong Kong retailers, including May Yang, the owner of Maymayking, have come to appreciate the lower rental cost incurred by lifting their shops off the street level. Doing so also creates a sense of discovery, as customers must make an effort to find the way for themselves. But these locations usually come without a visible shop window – a major shortcoming that holds many shop owners back.

Located within a residential building in the Soho area, Maymayking seems to be enjoying the commercial advantages this mode of business offers. Yet it exists minus all the usual shortcomings. The 30-square-metre first-floor unit it occupies is no different to other typical residences. However, the building's location on an exceedingly sleep slope grants it a sunken forecourt, lying half a floor below the shop unit. Connected to the apartment by a simple flight of stairs, the 45-square-metre forecourt enjoys a prominent street frontage. It has been opportunely reworked into a display gallery for merchandise, making up for the loss of a shop front and thus creating a strong street presence.

In a way, the architecture can be read as a composition of split spaces: an L-shaped forecourt denoted as the display area, wrapping around a rectangular mezzanine retail floor where the main action takes place. A serious overhaul has seen the once forgotten, ramshackle forecourt miraculously transformed into a pleasant, habitable space. The concrete floor was re-surfaced, walls were plastered, and the problem of rainwater leakage was resolved with a new roof of corrugated metal sheeting.

The entrance to the shop is via an aperture to the left of a screen (composed of white-painted metal rods) that frames the boundary of the forecourt. Akin to the usual pane of glass encasing the typical shop front, the screen has the rods sparsely spaced to allow uninterrupted visibility into the shop from the street. An additional layer of transparent plastic awning can be rolled down after hours, offering a limited degree of security as required. Its function is, however, to reveal rather than block out views completely.

The forecourt enjoys a prominent street frontage. It has been opportunely reworked into a display gallery for merchandise, making up for the loss of a shop front and thus creating a strong street presence.

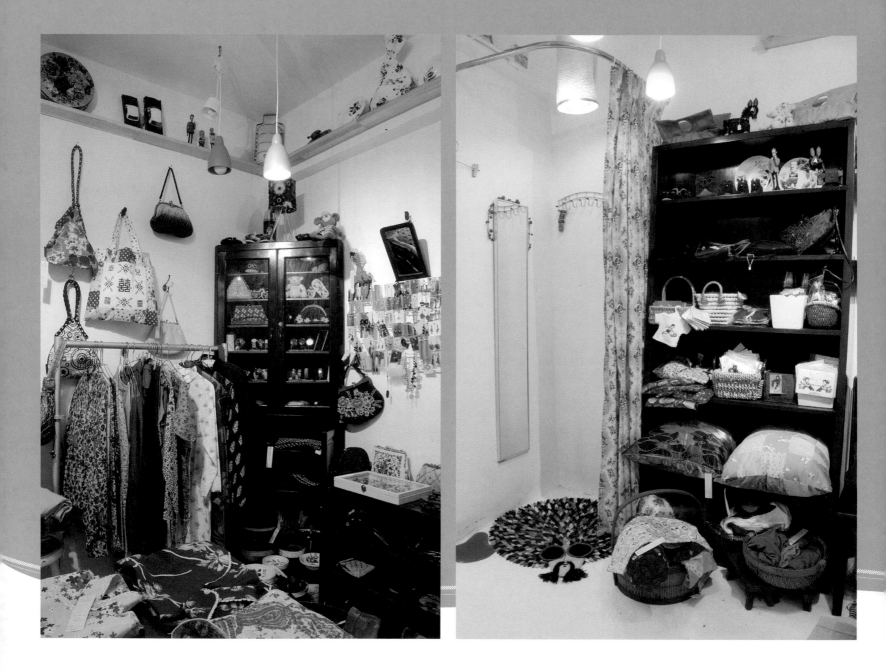

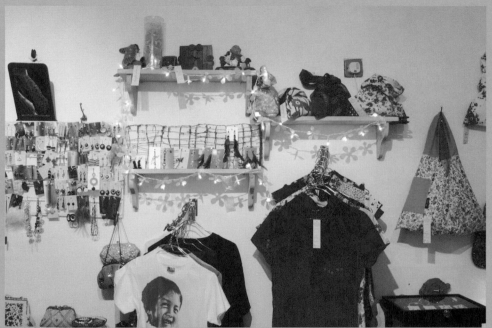

The space may be small, but the simple, practical touches speak volumes about the spirit behind the shop.

A storeroom at the rear is partitioned off by a traditional tinted glass screen, which was salvaged from an old building in China. A portal was custom built in order to accommodate the dimensions of the screen. At one point, this additional slot of space seems almost non-existent – the screen fits so immaculately well with the portal that it appears to become part of the rear wall. The screen also echoes the character of the array of products displayed here, which speak of a predominantly retro Chinese theme.

Upstairs, one arrives at the main retail space, where merchandise is scattered casually across the limited footprint available. The intimate domestic scale encourages customers to browse and touch the products. Other than that, traces that remind one of the space's former domestic use are virtually absent. Even the original windows and front door are camouflaged behind a second layer of white plastered boards. The neutral white of the envelope also allows the timber racks and furnishings to stand out, and focuses the customer's eyes on the colourful products.

The juxtaposition of the industrial fabrics of the interior with the retro Chinese motifs exhibited in the products does not come across as a contrived or calculated decision – it occurs rather because the makeover was done on a tight budget and in a narrow time frame. There is nothing extravagant about the interior, nor the products on sale. The space may be small, but the simple, practical touches speak volumes about the spirit behind the shop.

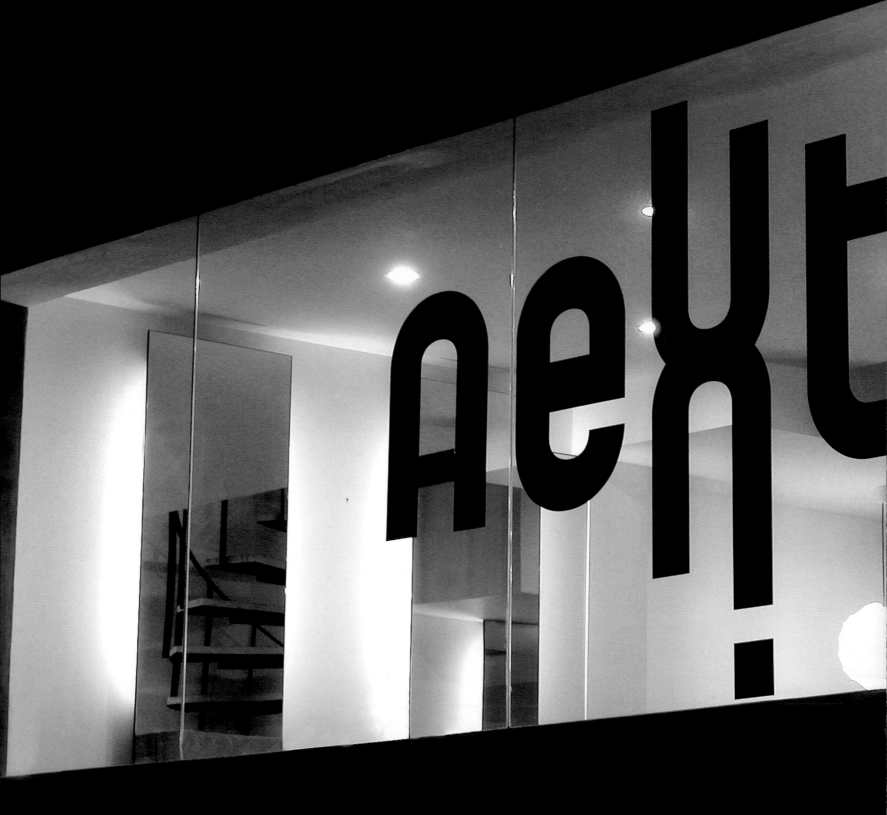

NEXT: IN READINESS

SINGAPOREAN DESIGNER ALVIN TAN PREFERS TO THINK OF NEXT AS A GALLERY RATHER THAN A HAIR SALON. IN HIS VIEW, THE STYLISTS ARE ARTISTS, AND THE DIRECTORS ARE CURATORS. HIS MAIN AGENDA FOR THE ARRANGEMENT OF THE INTERIOR WAS TO CREATE A SPACE THAT IS RAW AND TIMELESS – ONE THAT ALLOWS THE ART OF THE STYLIST TO BE REFLECTED, JUST AS A GALLERY SPACE IS (USUALLY) SUBSERVIENT TO THE WORK EXHIBITED IN IT.

text Narelle Yabuka **photography** Jeremy San / Stzern Studio **designer** Alvin Tan of at.lab interiors + furniture **main contractor** Dayabuilt Pte Ltd **electrical works** Ah Ho **key materials** concrete (cast in-situ), stainless steel **floor area** 140sqm **location** 271A Holland Avenue, Singapore. P (65) 6468 3323

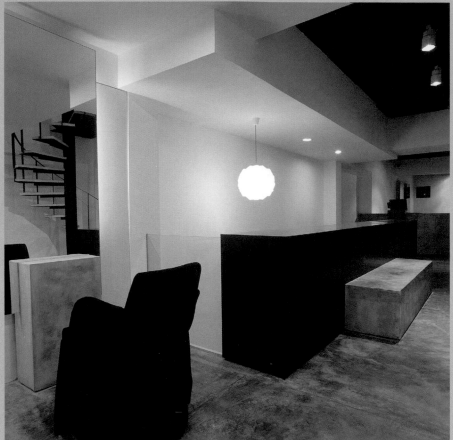

An unadorned vessel rendered in the unfussy finishes of concrete and black and white materials, Next is a stark yet stylish space designed to avoid connection with ever-changing trends. Forms have been reduced to their most basic configurations, and colours beyond the black-and-white spectrum have been eschewed. Not even the warm hues of timber infiltrate this abstract space. A black-painted ceiling makes a direct reference to "black box" museum architecture, where the context is painted black to enable a focus on the objects. Unadorned white-painted walls are equally recessive. Like an art gallery, the interior is a neutral canvas able to unflinchingly hold the constantly evolving cargo of clients and hair fashions.

The salon occupies a long, narrow two-level space within a shophouse in the quaint shopping and dining area of Holland Village. The main floor is located one storey above street level, and houses space for cutting and styling. The upper floor, accessed by a spiral staircase, accommodates the colouring area, as well as a roof terrace. A wide expanse of glazing at one end of the main lower floor washes the space with daylight. Originally, the salon owners had wished to divide the space into small, intimate cubicles. At Tan's insistence, however, they agreed to explore the potential of the large window and an open concept that would accentuate the lengthy proportion of the space.

With the themes of "art" and "fashion" in mind, Tan began creating scenes for the gallery. The first scene encountered is that containing the circular reception desk, which cleverly mimics the footprint of the spiral staircase on the opposite side of the space. Tan likens the monolithic concrete reception desk to a DJ console, from which the receptionist, ideally located with views across the entire space, sets the pace for the day's proceedings.

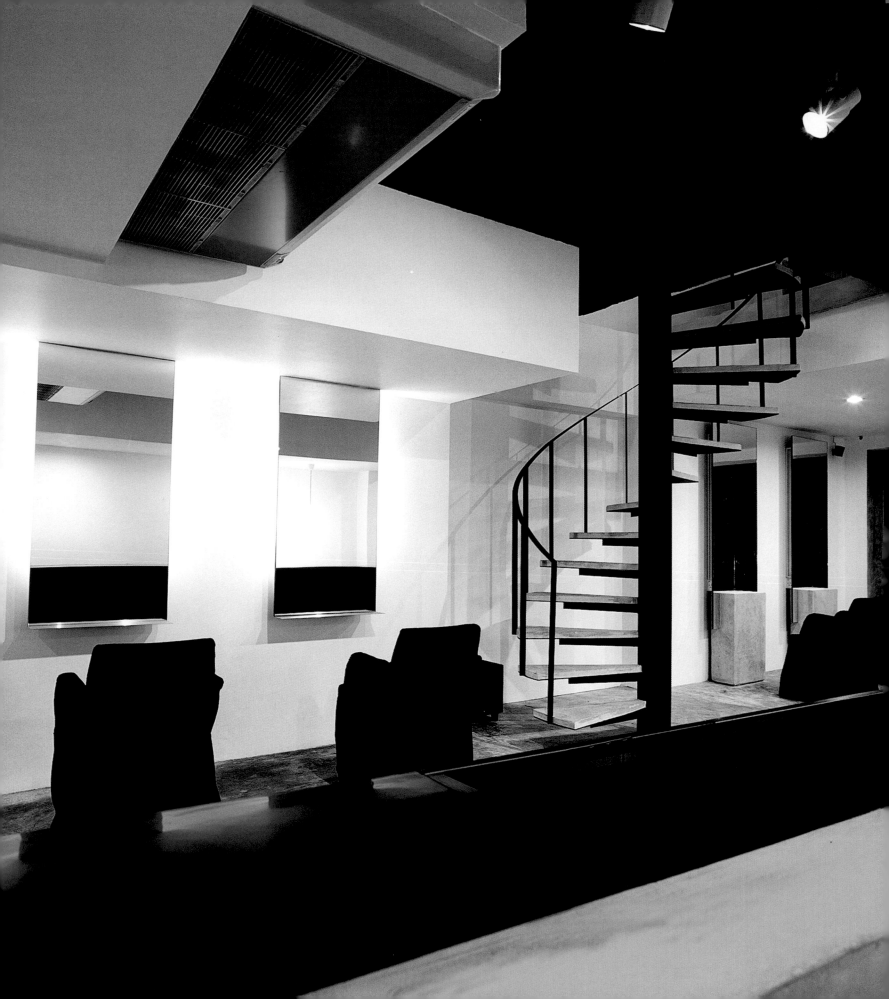

In this consistently neutral, yet evocative space of purity and quiet, the next trend in hair styling is always welcome.

The next scene involves a low, glossy black wall that replaces what was previously a full-height wall beside the entrance staircase. Functioning as both a waiting area and a storage cabinet, it reveals the interior slowly as one ascends the staircase. Tan wanted the cabinet to be something subtle that sits quietly in the interior. Seemingly over-sized as though it was a display plinth, the wall-cum-cabinet hides away all the hair products and magazines that the owners initially wished to display. Other equipment is mobile and travels with the stylist. The cabinet's recessive black colour is an appropriate reminder that waiting clients, seated before it, are indeed the focus in this space.

Tan regards the front of the space – the most significant scene in the gallery – as a stage where the act of hairstyling is brought to street level. Through the large window at the end of the space, the client and stylist unwittingly become performance artists for pedestrians and car passengers. Originally, the window was timber framed and divided into four panes. The frames were removed in favour of an uninterrupted panorama and a window that Tan feels "is almost like a TV screen". The "screen" works two ways, however, with the vivid green of tropical trees and the endless flow of traffic infiltrating the stark interior with the surprising intensity of a scream.

There is no doubt, though, that the clients are the focal point in Next, being seated upon simple, non-distracting black upholstered chairs and illuminated by gallery style spotlights. As if to emphasise the point, lighting tubes placed behind the mirrors wash light across the walls, dematerialising the surfaces around the mirrors, and drawing focus upon the images in the mirrors themselves. In this consistently neutral, yet evocative space of purity and quiet, the next trend in hair styling is always welcome.

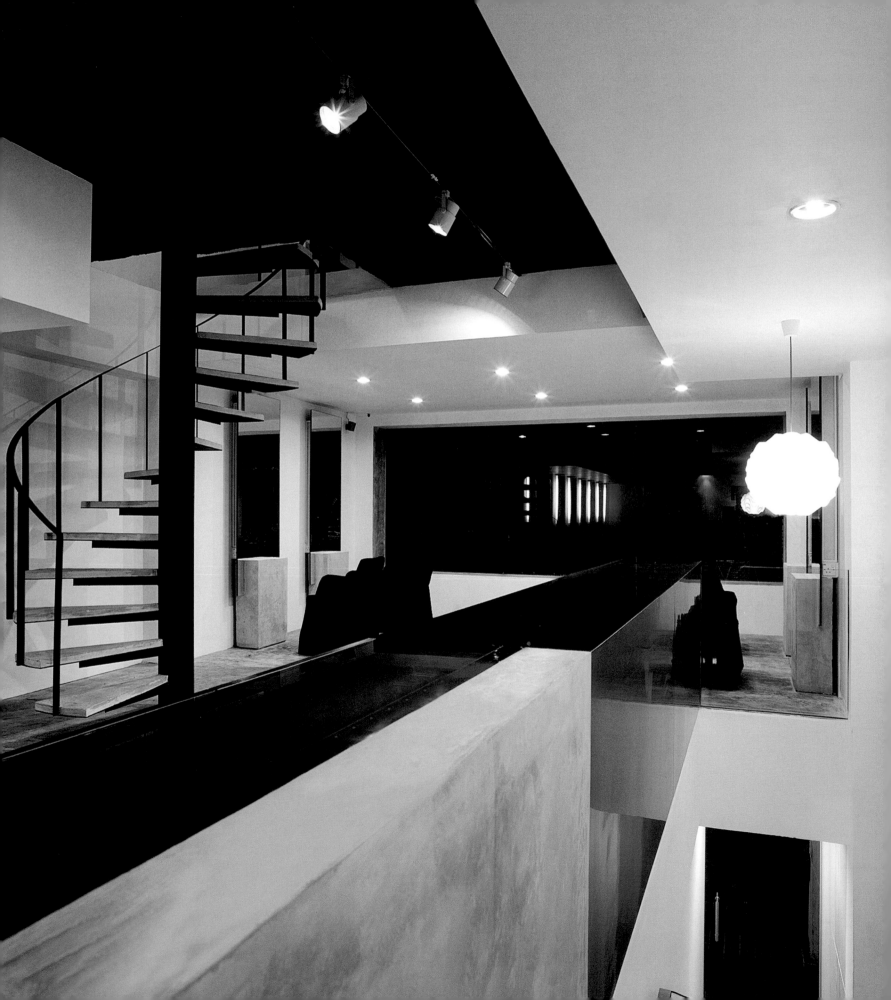

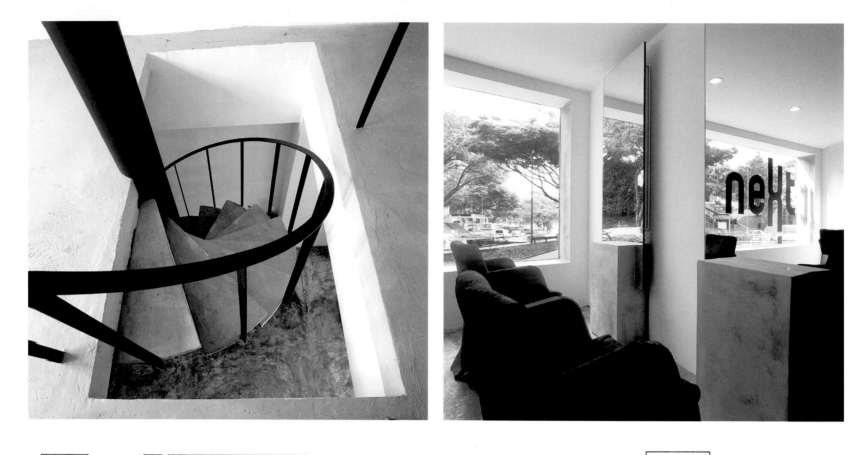

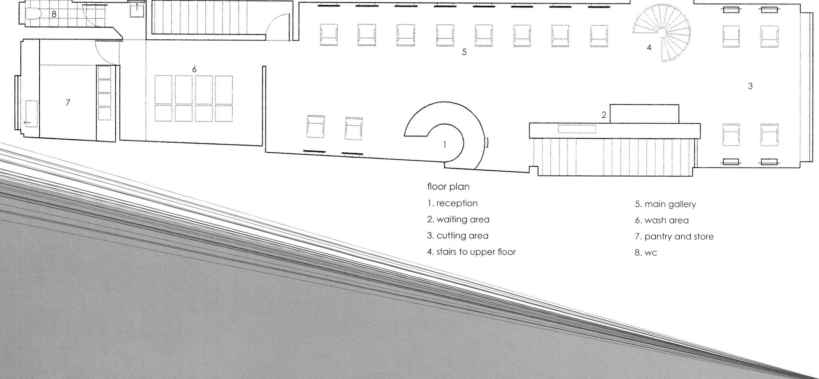

floor plan

1. reception
2. waiting area
3. cutting area
4. stairs to upper floor

5. main gallery
6. wash area
7. pantry and store
8. wc

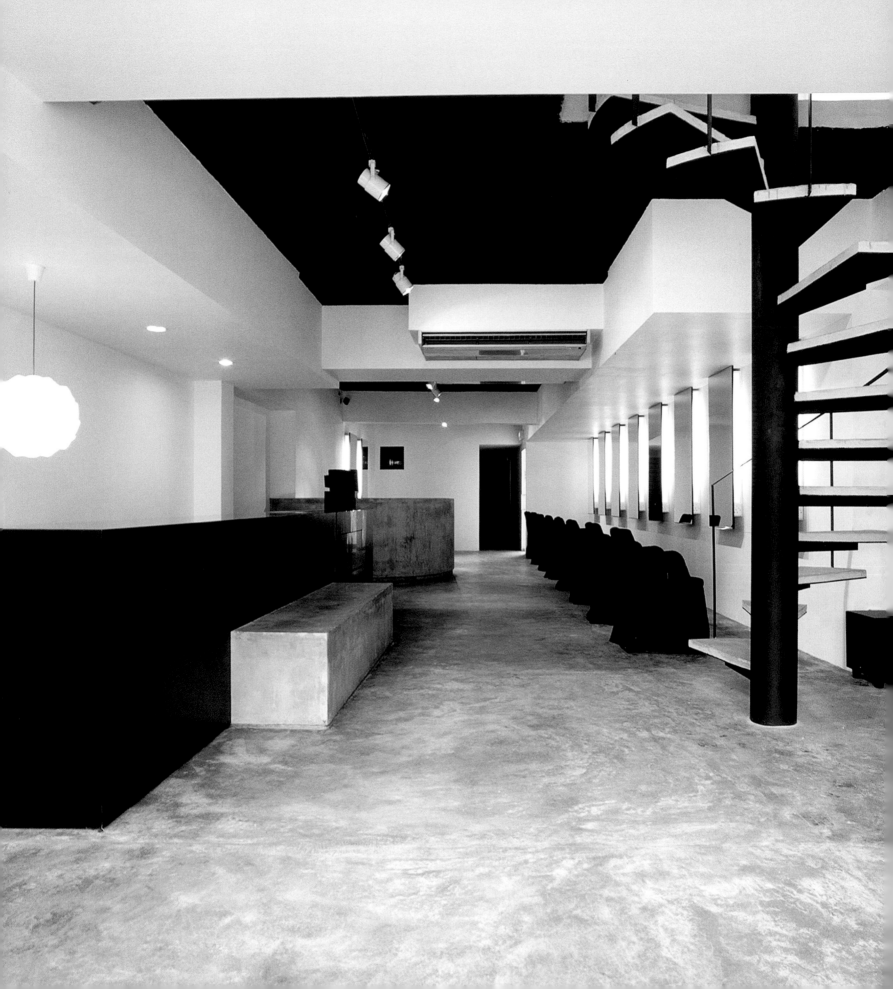

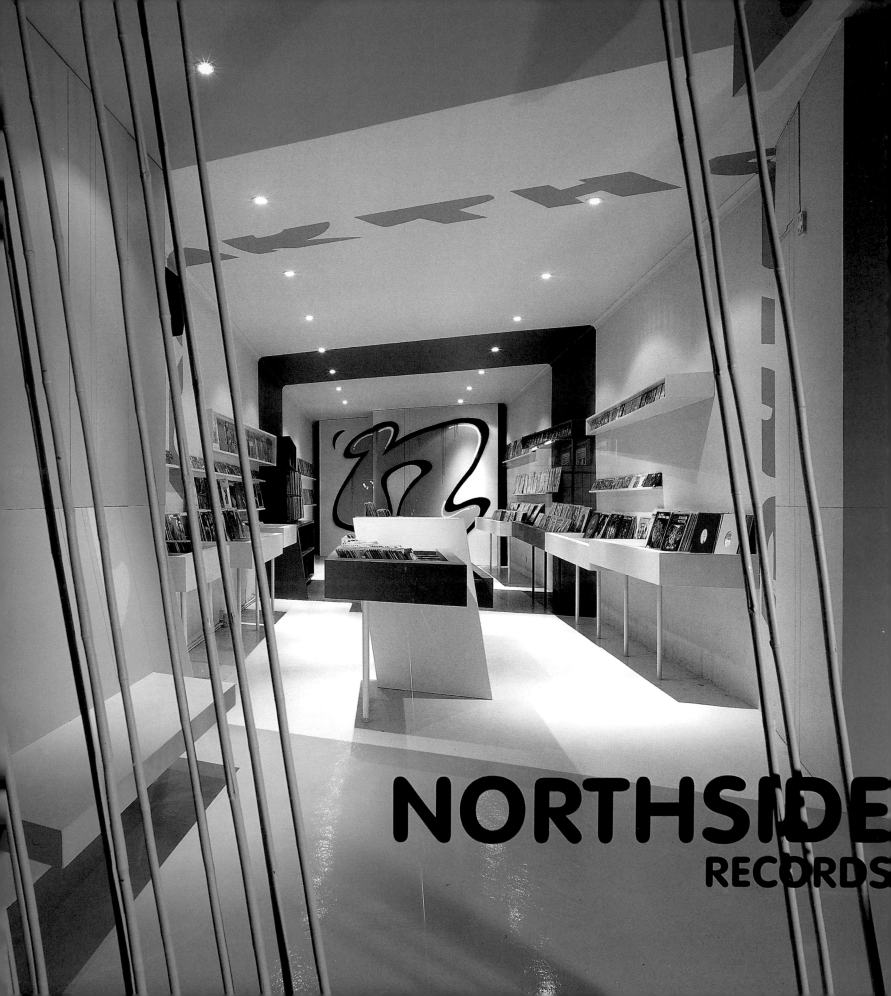

NORTHSIDE
RECORDS

NORTHSIDE RECORDS:
THE KEY OF "N"

DESPITE BEING UNDERSTOOD VIA DIFFERENT PARAMETERS, MUSIC AND ARCHITECTURE SHARE MANY QUALITIES; FOR EXAMPLE, WORDS AND CONCEPTS SUCH AS RHYTHM, PRELUDE, ACCENT AND MODULATION CAN APPLY EQUALLY TO BOTH. THE INTERIOR OF NORTHSIDE RECORDS SUCCEEDS IN BRINGING MUSIC AND ARCHITECTURE TOGETHER TO CREATE A FRESH SYMBIOTIC ARRANGEMENT.

text Narelle Yabuka **photography** Shannon McGrath **architect** Andy Wong **main contractor** Ian Stephens, Tony Stuart **key materials** MDF, paint, rubber flooring **floor area** 80sqm
location 236 Gertrude Street, Fitzroy, Melbourne, Australia. P (61) 3 9417 7557

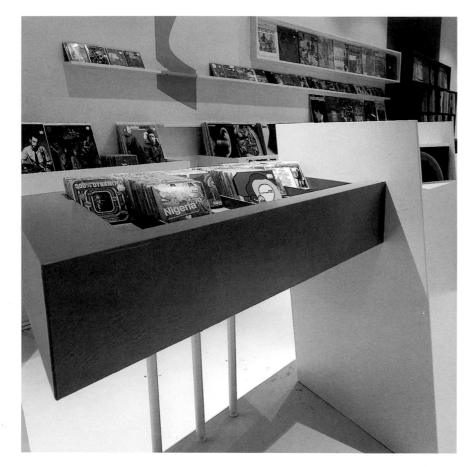

While listening to music involves an aural envelopment, with visual and spatial landscapes (perhaps) imagined by the listener, experiencing architecture generally involves the inverse. The aural dimension may be included, but it is not usually crucial to an understanding of a built environment, which is perceived primarily in terms of sight and touch. Yet the two disciplines share many commonalities, and the possibilities for a meaningful exploration of the crossover between them are rich.

At Northside Records, architect Andy Wong has translated the musical forms and music-making techniques of DJs into architectural form. The turntable processes of mixing, cutting and sampling have become form-making techniques, and have been used to create a unique interior that not only shows how music can take on a physical form, but also speaks volumes on the product being sold within it.

DJ Chris, the owner of Northside Records and a long-time professional DJ, had limited financial means with which to carry out the interior works. This, says Wong, was the greatest challenge of the project, but the one that ultimately pushed the limits of the design. With a minimal budget, a creative use of paint was one of the few design options available. In fact, aside from a strip of rubber flooring (its circular protrusions constituting a note of staccato texture), paint is the only finish used. Joinery units were constructed with economical MDF. Yet, even with such humble materials, a dynamic and successful interior has been achieved.

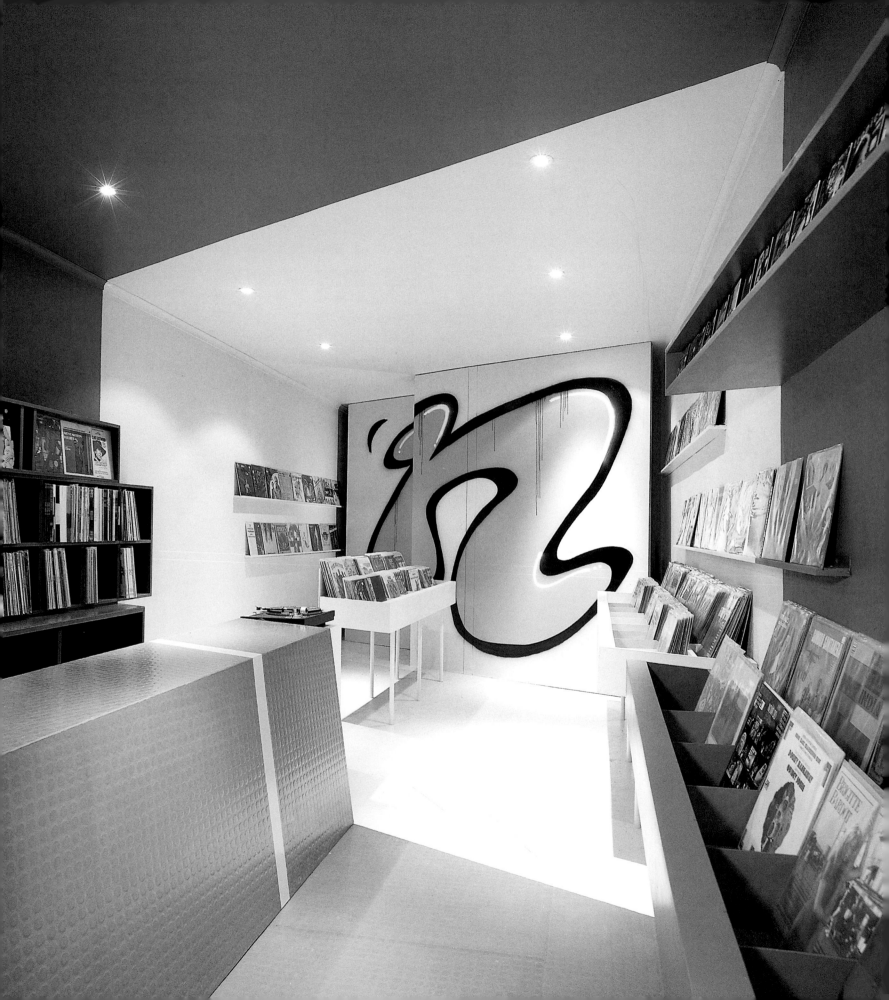

The storefront makes a vivid punctuation mark along the string of otherwise unobtrusive facades on Gertrude Street in Fitzroy – a northern inner-city suburb of Melbourne on whose aged, gritty streets and graffiti-filled laneways, an artistically-inclined populace shop and socialise. Vivid blue paint swathes not only the facade of Northside, but the whole entry space, immersing the customer with what is intended to be a fresh, friendly and optimistic sensation – a truncation from the course urbanity of the street. In the front window, angled bamboo provides a filtered screen to the entry listening seat, while also alluding to the grooves on a vinyl record.

The long, white volume is broken by loops of colour, which encompass the walls, ceiling and floor. Representing a repeated musical sequence, beat or sample, or perhaps simply a spinning record, the loops are a thoroughly spatial interpretation of music, prompting a sense of immersion and journey through the space of the store.

As one progresses further into the interior, Wong's interest in spatial and sculptural dynamism becomes evident. The narrow space is predominantly coated in a warm shade of off-white, with the linearity emphasised by the placement of the angular counter and display trays along the length of the interior. The long, white volume is broken by loops of colour, which encompass the walls, ceiling and floor. Representing a repeated musical sequence, beat or sample, or perhaps simply a spinning record, the loops are a thoroughly spatial interpretation of music, prompting a sense of immersion and journey through the space of the store. Against the volume of the loops (both spatial and musically-imagined), the white surfaces appear silent. The aural vacuum is filled by the selections of DJ Chris.

The angular joinery units, cut away at one corner, seem to float down the space. They can easily be imagined to be the architectural equivalent of musical samples taken by a DJ, and inserted into a soundscape at the opportune moments. A large supergraphic graffiti "N" covers the angled rear wall, acting as signage to the street. The artist was Wong himself, who harbours a personal interest in street culture. The "N" echoes through the interior, reappearing in fragments on a loop and at the entrance, as if it had been sampled and remixed.

Northside has become a favoured hangout for DJs both local and foreign, who are known to seek it out during visits to Melbourne. But the interior's success and street cred is evident even without knowledge of this. Original and dynamic, and the perfect three-dimensional advertisement for the stock within, the architecture can almost be heard.

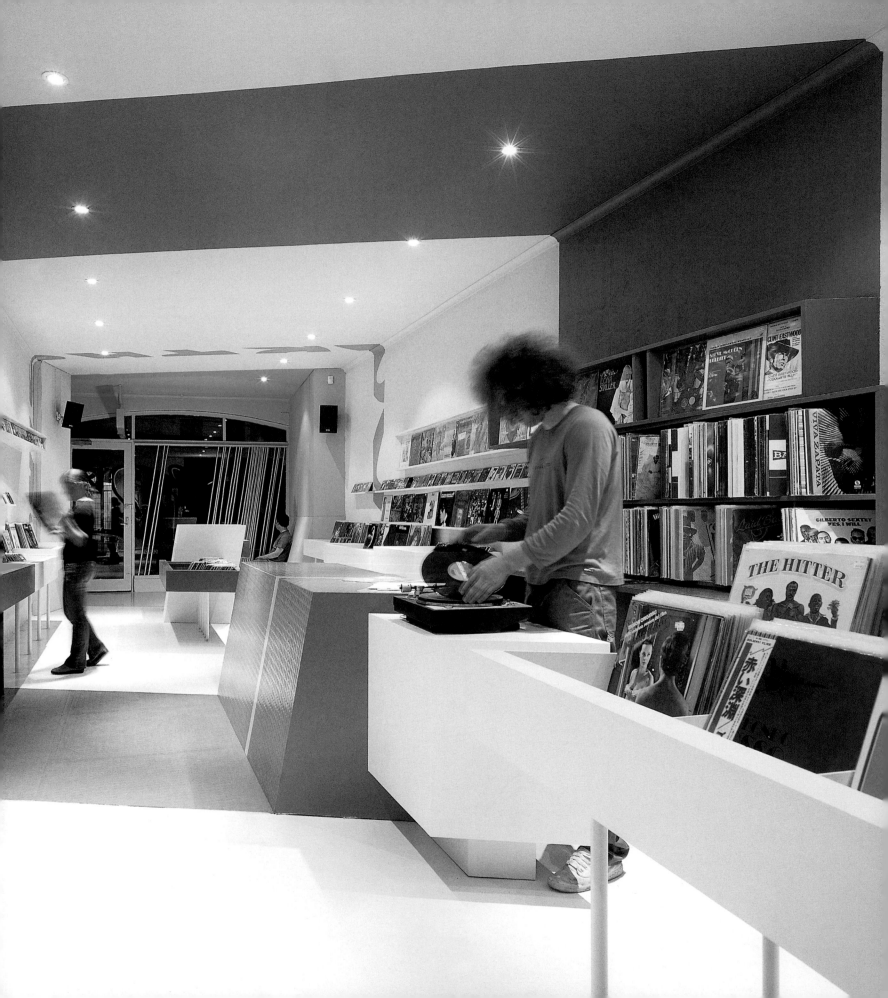

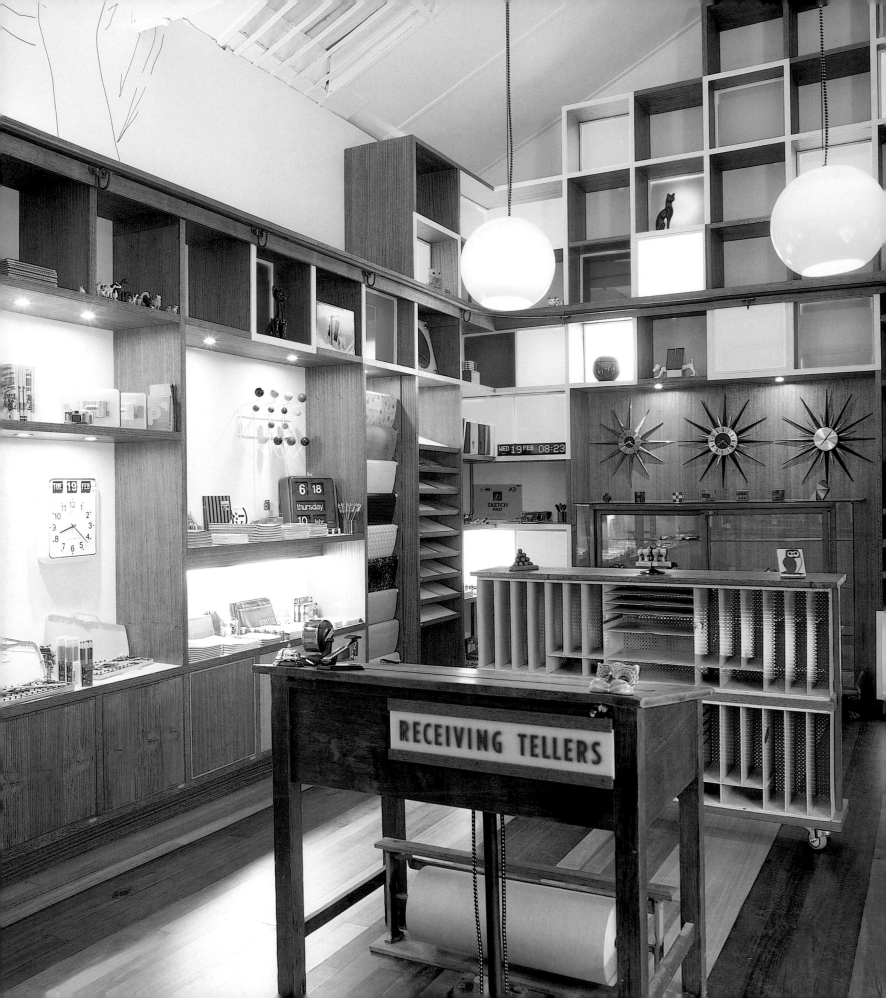

OTHER WORLDLY LIVES (OWL): NOSTALGIA TRIP

ANOTHER WORLD EXISTS JUST OFF ONE OF MELBOURNE'S TRENDIEST SHOPPING STRIPS. OWL IS A SMALL AND QUIRKY STATIONERY-CUM-MUSIC STORE – A COLOURFUL AND ECLECTIC ENVIRONMENT SELLING A SURPRISING COLLECTION OF OBJECTS REFLECTIVE OF THE 1950S, '60S AND '70S. IN THIS ENCHANTING, NOSTALGIC WONDERLAND, IRONY LENDS A HAND IN THE RETELLING OF HISTORY FROM A CONTEMPORARY PERSPECTIVE.

text Narelle Yabuka **photography** Ben Glezer **designer** Fat 4 Pty Ltd (Sarah Hamilton, Rachael Cotra, Kym Purtell, Bianca Wiegard) in collaboration with Amanda Moore **design team** Sarah Hamilton, Amanda Moore, Chris Summons **key materials** striped "skinny wood" flooring, Victorian ash veneer, glass panels, adhesive-backed vinyl, antique textured glass, steel railing, antique library ladder, retro cabinets and furniture **floor area** 35sqm **location** Shop 2, 30 Chatham Street, Prahran, Melbourne, Australia. P (61) 3 9510 6077

Nostalgia is often regarded as a bittersweet indulgence, marked by its inherent conflict of a warmly recalled past that – despite the most sentimental of yearnings – cannot be brought into the present. Such lamentation for people, places or things lost in the past sometimes points towards a sense of dissatisfaction with the present, and is quite able to distance the nostalgically inclined from the contemporary world. If a nostalgic outlook is linked, however, to a sense of the irony that pervades it, then the view to the past can become more relevant to today. And, the sentimental lamentation of a time lost might even take on a comedic slant.

Such seems to have been the realisation of Melbourne-based retail group Fat 4, who, after having established a line of clothing and accessory stores, have turned to a new kind of retail venture. "OWL [Other Worldly Lives] is unlike any other retail space, mixing old-school library, music store and stationer," explains Fat 4 member Bianca Wiegard. "It is a nostalgic trip through the 1950s, '60s and '70s," she elaborates, for people who might like to "bang on a glockenspiel, draw with an unusual pencil, or use a sundial to tell the time."

Beyond the nostalgic delight of these quirky pieces, there lies an amusing irony in the manner of presentation of the objects. OWL was born as a visual and spiritual antidote to today's sterile, homogenised supermarket-style retail spaces for stationery and other goods. The shop's configuration as a pigeon-holed old-world library, complete with an antique rolling library ladder, pokes fun at the contained collection of "historic" objects, while also establishing a "fantasy" theme through the recreation of the past, along with a spirited, more contemporary-style use of colour and light. The shop's own moniker adds to the library imagery through association with the nursery rhyme character the "wise old owl", which also conveniently hints at the wisdom behind the enterprise.

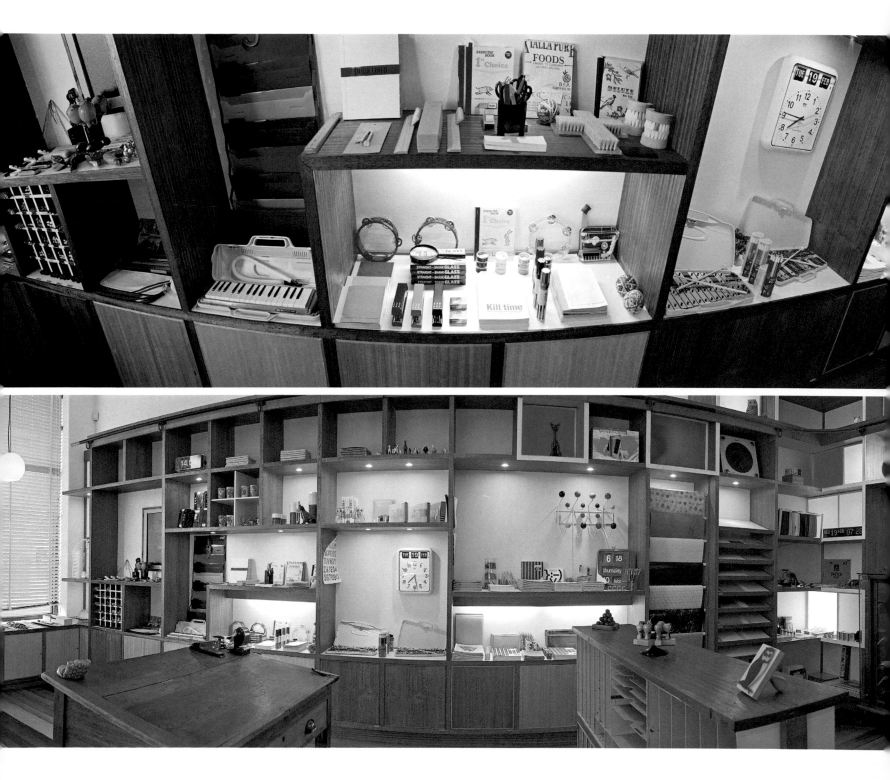

The shop is located on a gritty Melbourne side street, just off the busy shopping destination of Chapel Street in Prahran. From behind a large window set in a facade painted with pale retro-green coloured paint, a conglomeration of pink, yellow and timber hues screams out through mint-green Venetian blinds onto the footpath. The intention was that the interior would entice blinkered pedestrians off the street, as would a gingerbread house, drawing a smile in the process. Another world awaits inside.

The pigeon-hole shelving covers the three unglazed walls, reaching up seven metres in height at its peak on the rear wall. The shelving arrangement not only maximises the small floor area of the shop, but also induces the impression of a "wonderland" full of nooks and crannies waiting to be explored. Many of the pigeon-holes are back-lit by fluorescent tubes through coloured glass in various shades, creating a multifarious rainbow-like effect, and highlighting the unusual products on sale. Halogen downlights set into the shelves provide further illumination. Adding to the eclectic feel, the timber veneer that clads the shelves has been finished with various shades of stain. The timber floor is similarly stained in bands down its length.

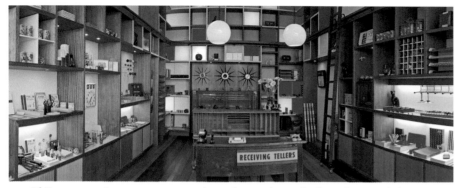

OWL was born as a visual and spiritual antidote to today's sterile, homogenised supermarket-style retail spaces for stationery and other goods. The shop's configuration as a pigeon-holed old-world library, complete with an antique rolling library ladder, pokes fun at the contained collection of "historic" objects.

The deliberate diversity designed into what is typically a generic, standardised display and storage system reflects the crux of the OWL rationale. With the presentation of quirky, nostalgic artefacts in a playful manner, the OWL interior calls to mind the enchantment of fairy tales. The invocation of an old-world environment, given a contemporary slant through use of vibrant colour and arrangement (and tongue-in-cheek details such as the "receiving tellers" sign on the old school desk-turned-sales counter) links the past to the present through a satisfying sense of irony. "OWL is a stationery store-cum-nostalgia trip," says Wiegard, "and it's got a whole lotta soul."

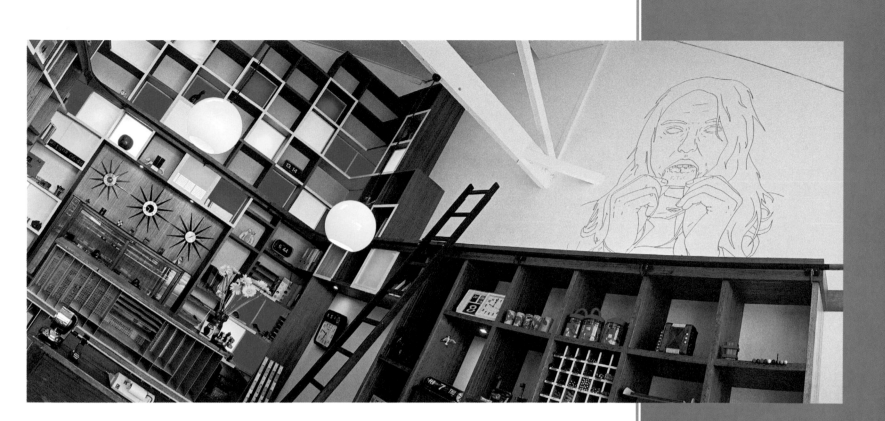

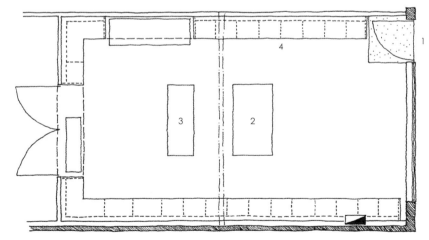

floor plan

1. entrance
2. sales counter
3. wrap counter
4. display shelves

PAGE ONE:
READING SPACE

PAGE ONE BOASTS A CHAIN OF BOOKSTORES IN THE ASIAN REGION. AT ITS HONG KONG CENTRAL OUTLET, VISUAL ENGAGEMENT BETWEEN THE INTERIOR AND EXTERIOR REIGNS, PROVIDING CONTEMPLATIVE CITY VIEWS TO SHOPPERS, AND COAXING PASSERS-BY TO ENTER. AND WITH SPECIAL TOUCHES THAT EVOKE ASPECTS OF THE LOCAL CONTEXT, THE SHOP MANAGES TO FURTHER ANCHOR ITSELF TO THE NEIGHBOURHOOD.

text Catherine Cheung **photography** Kelley Cheng **architect** Kay Ngee Tan Architects **graphic designer** Page One Publishing Pte Ltd **main contractor** Thomas Lo Contracting Ltd **m&e consultant** E-Tech Services Ltd **lighting consultant** Chris Mok of Spectrum HK **key materials** stone tiles, ceramic tiles, timber flooring, bamboo shelving panels, plywood, laminate, timber ceiling panels, artificial silk **floor area** 500sqm **location** 2/F, Century Square, 1-13 D'Aguilar Street, Central, Hong Kong. P (852) 2536 0111

In the cut-throat retail environment of Hong Kong, success is largely a matter of getting noticed. All retailers, whether they sell apparel, shoes or home products, are fighting to be noticed in a city that is simply packed with shops, shops and more shops. Even the business of book selling cannot escape from this battle for customer attention. After all, it is whether a shop is noticeable to the passer-by that accounts largely for its success or, in the less fortunate case, failure.

So, despite being situated within close proximity to the buzzing Lan Kwai Fong district, the upstairs location of this Page One bookshop does not initially instill confidence of success. It is tucked away on the first floor of an office block, and to get there, customers must climb several steps before arriving the lobby, and then travel up a spiral staircase on the right. Essentially, there is no shop front to walk past. The only way to tempt customers inside is through the shop's aperture to the outside world – its windows.

Often, spaces with too many windows are avoided by bookshop planners, primarily due to the loss of wall surfaces for the display of stock. But architect Kay Ngee Tan has used this window-lined space to Page One's advantage. By leaving all the windows unhindered, Tan has simply allowed the shop to glow like signage. When the shop is illuminated at night, its skin of transparent glass reads like a gigantic lantern. During the day, the windows act like a framed frontage, creating a dialogue between the passer-by on the street and the happenings inside. Either way, the facade is able to draw people's eyes with its unobtrusive treatment.

Often, spaces with too many windows are avoided by bookshop planners, primarily due to the loss of wall surfaces for the display of stock. But architect Kay Ngee Tan has used this window-lined space to Page One's advantage.

Seats are arranged along the openings in a bid to capitalise on the natural light that streams into the space. They also offer customers transient perspectives into the urbanscape, and a visual break as they move through the orderly bookshelves. As Tan explained, the views out from the interior and in from the exterior are very much the key of the design concept.

A new wall-shelf design was devised to help accomplish these views. The shop was sliced into two halves vertically, establishing an uninterrupted visibility across the shop, which allows exterior views to penetrate even to the rear of the space. A variety of display arrangements was also enabled by this ingenious idea – on the lower shelves, books can be placed with the spine facing out, or in parallel to the wall to showcase the cover on the upper shelves. In between the two components, lights are fixed and books lie flat for ease of browsing and handling.

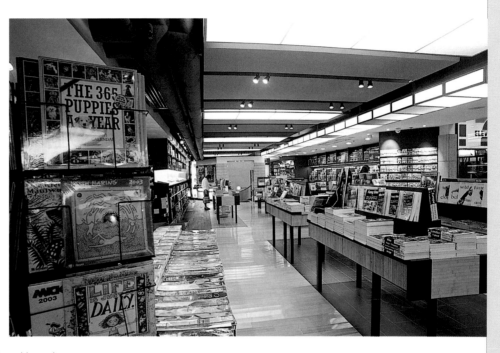

Despite being a regional chain, the shop manages to anchor itself to the neighbourhood with special touches that evoke aspects of the local context. For example, the smaller footprint prompted the designer to reconsider the design of the display shelves, which were thus redesigned based on the form, proportion and aesthetics of Ming dynasty furniture pieces. The sober palette of dark-stained bamboo and grey laminate were aptly chosen as a backdrop to the colourful book covers.

Rather than employing eye-catching signage on the exterior, signs are used internally to denote different territories. Scattered throughout the shop at strategic locations, such as at the cashier, they from another layer of interest which adds to the visual excitement of the site. The facade of the shop might have been downplayed, but the wow factor needed to capture customers was certainly not lost.

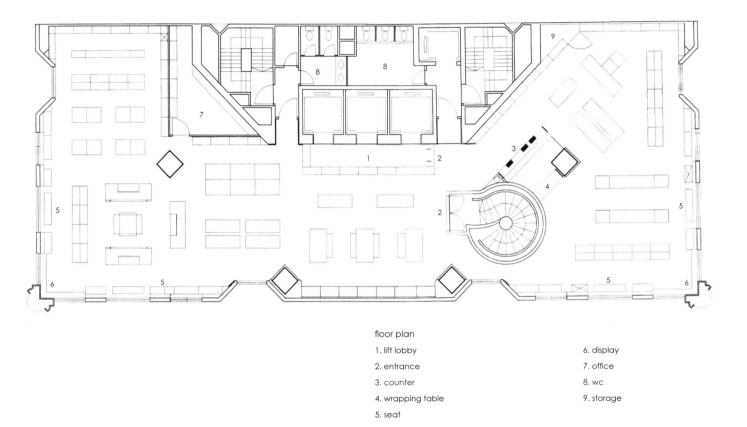

floor plan

1. lift lobby
2. entrance
3. counter
4. wrapping table
5. seat

6. display
7. office
8. wc
9. storage

Seats are arranged along the openings in a bid to capitalise on the natural light that streams into the space. They also offer customers transient perspectives into the urbanscape, and a visual break as they move through the orderly bookshelves.

PROJECTSHOPBLOODBROS:
ENCOUNTERING COOL

A SENSE OF DISCOVERY PREVAILS WITHIN SINGAPORE FASHION STORE PROJECTSHOPBLOODBROS, WHERE AN ECLECTIC INTERIOR REFLECTS THE HIP, RELAXED HEART OF THE PROJECTSHOP BRAND. A DELECTABLE CAFE AT THE REAR ENTICES CUSTOMERS TO TAKE A BREAK FROM THE RETAIL CIRCUIT, REINFORCING THE PLEASURABLE ASPECTS OF CONSUMPTION, WHILE ALSO SUCCESSFULLY CONSOLIDATING THE BRAND IMAGE THROUGH BOTH INTERIOR AND CULINARY DESIGN.

text Narelle Yabuka **photography** Gilbert Chua, Kelley Cheng **design and concept** projectshopBLOODbros **project team** Richard Chamberlain, Peter Teo, Philip Chin **interior consultant** Aamer Taher Studio **main contractor** Tarkus Interiors Pte Ltd **key materials** hollow brick, mild steel grille and gate, plywood and galvanised steel hanging fixtures, galvanised steel racking, brushed steel counters, tempered glass, timber preparation counters, teak display cabinets and tables **floor area** 200sqm **location** 290 Orchard Road, #02-20 Paragon Shopping Centre, Singapore. P (65) 6734 7209

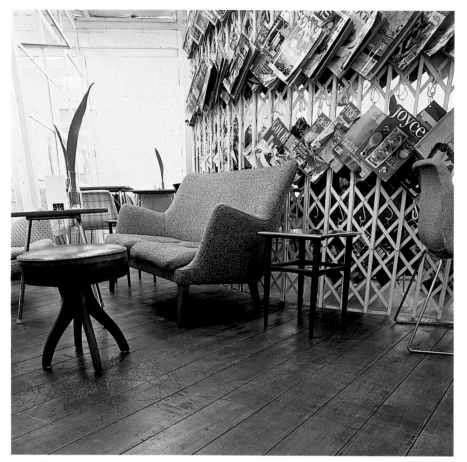

Themed in design to suit the casual nature of the projectshop brand, the cafe appears like a little surprise at the rear of the shop space – unexpected, yet soothing with its intimate, homely atmosphere.

There can be little argument against the fact that shopping has become a pastime in today's global developed world. Shopping spaces have become leisure spaces – sites for the seeking of pleasure, where, nevertheless, competition between brands is a matter of utmost seriousness. It requires foresight indeed on the part of the retailer and the retail designer to achieve a selling space that stands out from the crowd. And if the customer can be gratified as well as seduced during their visit, then their experience of the brand is likely to be that much more memorable.

The projectshopBLOODbros store in Singapore's exclusive Paragon shopping centre certainly leaves a lasting impression. Even better, it offers a pleasant place to spend time. In fact, it is a sought after hang-out destination, thanks in no small way to a cafe within the store. Themed in design to suit the casual nature of the projectshop brand, it appears like a little surprise at the rear of the shop space – unexpected, yet soothing with its intimate, homely atmosphere and flavoursome, home-style dishes. Its presence has brought a significant level of dynamism to the store interior, in terms of both visual and functional diversity, and traffic flow. The cafe's popularity has even been known to generate a waiting list for tables – surely evidence of a satisfied customer base.

Fashion is the primary fodder of projectshop, however. The Singapore-based design partnership says its products reflect "an easy, laid-back metropical existence", with design inspiration drawn "in equal measure from the craft of regional artisans and the demands of our modern global nomadic society." It naturally follows that projectshop would wish their retail spaces to maintain a casual feel. At the Paragon store, the aim was to provide for a shopping experience that would not stifle or dictate to customers, but allow them to make their own discoveries. As such, a fusion of design styles and an abundant display of stock define the store interior, creating a laidback environment where customers are encouraged to explore at their own pace.

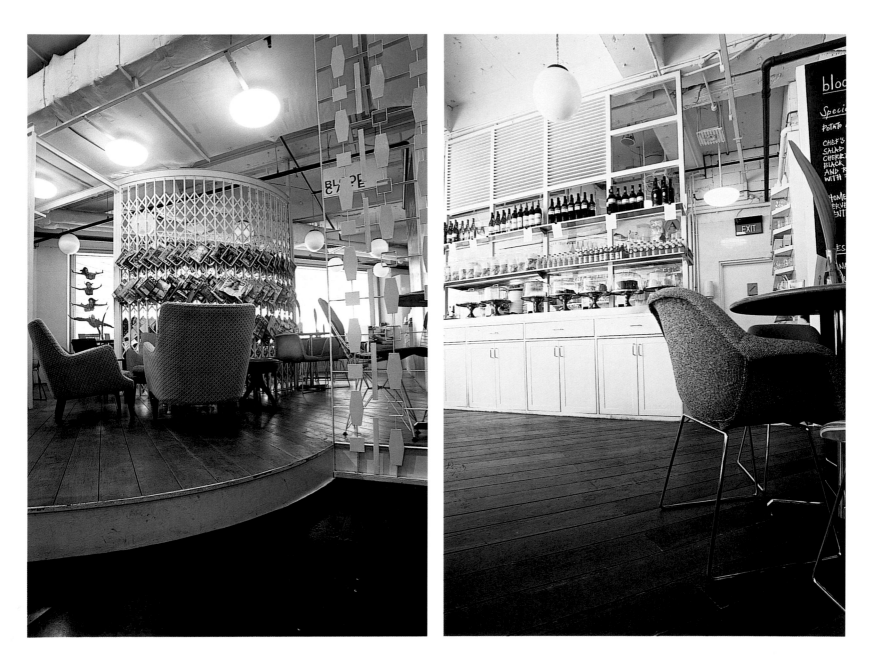

The primary inspiration for the space was the idea of a home, which is by nature casual and relaxed. Industrial and retro themes have been fused with this, adding a hip and raw edge. Exposed ceiling ducts and conduits, unrendered concrete blocks and oxidised steel flooring sheets hint at the urban transience at the heart of the brand. Simultaneously, lightweight display systems and screens, and loose scattered furniture notion towards the brand's carefree tropical soul. Steel display racks climb the full wall height in a staggered arrangement, echoing both the exposed services on the ceiling, and the retro metal grilles. Loose furniture and custom-designed racks are scattered casually through the central shop area, prompting a sense of the unexpected.

A round-edged, raised timber floor denotes the realm of the cafe, where an eclectic collection of retro furniture provides a comfortable point of respite for the weary shopper. A centrally placed, rounded metal grille serves a dual purpose – it functions as both a hanging rack for an immense magazine collection, and as an enclosing screen, continuing the design discourse of discovery. Beyond it, customers are treated to a glimpse of the streetscape below – a rare occurrence in the typically inward-looking environments of most shopping centres.

The feeling of discovery as one traverses through the store, and finally, discovers the cafe, can make for a memorable encounter indeed. The experiential aspect of a personal journey of discovery can certainly leave a mark on one's mind. And aside from the cafe's power to increase traffic flow through the store, it is successful also in its reinforcement of the concept of the project-shop brand – relaxed yet hip, and unquestionably cool.

floor plan

1. entrance
2. mild steel grille
3. storage
4. mild steel racking system
5. changing rooms
6. service counter
7. cafe
8. preparation counter
9. kitchen

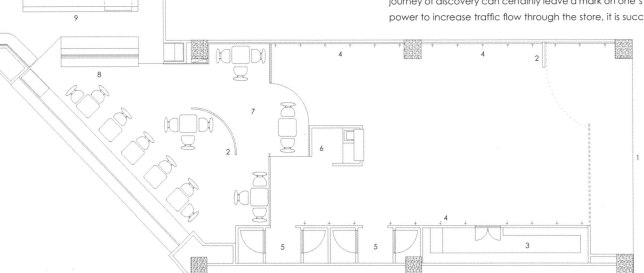

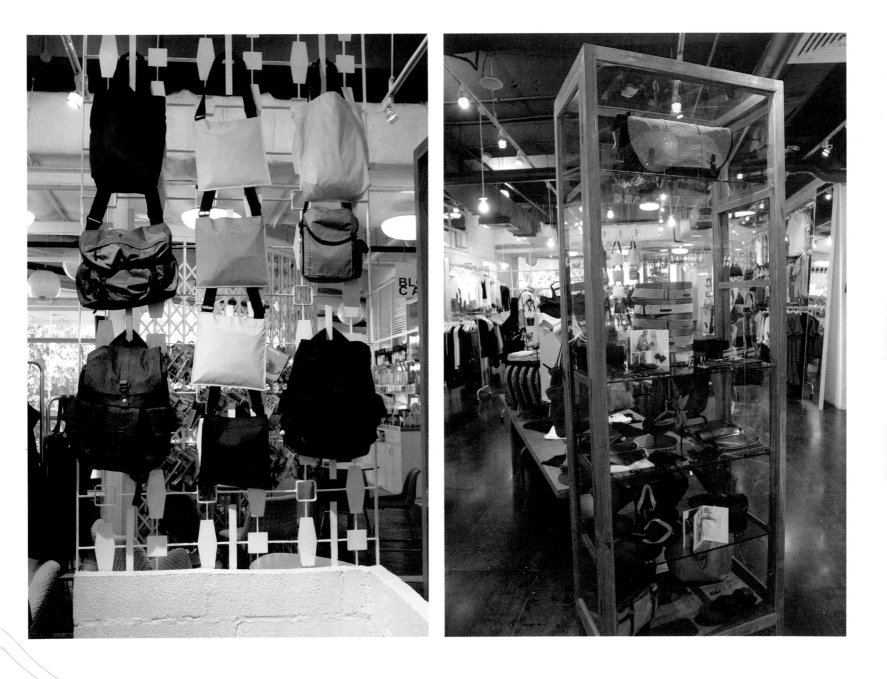

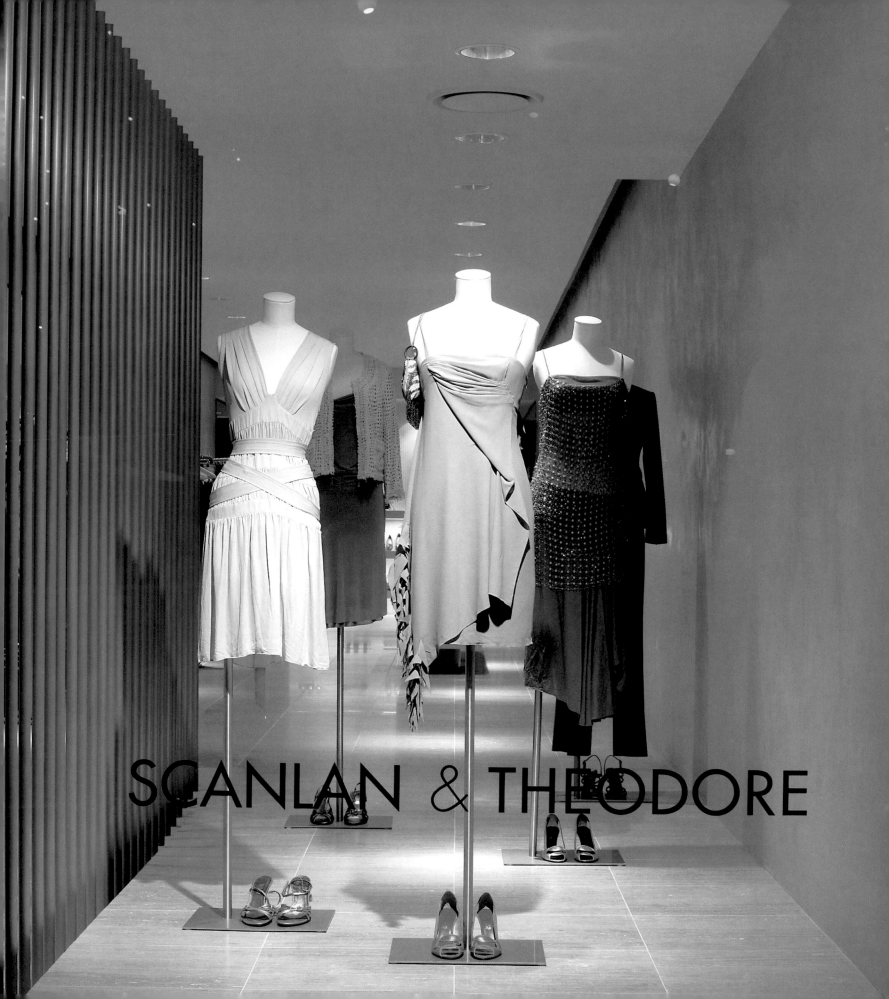

SCANLAN & THEODORE

SCANLAN & THEODORE:
CURIOUSLY BEAUTIFUL

THERE CANNOT OCCUR MANY INSTANCES WHEN RETAIL SPACE DESIGNERS ARE ABLE – EVEN ENCOURAGED – TO DESIGN AN ENVIRONMENT OF REDUCTION, RATHER THAN ONE THAT MAXIMISES THE POTENTIAL FOR VOLUMINOUS DISPLAY. WHEN AUSTRALIAN WOMEN'S FASHION LABEL SCANLAN & THEODORE APPROACHED DAVID HICKS TO DESIGN A NEW PERTH STORE, HE FOUND HIMSELF CREATING A SANCTUARY OF CURIOUS, SPARSE BEAUTY.

text Narelle Yabuka **photography** Robert Frith **designer** David Hicks Pty Ltd **main contractor** Time Projects **furniture supplier** DeDeCe **key materials** hand polished plaster, honed travertine, mirror, pewter **floor area** 115sqm **location** 36 Bayview Terrace, Claremont, Perth, Australia. P (61) 8 9385 4747

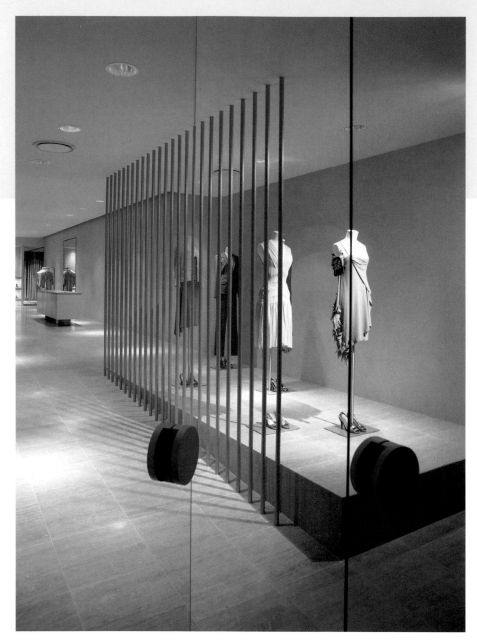

When it comes to the competitive world of retail space design, a brand must have a solid reputation indeed before it can dismiss the need for attention-grabbing signage and flashy interior elements, leave its competitors to do the haggling, and rely solely on its product to entice customers off the street and through its doors. Melbourne-based women's fashion label Scanlan & Theodore commands such enviable respect in Australia, and for the design of its new store in Perth, designer David Hicks took the chance to strip retailing back to its fundamentals.

Since its founding in 1987, Scanlan & Theodore has established itself as a fine purveyor of sophisticated and elegant clothing, shoes and bags, and is enjoying a rising international status. Influenced by art, the label's collections are also characterised by a fascination with the past, but are coloured with a hint of subversion. Creative director Gary Theodore describes his designs as "curiously beautiful", and says his collections appeal to women who are confident and feminine, with a strong sense of style. Drawing on a thorough understanding of the label's design ethos and customer base, Hicks has rendered an eloquent interior for the Perth boutique that seems the perfect translation of its essence into built form.

The store enjoys a space on one of the most desirable fashion retail streets in Perth. Tree-lined Bayview Terrace, in the plush riverside western suburb of Claremont, is a favoured pilgrimage point for many of Perth's most fashion-savvy residents. A combination of high-end and mainstream outlets compete along its length for customers often garishly and with the traditional approach of maximising the number of goods on display. In stark opposition to this approach, Scanlan & Theodore wanted to create – above all – space.

The brief issued to Hicks stipulated the eradication of all built-in clothing display units, and instead, the use of the signature Scanlan & Theodore stand-alone, organic-shaped racks, in order to achieve maximum exposure of the pieces. This would allow each item to "breathe" and take on a life and form of its own. The wish to minimise the retail environment was a bold move, but Hicks has achieved a most successful result, instilling the shop space of number 36 with an air of peace and a promise of respite.

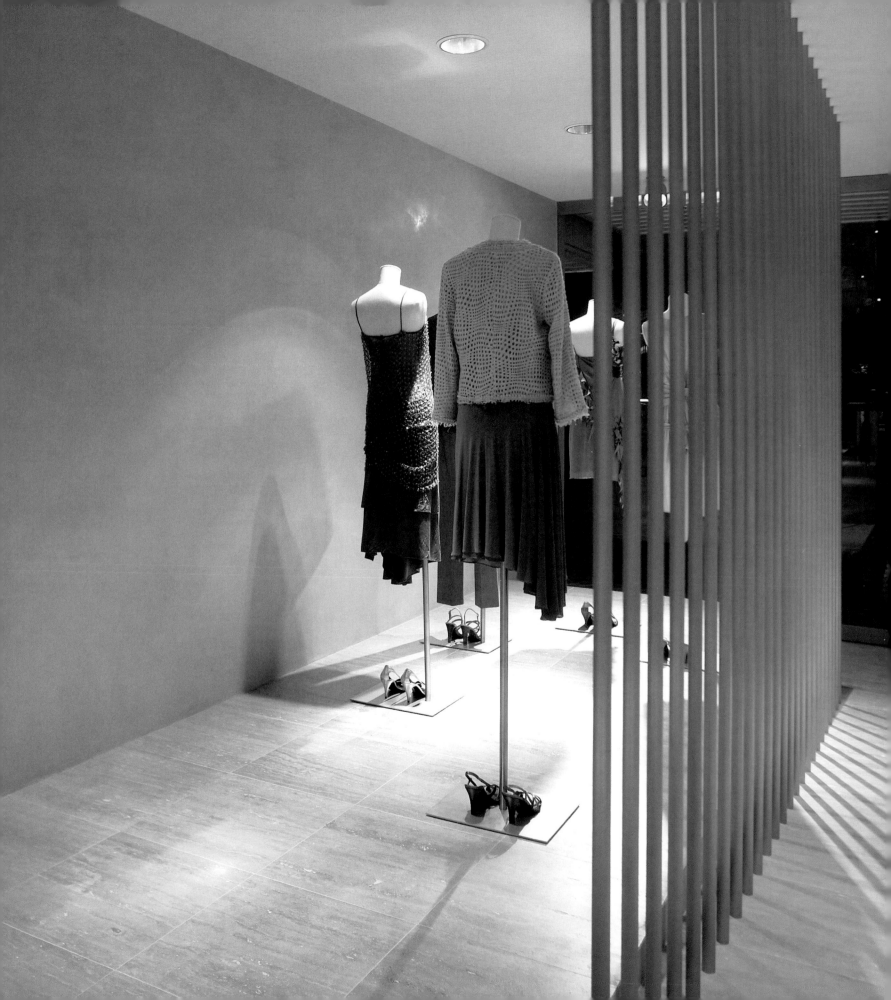

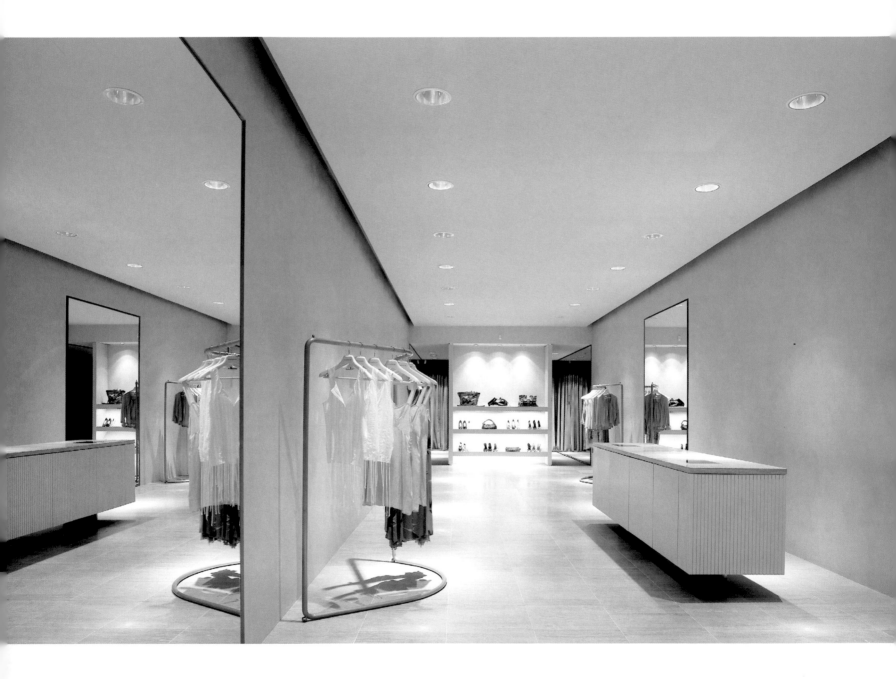

The presence of a sanctuary is evident from the footpath. The store's street front is itself an exercise in reduction – composed merely of a skin of glass flush with the building edge, and unadorned besides a small, unfussy rendition of the brand logo, two circular door handles, and a pewter trim to the glass doors. In replacement of the recessed entry doors common to the neighbours, the floor inside the footpath-edge doors ramps up gently to the merchandise floor height, providing the customer with a smooth transition into a space that is clearly disassociated from the street's bustle. The ramp skirts a tubular pewter feature screen that in turn edges the window display area. Visibility through the screen alters as it is passed by, gradually revealing (in a spatial manner) the display mannequins that are staggered along its length.

Signature muted earthy tones compose the slick interior. Hand-selected Italian travertine marble adorns the floor, while bare walls are treated with polished plaster, providing a subtle backdrop to the freestanding pewter-finished racks. The sales counter unit floats mysteriously within the space, cantilevering over two concealed supports. Shelves at the rear house a separate shoe and accessories display area. Their sharp illumination provides an alluring draw for the eye, and seems to dissolve the rear wall of the merchandising space. Beyond, the change room area is a haven lined with full-height mirror, luxurious velvet curtains, and ribbed timber wall panelling finished in a matt nude-coloured paint.

Scanlan & Theodore carries itself with the air of a sumptuous gallery, rather than a retail outlet. The creation of "space" rather than visual bombardment was a bold move that has spawned a very unique retail environment. This is an interior that accentuates the creations housed within – existing quietly as a quality backdrop to the exquisite workmanship of each Scanlan & Theodore item.

This is an interior that accentuates the creations housed within – existing quietly as a quality backdrop to the exquisite workmanship of each Scanlan & Theodore item.

167

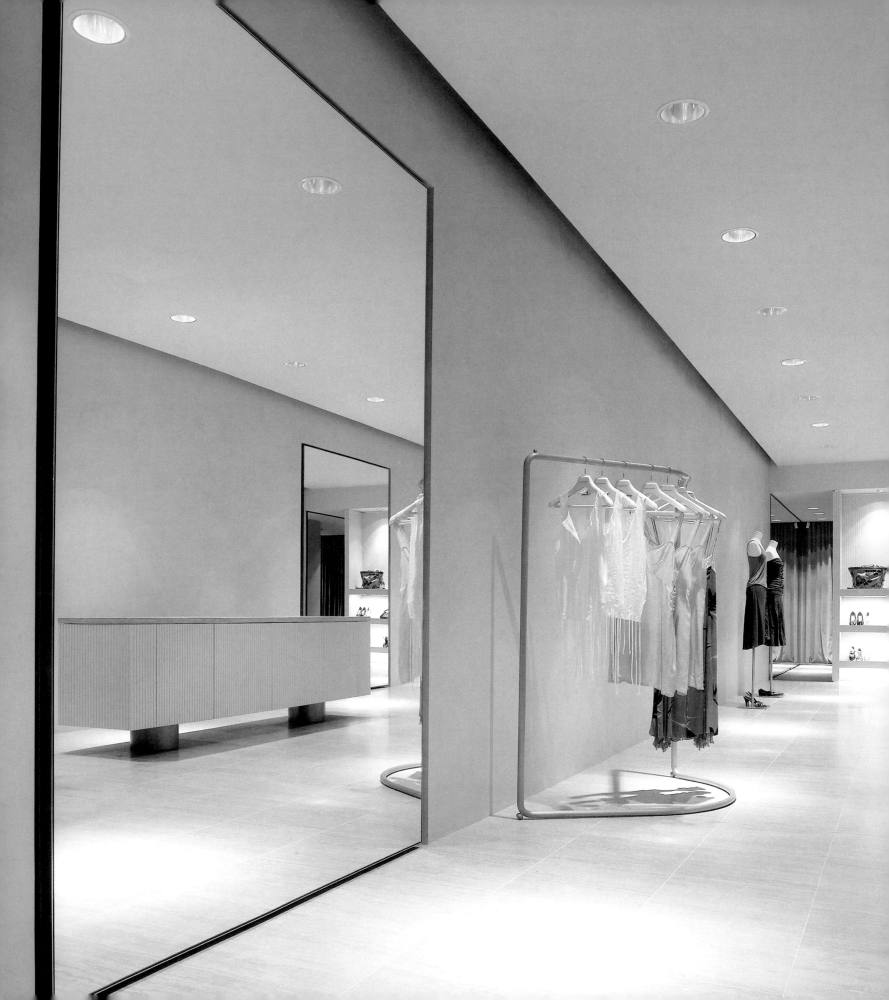

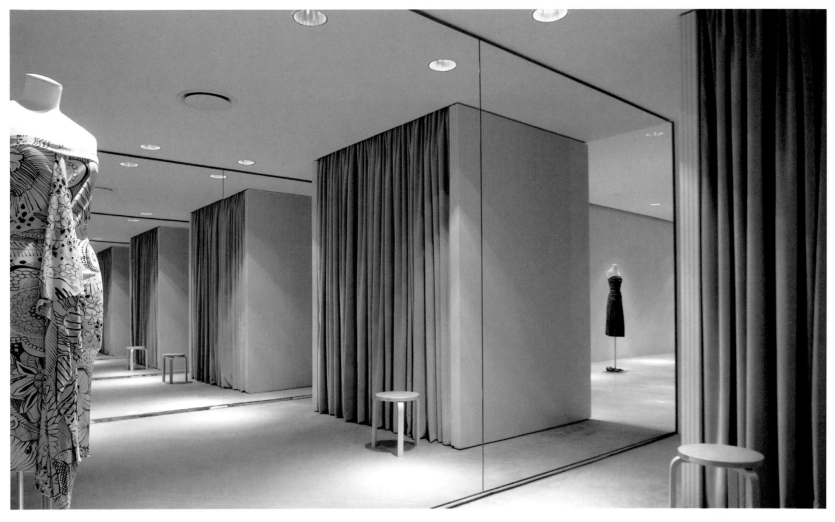

The wish to minimise the retail environment was a bold move, but Hicks has achieved a most successful result, instilling the shop space with an air of peace and a promise of respite.

floor plan

1. entrance
2. ramp
3. display rack
4. service counter
5. changing rooms

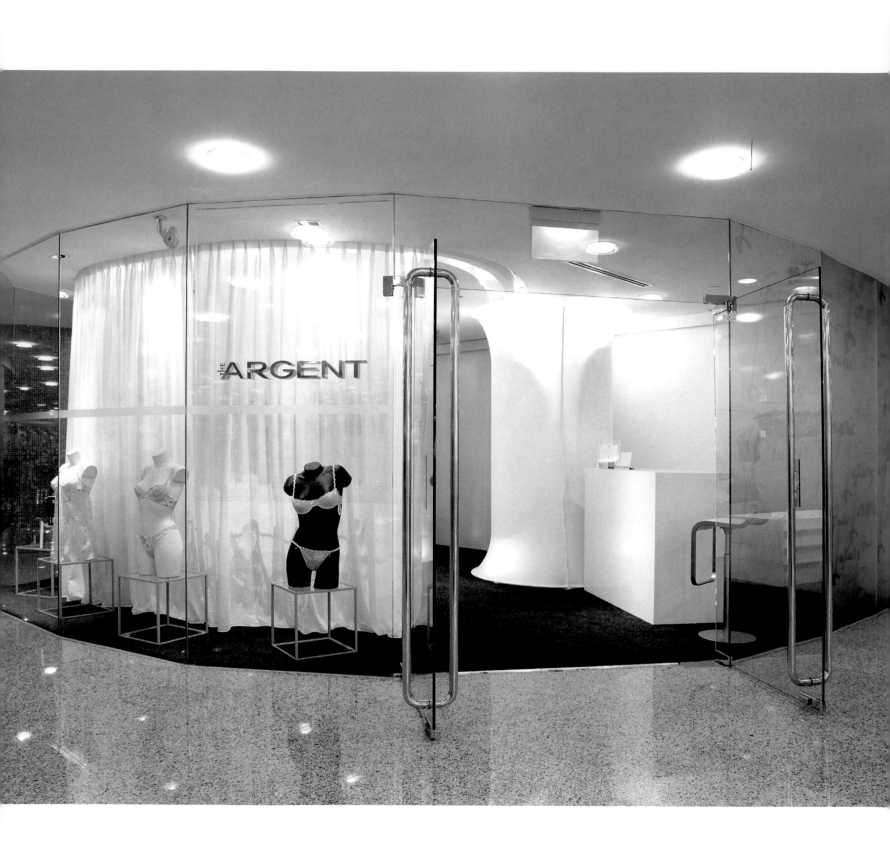

THE ARGENT:
CURVACEOUS, COURAGEOUS

A DOSE OF FEMININE SEDUCTION HAS MADE ITS PRESENCE FELT IN THE WHEELOCK PLACE SHOPPING CENTRE ON SINGAPORE'S ORCHARD ROAD. THE ARGENT, A NEW LUXURY LINGERIE BOUDOIR, IS A TEASING CONFIGURATION OF CURVES ARRANGED TO REVEAL THE INTERIOR IN WAYS THAT ARE BOTH SHY AND UNABASHED.

text Sabrina Koh **photography** Tim Nolan (courtesy of CUbE Associate Design Private Limited) **designer** Sarah Tham at CUbE Associate Design Private Limited **graphic designer** Grafitti International **main contractor** Everlasting Design and Contracts **curtain and fabric supplier** M&L Furnishings **signage** Signlab **key materials** sheer fabric, stretched fabric, stainless steel, laminate **floor area** 30sqm **location** 501 Orchard Road, #03-17A, Wheelock Place, Singapore. P (65) 6737 1812

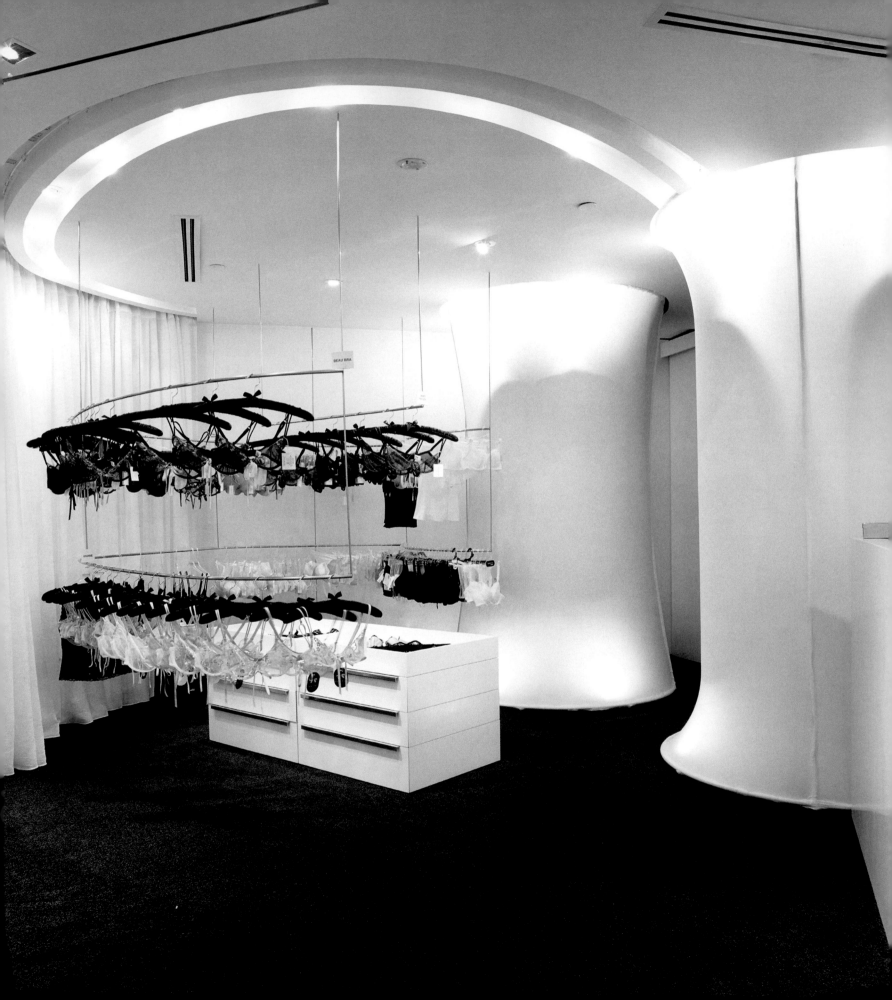

Romanticism is making a comeback, and love is in the air… What could be more fabulous than indulging oneself in a paradise of sexy lingerie? Responding to the cries of Singapore's lingerie-hungry women, The Argent has brought with it from France a closet full of specialty brands to curve snugly around our sensuous contours.

Located within the beautiful architectural cone of Wheelock Place, the site commands the mind to bloom and vivid fantasies to flow. It is no wonder that a detailed and unique interior design scheme was adopted for The Argent, to further engage the imagination. Even though this is a modestly-sized boutique, its sizeable visual impact comes from its sinuous interior: the organic, almost cocoon-like space, and the interaction with fabrics encouraged within. And, to the credit of CUbE Associate Design, it only took a month for this bombshell to hit the town!

Femininity. Stretching seductively, sheer and opaque upholstered curvilinear panels create a sexy hourglass feel. Dark grey-carpeted flooring runs through the padded boudoir, gracing the soles of distinguished patrons. And to fit the building's organic structure, floating stainless steel frames were specially designed. Designer Sarah Tham amplified the small, luxurious boudoir by carefully playing with the contours and materiality. "Choosing an appropriate fabric for the hour-glass changing rooms, and [deciphering] the fabrication process presented me with a great design challenge!" she explains.

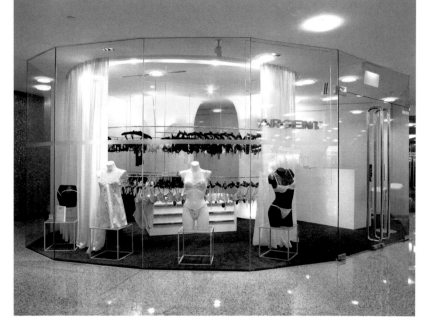

Even though this is a modestly-sized boutique, its sizeable visual impact comes from its sinuous interior: the organic, almost cocoon-like space, and the interaction with fabrics encouraged within.

The Argent, in all its deliciousness, projects a spatial importance that is both well endowed and luxuriously proportioned – pun intended.

Femme-ininity. The flowing circumference of the shop enriches the open interior with sheer draw-curtains, acting both as a backdrop and a partition to maximise form and function. The curtains also function as a filter to the intense "exterior glare". Tham explains with a girlish laugh, "When we were styling and dressing up the unit, it attracted a lot of attention from the male staff." In the context of interior design, it is always desirable to find serenity in a space. It may seem oxymoronic in this case though, as one could feel a little awkward with two rigid IT showrooms overlooking the space. But with the deft art of reverse psychology, The Argent is ready to challenge this concept. The persistent stares of onlookers can in fact invoke a resulting sense of feminist pride that actually borders on domination.

Nevertheless, it may take a chest full of courage for some to step into this private unit, past selections of cup sizes and adjustable G-strings that can be admired freely from the shop's perimeter. Indeed, the circular lines of suspended clothes racks provide a perfect frame for Peeping Toms. And if one were to look at The Argent from plan view, it almost seems like an abstract bra, sitting gracefully within the building. (What else could the two adjacent circular changing suites symbolise?)

But, could you imagine going through life without a piece of sexy lingerie to call your own? It is simply one of those things that women yearn to have and men fantasise over. And sometimes vice versa too. Whatever the reason, a certain therapeutic effect is sure to engulf you once you enter The Argent and become the proud owner of a few desirable new underthings. The Argent, in all its deliciousness, projects a spatial importance that is both well endowed and luxuriously proportioned – pun intended.

floor plan

1. entrance
2. curtain
3. window display
4. hanging rail
5. display cabinet

6. fitting room
7. waiting corner
8. cashier counter
9. storage cabinet

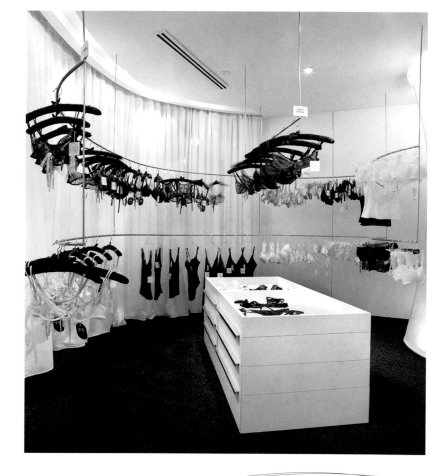

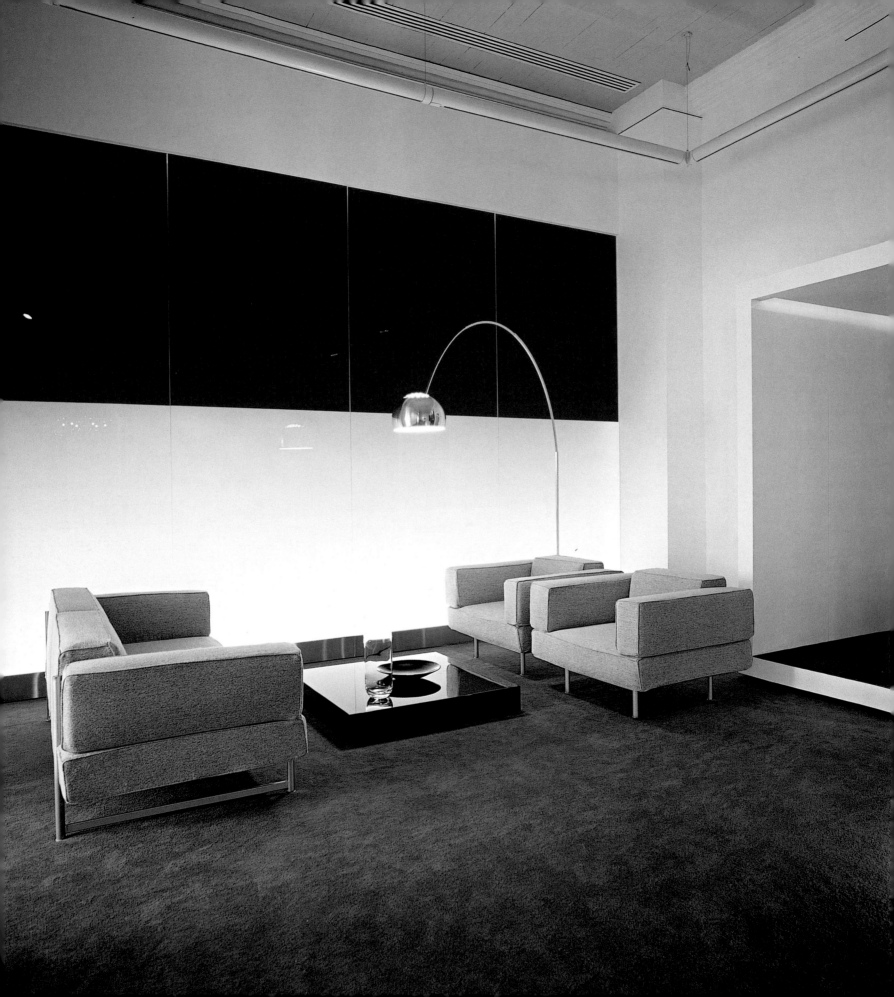

THE SPA-LON:
PEACE PROCESS

INNER PEACE IS CLOSE AT HAND FOR SPA-GOERS IN SINGAPORE. DESIGNER PETER TAY HAS CRAFTED FOR THE SPA-LON AN INTERIOR CONDUCIVE TO REJUVENATION AND THE ATTAINMENT OF INNER PEACE. IMPRESSIVELY, HE HAS DONE SO NOT THROUGH A TIRED REPLICATION OF THE SETTINGS OF RESORT SPAS, BUT THROUGH A THOUGHTFUL MINIMALIST APPROACH THAT IS CONSIDERATE TO THE SENSES OF THE PATRONS, THE ESTABLISHMENT'S FUNCTION, AND ITS UNIQUE SETTING.

text Narelle Yabuka **photography** Francis Ng **designer** Peter Tay (P 3) **main** contractor Grandwork Interiors Pte Ltd **key materials** frosted glass, timber, homogenous tiles, stainless steel
floor area 370sqm **location** 30 Victoria Street, #02-02/04/05, Caldwell House, Singapore. P (65) 6837 0131

Here, impressions of bliss, peacefulness and rejuvenation are elicited not by a heavily applied interior skin of stone, timber and water features, but rather by a composition of precision and clarity.

Whether it exists as a by-product of a more stressed, health-conscious society, or simply as a matter of "lifestyle" fashion, there can be no argument that there is today a noticeable trend towards spa culture. Spas have begun to appear in countless locations, from shopping centres, to urban hotels, to dedicated resort destinations, and even airports. In Singapore, a leader in the industry's phenomenal growth has been The SPA-Ion – a beauty and skin treatment centre that focuses on the medical, health and cosmetic sectors.

The company's new outlet in central Singapore's historic CHIJMES complex of buildings is one of its first to cater to both women and men, with separate zones for each. "A fresh new look" for the interior was asked of designer Peter Tay – something "modern" and different from The SPA-Ion's other outlets in Singapore. The outcome is a space that deviates entirely from the typical tropical theme applied to many spas in Asia. Here, impressions of bliss, peacefulness and rejuvenation are elicited not by a heavily applied interior skin of stone, timber and water features, but rather by a composition of precision and clarity.

Tay's minimalist design approach suited not only the agenda of his client, but also proved non-intrusive to the significant historical shell and context within which he was designing. Constructed in the 1840s, Caldwell House sits comfortably beside the Convent of the Holy Infant Jesus (from which the acronym CHIJMES was developed) and the convent's chapel. While the architecture of these buildings has been keenly preserved, their functions have certainly altered with the redevelopment of the complex, which now houses shops, lively bars and restaurants, and gallery spaces. Tay was determined not to usurp the existing interior architecture of The SPA-Ion's second-storey unit in Caldwell House. Instead, he wished to merely insert a new volume into the existing one, and do so in a manner that would not compete stylistically.

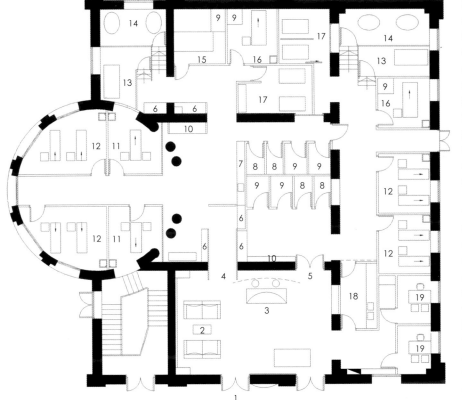

What results is a composition of simple rectilinear forms, rendered largely in a visually calm colour palette of white and grey, which seems to float lightly beneath the original ceiling and decorative architectural mouldings. With its expansive stretches of grey carpet, frosted glass and white-washed walls, its concealed lighting, and its fine detailing, the feeling of the space is almost clinical – a fitting impression when one discovers The SPA-lon's dedicated application of new technologies and products, such as an oxygenating sauna imported from the USA. As if to cheekily play up this perception of disciplined purity, Tay has enlivened the reception area with a clever treatment of the entrance to the women's section; beckoning like a spacecraft-inspired portal, a "floating" box on concealed supports, illuminated by strips of concealed overhead lighting, waits to transport customers to the realm of bliss beyond.

Tay has disallowed the clinical inclination to lend itself to notions of coldness or indifference, however. He has displayed a sensitive manipulation of colour, tactility and texture throughout – most strikingly in the reception area, where a back-lit feature wall of frosted glass, partly left translucent and partly coloured a vibrant red, injects a rich hue into the space. In the Jacuzzi and Chinese herbal tub rooms, warmly hued raised timber floors delight the eyes while comforting the bare feet beneath. In the showers and change rooms, homogenous tiles in a sandblasted granite look equally play a visual as well as functional role, providing a digression from the white and grey colour scheme. An extensive use of frosted glass throughout, for doors as well as screen walls, translates a notion of softness that speaks dexterously of the delicate procedures undertaken here.

floor plan

1. main entrance
2. waiting area
3. reception counter
4. entrance to female section
5. entrance to male section
6. storage
7. make-up counter
8. changing room
9. shower
10. locker
11. vip facial massage
12. facial massage
13. jacuzzi
14. chinese herbal tub
15. massotherm wrap
16. body massage
17. oxygenating sauna
18. kitchen
19. consultation room

A final reinforcement of the themes operating within The SPA-lon is the series of black-and-white photographs that adorn the walls of the treatment rooms. These large scale pieces, each portraying a view of timber at close range, cleverly establish a visual link between the grain of the timber and the contours of the skin. They also manage to incorporate a hint of the tranquility of nature – but in a fittingly abstract manner that does not belie the urban setting of the establishment.

THELIFESHOP:
A NEW ASIAN MANIFESTO

HOW DO YOU INTEGRATE FASHION WITH FURNITURE? THAT HAS BEEN THE QUESTION ON THE MINDS OF THELIFESHOP'S OWNERS. VENTURING INTO UNCHARTERED TERRITORY WITH THEIR NEW FLAGSHIP SHOWROOM, THEY DESIGNED A BEAUTIFUL LIFESTYLE STORE FOR THEIR LINE OF ASIAN FURNITURE AND HIP HOME ACCESSORIES, UNRAVELLING A FRESH ERA IN HOME FASHION.

text Ethel Ong **photography** Kelley Cheng **designer** Susie Tay and Liang **main contractor** Mason Works Pte Ltd **key materials** cement, handmade ceramic tiles, glass tiles **floor area** 420sqm
location 252 North Bridge Road, Raffles City Shopping Centre, #03-25, Singapore. P (65) 6338 3998

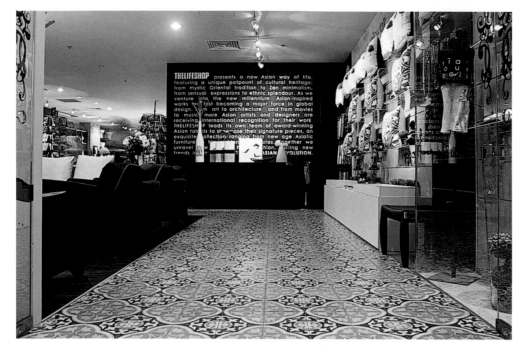

At the turn of the millennium, Asian-inspired works were fast becoming a major force on the global style circuit. From movies to music, art to architecture, more Asian artists' and designers' work was receiving international recognition. Since 1994, furniture retailer THELIFESHOP has been leading a quiet revolution to raise the awareness of "new Asian" designs in Singapore, exhibiting a unique potpourri of cultural heritage from Zen minimalism to the mystic traditions of the Orient, from the sensual expressions of India to the ethnic splendour of Indochina. Helmed by a team of Singaporean entrepreneurs, THELIFESHOP has become known for its exquisite collection of signature Asian pieces, ranging from timeless furniture to hip home fashion accessories.

Having built up a sizeable cult following over the last decade, THELIFESHOP opened a flagship showroom in conjunction with their ten year anniversary. Designed around the concept of a house, the showroom is comprised of a front and rear entrance, living room, dining area, open courtyard, and even a bedroom area. Each area of the homely showroom has been christened with a different nickname, including endearing terms such as "Flower Power", "Dressing Room", "Pillow Talk", "Night Life" and "Museum of Objects". The showroom also houses the "Gallery" – a wall space showcasing the work of local artists.

Not wanting to sell furniture in the manner of every other furniture shop, THELIFESHOP owners Susie Tay and Liang designed the showroom with a home fashion concept. Explains Tay, "With this new showroom, we went against all the formulas in the retail industry. We wanted to give a different experience. We pushed everything to the limit." Elements within were clearly dramatised. For example, right in the middle of the store, an oversized counter throws one's sense of proportion off balance, yet it anchors the surrounding elements impressively. Graphics carrying seasonal in-store trends fill the walls, adding a touch of zest.

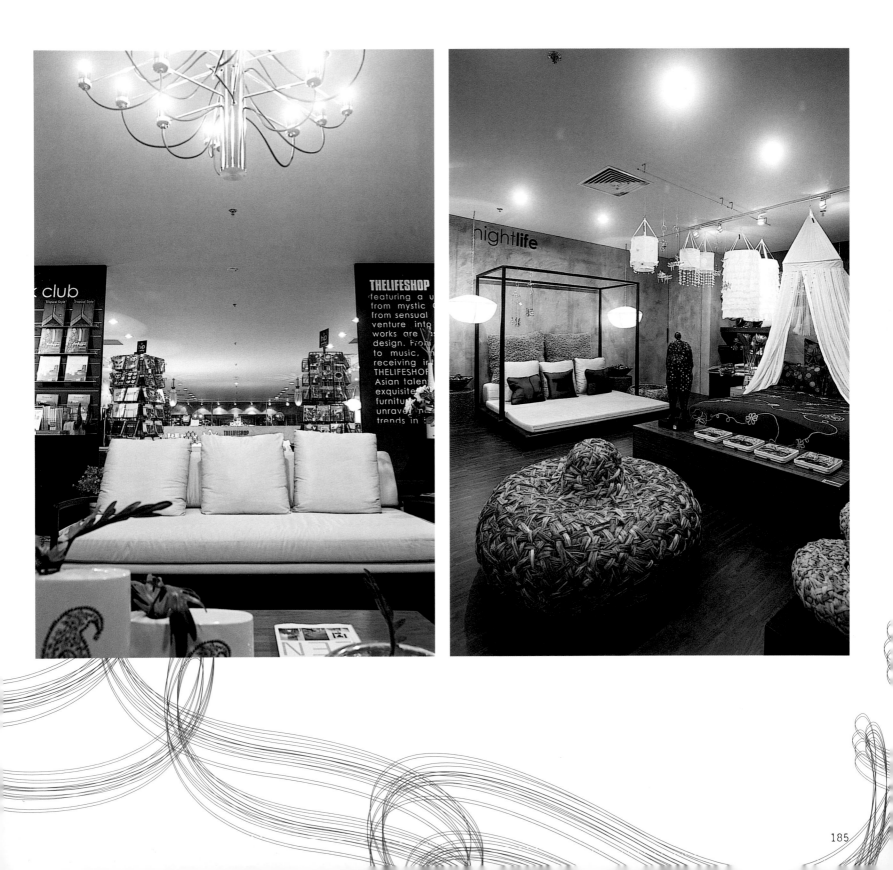

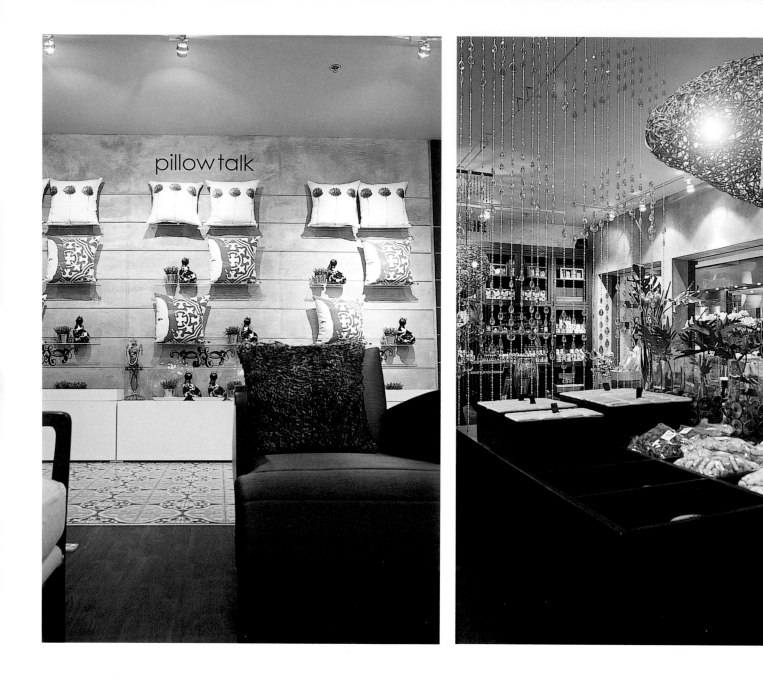

pillow talk

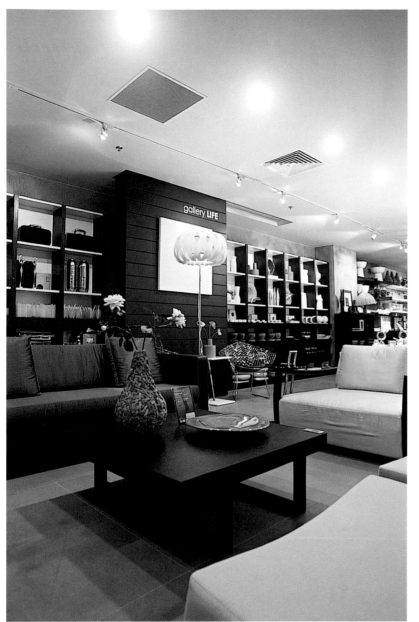

A fashionable bright pink wall in the front of the store sets the mood for the whole experience of the interior. Not chosen simply on a whim, the refreshing pink is really an embodiment of THELIFESHOP's motto – to be lively, exotic, creative, and happy. And while this hip showroom signals a new era in home fashion, it manages to retain a nostalgic charm. The owners painstakingly sourced a traditional Peranakan tile factory and had the store's floor tiles custom-made in THELIFESHOP's signature colours. This set the tone for the rest of the store design, with wall motifs and window appliques following the same floral pattern.

A keen attention to detail is evident – cut-outs in the glass entrance doors, for example, replace conventional door handles, adding an extra touch of ingenuity and uniqueness. The absence of door handles bestows visual fluidity and introduces the concept of inter-activity, allowing customers an uninterrupted view inside and out. The store's signature floral motif flows through to the entrance doors, wrapping up the store's design in a pretty, beguiling package.

Always eager to raise the profile of Singapore's design industry, Tay comments, "Tourists come in and out and take photos in all the various corners of the store – especially with our big signature poster. We hope THELIFESHOP has made people sit up and take notice of Singaporean designs, and now, through the design of our showroom, [that we can provide] some form of Singapore experience." And with jazz playing in background, it is easy to lose oneself and melt away in the beautiful atmosphere of THELIFESHOP.

Ten years down the road, THELIFESHOP has become one of the most recognisable and respected brands to emerge from Singapore – an impressive feat for its owners, who had no background in retail. With the design of their new home fashion store, they have single handedly created an exciting and fresh fashion angle for the home furnishing industry. More significant though, is that they have perhaps managed to capture what is even to this day, a concept that is undefined and abstract, yet so desperately sought after by the entire nation – that elusive Singapore identity.

THELIFESHOP has been leading a quiet revolution to raise the awareness of "new Asian" designs in Singapore, exhibiting a unique potpourri of cultural heritage from Zen minimalism to the mystic traditions of the Orient, from the sensual expressions of India to the ethnic splendour of Indochina.

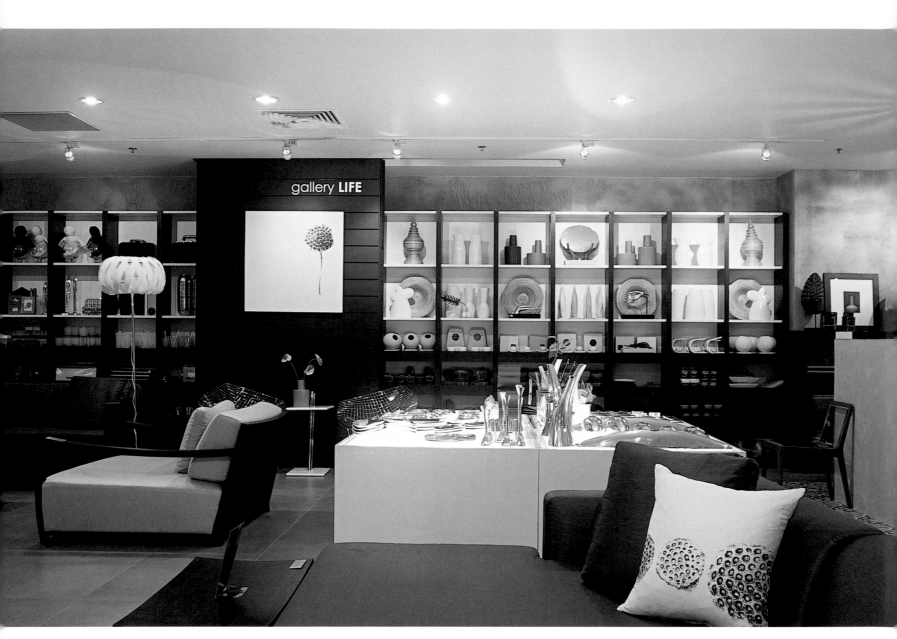

A fashionable bright pink wall in the front of the store sets the mood for the whole experience of the interior. Not chosen simply on a whim, the refreshing pink is really an embodiment of THELIFESHOP's motto — to be lively, exotic, creative, and happy.

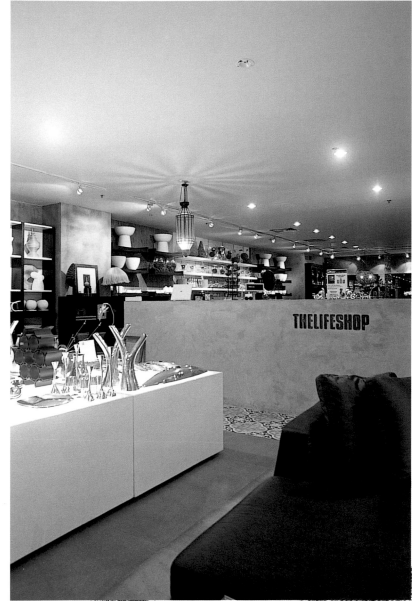

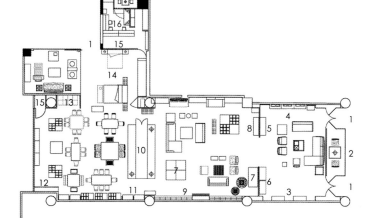

floor plan

1. entrance
2. display
3. "museum of objects"
4. "pillow talk"
5. "new asian revolution manifesto"
6. "designer bookclub"
7. "hip objects"
8. "dressing room"
9. "gallery life"
10. counter
11. "ceramics"
12. "spa life"
13. "flowers"
14. "night life"
15. store
16. office

DESIGNER/ARCHITECT INDEX

Fat 4 Pty Ltd (Melbourne)
P (61) 3 9510 3302

Flea + Cents (Hong Kong)
P (852) 2528 0808

Fluxus Interior (Singapore)

Mike Chen (Hong Kong)
P (852) 2179 5388

Peter Tay (P 3) (Singapore)
P (65) 6345 8142

projectshopBLOODbros (Singapore)

ACKNOWLEDGEMENTS

We wish to express our gratitude to all the architects and designers for their kind permission to publish their work, to the offices and photographers who have allowed us to use their images, to our foreign co-ordinators and contributing writers for their invaluable efforts, and most of all, to the shop owners who have so graciously allowed us to share their stylish outlets with readers across the world.

We would like to acknowledge the hard work of all involved in the production of this book. Thank you all.